THE HUNTINGTON ART COLLECTIONS: A HANDBOOK

Copyright 1986. The Huntington Library. San Marino, California
Designed by Ward Ritchie

The publication of this book was supported by a grant
from the National Endowment for the Arts

Library of Congress Cataloging in Publication Data

ISBN 0–87328–090–3

CONTENTS

Introduction / 1

British Art
 Paintings / 3
 Miniature Portraits / 42
 Drawings and Watercolors / 48
 Sculpture / 54
 Silver / 62
 Furniture and Decorative Objects / 70
 Ceramics and Glass / 78
 Chelsea / 78
 Wedgwood / 84

Continental European Art
 French Paintings / 86
 Eighteenth Century / 86
 Barbizon and Related / 92
 French Sculpture / 96
 Eighteenth Century / 96
 Later Sculpture / 104
 French Decorative Art / 106
 Tapestries and Fabrics / 106
 Furniture / 108

Sèvres Porcelain / 116
Snuffboxes / 120
Continental Paintings Other Than French
 Renaissance / 122
 Additional Renaissance Paintings
 Not Normally on Public
 Exhibition / 126
 Dutch and Flemish Seventeenth-
 Century / 128
 Italian Eighteenth-Century / 130
Renaissance Bronzes / 134

American Art
 Paintings / 142
 Drawings / 167
 Sculpture / 168

Prints / 172

Miscellaneous Art Objects / 174

Garden Sculpture / 176

Index / 181

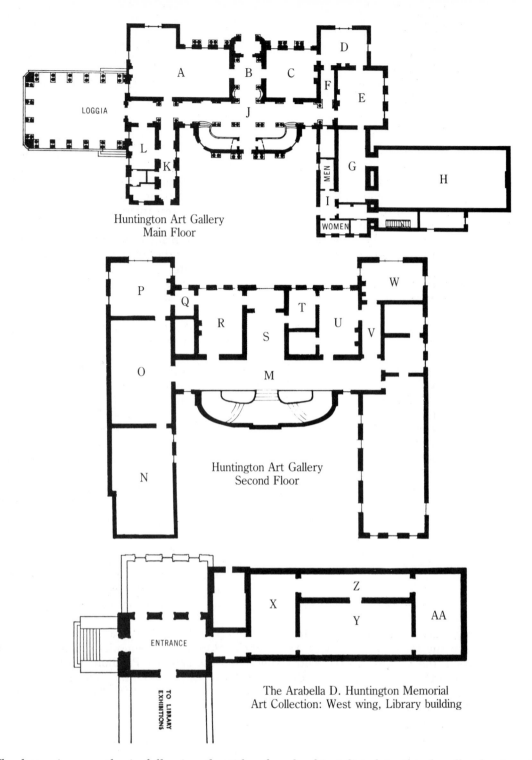

Huntington Art Gallery
Main Floor

Huntington Art Gallery
Second Floor

The Arabella D. Huntington Memorial
Art Collection: West wing, Library building

The letter in parenthesis following the title of each object listed in this handbook gives the location of the object on the above plans at the time this handbook was printed. The number in parenthesis at the end of each catalog entry is the accession number for the object. If the object is illustrated, the accession number is repeated under the illustration. Not all objects listed in the handbook are on exhibition.

INTRODUCTION

The Huntington Art Collections differ in at least one important respect from those of the normal community art museum. The collections are specialized rather than general in character. They focus on eighteenth-century British and French art, and on American art ranging in date from the early eighteenth century to the early twentieth.

The best known part of the collections is a large group of British portraits created between 1770 and 1800. Around these paintings have been assembled other objects of the same period, particularly French paintings, and French and English sculpture, tapestries, furniture, porcelain, and silver. Additional British paintings, drawings, and watercolors enlarge both the chronological coverage and the variety of types represented, but the focus remains on the late eighteenth century.

In 1984 American art was established as an important part of the Huntington as the result of a major gift from the Virginia Steele Scott Foundation. The American painting collection, housed in a physically separate building, currently consists of about sixty works ranging in date from the 1740s to the 1930s. The emphasis is on the nineteenth century. The Huntington also has important collections of American graphic art, particularly photographs.

Such specialized collections do not illustrate the striking shifts in taste that operate over a longer span of history, nor the dramatic differences in art works produced by cultures widely separated racially and geographically. But they have the advantage of being able to present a rich and explicit view of the periods and countries chosen for specialization. In particular, the Huntington offers opportunities for the study of British art of the Georgian period that for quality, variety, and depth cannot be surpassed outside London.

The Huntington Art Collections are not static. The core of the British collection, including many of the most famous paintings, was assembled by Henry E. Huntington between 1910 and his death in 1927. But the collections have continued to grow by both gift and purchase ever since, and the rate of growth has increased dramatically from the late 1950s to the present. Major areas of growth in British art during the last thirty years have been in drawings and watercolors, sculpture, silver, and furniture. The representation of French and other European eighteenth-century painting was greatly strengthened in 1978 by the bequest of the Adele S. Browning Memorial Collection from Judge and Mrs. Lucius P. Green. The opening in 1984 of the Virginia Steele Scott Gallery for American art began a major new chapter in the growth of the Huntington Art Collections.

This handbook contains basic factual information about works of art regularly, and occasionally, on exhibition in the Huntington Gallery, the Arabella Huntington Memorial Collection (in the Library building), the Virginia Steele Scott Gallery, and the entrance Pavilion. Visitors wishing more detailed information are referred to the catalogs devoted to special facets of the collections. A complete list of all publications in print related to the Huntington Art Collections is available through the Publications Department.

THE GREAT PERIOD of British painting is approximately one hundred years, from the mid-eighteenth to the mid-nineteenth century. During that time, as never before or since, British art is on a par with the best that continental Europe is producing, and British painters are acknowledged internationally as among the leaders of the day. The period is ushered in with the mature works of Hogarth in the 1740s and concludes with the late landscapes of Turner in the 1840s. In between come most of the great names of British painting and drawing: Reynolds, Gainsborough, Blake, Constable. The artistic material of this period seen in bulk presents almost incredible variety, much of it on an astonishingly high level qualitatively. The Huntington Art Gallery offers an excellent view of this epoch in British art.

The most prominent feature of the Huntington collection is a group of twenty full-length portraits by Reynolds, Gainsborough, Romney, and Lawrence, including such famous pictures as "The Blue Boy," "Pinkie," and "Mrs. Siddons as the Tragic Muse." Portraits of this type were a specialty of the period and absorbed much of the energy of the most gifted artists. Although most of the pictures were created on commission from the sitter, many were also intended for public display. They made their initial appearances at the annual Royal Academy exhibition, which was then the principal artistic event of the year. "The Blue Boy," for instance, almost certainly appeared in 1770, "Mrs. Siddons as the Tragic Muse" in 1784, and "Pinkie" in 1795. A somewhat grand and rhetorical air was considered appropriate for this type of "public face" painting, and this artistic intention should be kept in mind when looking at these portraits. At other times, or under other circumstances, the artists of the period could be much more informal and domestic in tone. The small-scale group portraits called "conversation pieces" (several of which are displayed in the southeast room [P] on the second floor of the gallery) show the other side of the coin. This sort of flexibility in artistic style and objective is particularly characteristic of British painting of the period covered by the Huntington collection.

If portraits are the leading art form in late eighteenth-century British art, landscape takes over in the early nineteenth. The period is dominated by two giants, Constable and Turner, who overshadow a host of highly gifted but lesser artists. A great deal of the activity in landscape took place in the medium of watercolor rather than oil, and the major portion of the Huntington gallery's holdings in British landscape is thus classed as drawings. But Constable's "View on the Stour near Dedham," in the Main Gallery (H), deserves to be considered one of the outstanding achievements not only in British but also in European landscape painting.

A substantial number of British painters devoted their talents to genre subjects, particularly scenes involving animals. Many of these pictures reflect the national preoccupation with racing and hunting; others are more concerned with simple farmyard themes. Paintings of these types, by some of the principal practitioners—Stubbs, Marshall, Sartorius, and Morland—are on display in the southwest room (W) on the second floor of the gallery.

British artists had no great success with painting narrative pictures on themes from history, the Bible, and the classics of literature—the type of painting that dominates European art up to the late eighteenth century. But pictures of this sort were certainly greatly esteemed by British artists, and many of them worked on subjects of this kind. The most notable British achievement in this area was in drawings rather than paintings, and centers on one of the most extraordinary artists of the period, William Blake. Nearly all of Blake's work is in pen-and-watercolor which suffers by prolonged exposure to light. Consequently the gallery's extensive holdings of works by Blake and other artists who worked in a similar vein are not constantly on view; but a selection of his drawings is normally displayed for at least a portion of each year.

3

Aikman, William (1682–1731) attributed to
James Thomson (1700–1748)
Canvas: 30½ x 26 in. *Acq.:* 1920, (20.23).

Alken, Henry (1785–1851)
Four Cockfight Scenes
Panel: 9½ x 11½ in. each *Acq.:* 1974 (gift of
Audrienne Moseley), (74.61.2 A-D)

Birley, Oswald (1880–1952)
Henry Edwards Huntington (1850–1927) (Entrance
Foyer of the Library)
Canvas: 50 x 40 in.; signed and dated 1924.
Acq.: 1924, (24.13).

Arabella Duval Huntington (1850–1924) (Entrance
Foyer of the Library)
Canvas: 50 x 40 in.; signed and dated 1924.
Acq.: 1924, (24.14).

Bonington, Richard Parkes (1802–1828)
View of Venice (T)
Oil on board: 12 x 16 in. Painted in 1826
Acq.: 1983 (Adele S. Browning Memorial
Collection), (83.1).

Boultbee, John (c.1745–c.1812)
A Racehorse
Canvas: 27 x 35 in. *Acq.:* 1941 (gift of Mrs. Max
Farrand), (41.3).

Constable, John (1776–1837)
The Artist's Sisters, Anne and Mary Constable (P)
Canvas: 15 x 11½ in. Painted about 1818.
Coll.: Hugh Golding Constable; Col. J. H.
Constable. *Acq.:* 1961, (61.07).

Flatford Mill from the Lock (U)
Canvas: 10 x 12 in. Painted in 1810 or 1811.
Coll.: Isabel Constable; George Salting; Earl of
Haddington. *Acq.:* 1979 (Adele S. Browning
Memorial Collection), (79.11).

Salisbury Cathedral (D)
Known as the "Small Cathedral" or the "Wedding
Present" picture.
Canvas: 25 x 30 in. Signed and dated 1823.
Coll.: Mirehouse. *Acq.:* 1952, (52.02).

4

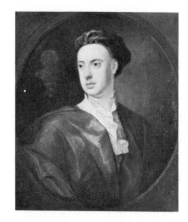

(20.23)

(74.61.2A)

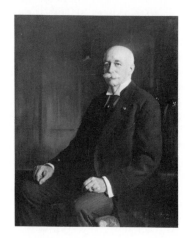

(24.13)

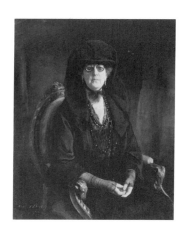

(24.14)

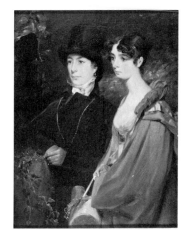

(61.07)

(83.1)

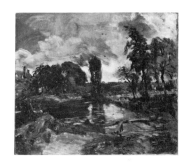

(79.11)

(41.3)

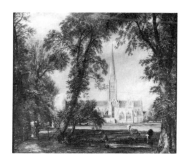

(52.02)

View on the Stour near Dedham (H)
A Suffolk landscape, near Constable's home.
Canvas: 51 x 74 in. Signed "John Constable pinx.
London 1822." *Coll.:* W. Carpenter; Horrocks
Miller. *Acq.:* 1925, (25.18).

Cosway, Richard (1742–1821)
Mrs. Joseph Smith (O)
Mrs. Smith, nee Margaret Cocks, niece of Charles
Cocks, first Lord Somers.
Canvas: 36 x 27½ in. Signed and dated 1787.
Coll.: G. J. Philip-Smith; Clifford E. Clinton.
Acq.: 1960 (gift of Mr. and Mrs. Clifford E. Clinton),
(60.08).

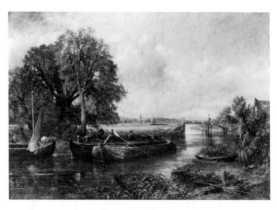

(25.18)

Cotes, Francis (1726–70)
Thomas Crathorne and His Wife, Isabel (G)
Isabel Crathorne was the daughter of Sir John
Swinburne, Bart., and a great-aunt of the poet
Algernon Charles Swinburne.
Canvas: 52½ x 59½ in. Signed and dated 1767.
Coll.: Viscount Kemsley. *Acq.:* 1964, (64.09).

Crome, John (1768–1821)
The Edge of a Common (G)
Canvas: 69½ x 55½ in. Painted about 1812.
Coll.: P. M. Turner. *Acq.:* 1933, (33.02).

Dance, Nathaniel (1735–1811) attributed to
Richard Cumberland (O)
Canvas: 29¾ x 25 in. *Coll.:* Taylor.
Acq.: 1938 (gift of Florence M. Quinn), (44.103).

Devis, Arthur (1711–1787)
*George 1st Lord Lyttelton, His Brother Lt. Gen. Sir
Richard Lyttelton, and Sir Richard's Wife Rachel* (P)
Canvas: 49½ x 39½ in. Signed and dated
1748. *Coll.:* Lyttelton; Catherine Wood; B. W.
Bourne; Robert Tritton. *Acq.:* 1965, (65.05).

De Wint, Peter (1784–1849)
Study of Foliage
Oil on paper mounted on board; 10⅜ x 13⅜
in. *Coll.:* Miss Tatlock, the artist's grand-daughter;
Sir Geoffrey Harmsworth. *Acq.:* 1982, (82.32).

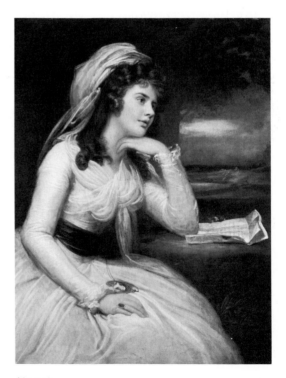

(60.08)

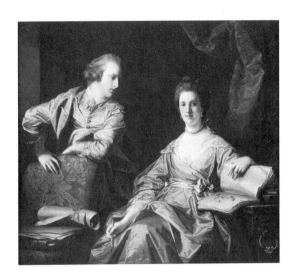

(64.09)

(44.103)

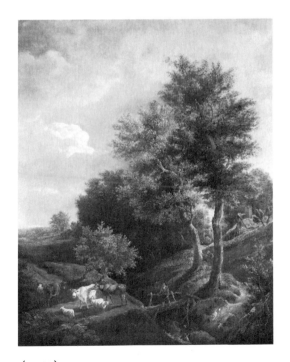

(33.02)

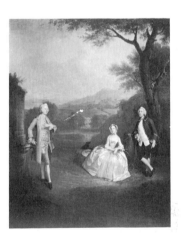

(65.05)

(82.32)

Dupont, Gainsborough (c. 1754–97)
Landscape
Oil on paper, 12 x 16⁹⁄₁₆ in.
Coll.: J. Meheux; Easton; Carew Hunt; Brian Jenks.
Acq.: 1973, (73.25A).

Landscape
Oil on paper, 12 x 16¹³⁄₁₆ in.
Coll.: (as for 73.25A) *Acq.:* 1973, (73.25B).

Etty, William (1787–1849)
Still Life (Q)
Panel: 12½ x 16¼ in. *Coll.:* Henry Burton; T.
Gabriel. *Acq.:* 1964, (64.12).

Gainsborough, Thomas (1727–88)
Karl Friedrich Abel (H)
Karl Abel (1725–87), chamber musician to Queen
Charlotte; friend of Gainsborough.
Canvas: 88 x 58 in. Painted about 1777.
Coll.: Queen Charlotte; Egremont; George J. Gould.
Acq.: 1925, (25.19).

Mrs. Henry Beaufoy (M)
Elizabeth (1754?–1824?), daughter of William
Jenks; married (1) Henry Beaufoy, about 1770, and
(2) Joseph Pycroft, 1797. *Canvas:* 90 x 58¾ in.
Painted about 1780. *Coll.:* Beaufoy; Heathcote;
Alfred de Rothschild; Lady Carnarvon.
Acq.: 1924, (24.01).

Jonathan Buttall: "The Blue Boy" (H)
Jonathan Buttall (about 1752–1805), son of a
hardware merchant; a friend of Gainsborough.
Canvas: 70 x 48 in. Painted about 1770.
Coll.: Buttall; Nesbitt; John Hoppner;
Westminster. *Acq.:* 1921, (21.01).

The Cottage Door (H)
Canvas: 58 x 47 in. Painted, presumably, about
1780. *Coll.:* Harvey of Catton, Norfolk; Coppin,
Norwich; De Tabley; Westminster. *Acq.:* 1922,
(22.03).

Anne, Duchess of Cumberland (C)
Anne (1743–1808), daughter of Simon Luttrell, 1st
earl of Carhampton; married (1) Christopher
Horton, 1765, and (2) H.R.H. Henry Frederick, duke
of Cumberland, brother of George III, 1771.
Canvas: 35¼ x 27¾ in. Painted 1775–80.
Coll.: Lawley; Wenlock. *Acq.:* 1912, (12.10).

(73.25A)

(73.25B)

(64.12)

(25.19)

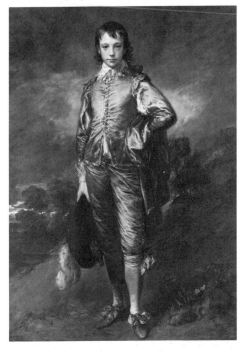

(21.01)

(24.01)

(12.10)

(22.03)

Mrs. Henry Fane (H)
Anne (1758–1838), daughter of Edward Batson;
married Henry Fane, second son of Thomas, 8th
earl of Westmoreland, 1778.
Canvas: 35 x 27 in. Painted about 1782.
Coll.: Fane; Michel; E. L. Raphael. *Acq.:* 1926,
(26.108).

Lady with a Spaniel (P)
Canvas: 30 x 25 in. Painted about 1750.
Coll.: Fairfax Murray; Brocket. *Acq.:* 1947,
(47.01).

Edward, 2d Viscount Ligonier (H)
Edward (1740–82), son of Col. Francis Ligonier;
succeeded his uncle, John, 1st viscount, in 1770;
married (1) Penelope Pitt, 1766 (see her portrait
below), and (2) Lady Mary Henley, 1773.
Canvas: 92½ x 61½ in. Painted 1770.
Coll.: Rivers. *Acq.:* 1911, (11.30).

Penelope, Viscountess Ligonier (H)
Penelope (1749–1827), daughter of George Pitt, 1st
Baron Rivers; married (1) Edward, 2d Viscount
Ligonier, 1766 (see his portrait above), and (2)
Private Smith of the Horse Guards, 1784.
Canvas: 93 x 61 in. Painted 1770.
Coll.: Rivers. *Acq.:* 1911, (11.29).

Mrs. John Meares (H)
Henrietta (b. about 1760), daughter of Henry Read;
granddaughter of Sir Benjamin Truman; married
John Meares, 1790.
Canvas: 88 x 55½ in. Painted about 1777.
Coll.: Truman; Villebois; Alfred de Rothschild; Lady
Carnarvon. *Acq.:* 1924, (24.02).

Juliana, Lady Petre (H)
Juliana (1769–1833), daughter of Henry Howard;
married Robert, 9th Baron Petre of Writtle (1742–
1801), 1788.
Canvas: 88¾ x 57¼ in. Painted 1788.
Coll.: Petre. *Acq.:* 1911, (11.25).

Young Hobbinol and Ganderetta (U)
Canvas: 49½ x 39½ in. Probably painted in
1788. *Coll.:* Thomas Macklin; Sir R. C. Hoare;
Samson Wertheimer; Baron Albert von Rothschild;
Baron Louis Rothschild. *Acq.:* 1978 (Adele S.
Browning Memorial Collection), (78.20.30).

10

(26.108)

(47.01)

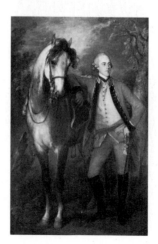

(11.30)

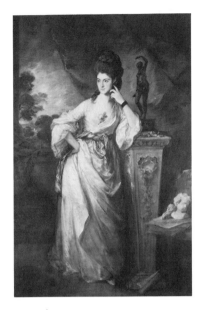

(11.29)

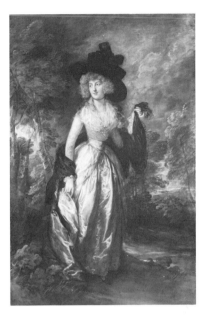

(11.25)

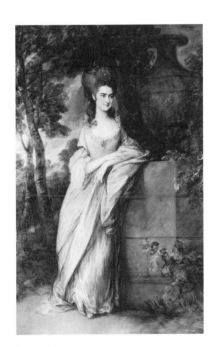

(24.02)

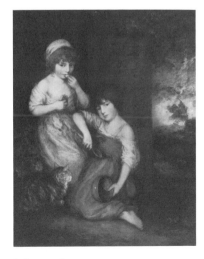

(78.20.30)

Hayman, Francis (1708–76)
A Bailiff (P)
Canvas: 25¼ x 18 in. *Acq.:* 1947, (47.03).

The Gascoigne Family (P)
The identification of the family is based on
tradition.
Canvas: 40 x 50 in. *Coll.:* Mrs. R. O'Brien.
Acq.: 1957, (57.08).

Hayter, George (1792–1871)
Portrait Sketch of John Poulter (Q)
Panel: 12½ x 10½ in. Signed and dated
1834. *Acq.:* 1982 (gift of the Friends), (82.210).

Herring, John Frederick, Sr. (1795–1865)
Cotherstone (V), winner of the Derby in 1843.
Canvas: 14½ x 19½ in. Signed and dated
1844. *Acq.:* 1980 (bequest of Audrienne
Moseley), (74.61.5).

Plenipotentiary
Canvas: 13¾ x 17½ in. Signed. *Acq.:* 1980
(bequest of Audrienne Moseley), (74.61.4).

Alice Hawthorn
Canvas: 12 x 15¾ in. Signed and dated
1844. *Acq.:* 1980 (bequest of Audrienne
Moseley), (74.61.3).

Highmore, Joseph (1692–1780)
Man in a White Silk Waistcoat (D)
Canvas: 49¼ x 39¼ in. *Coll.:* Phelips of
Montacute; Evans. *Acq.:* 1934, (34.01).

Hodges, William (1744–97)
A View near Fort Gwalior, India (Q)
Canvas: 12¾ x 18¼ in. *Acq.:* 1933,
(33.06). *Note:* In earlier publications this painting
was identified as "Roman Landscape" by Richard
Wilson.

12

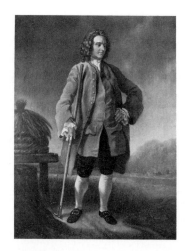

(47.03)

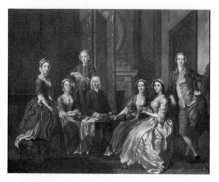

(57.08)

(82.210)

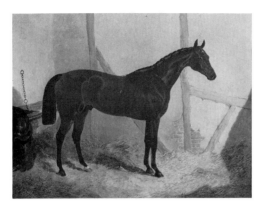

(74.61.5)

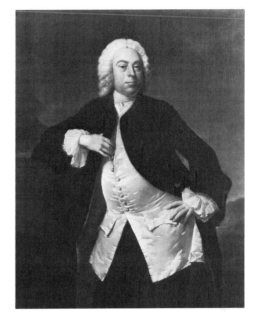

(34.01)

(74.61.4)

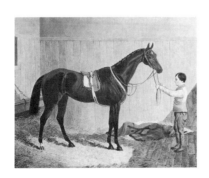

(74.61.3)

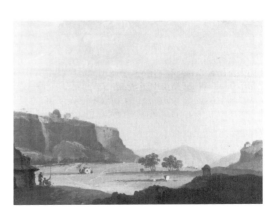

(33.06)

13

Hogarth, William (1697–1764)
Frederick Frankland (E)
Frederick (1694–1768), son of Sir Thomas
Frankland, 2d bart.; a director of the Bank of
England, 1736; commissioner of excise, 1753–63;
married (1) Elizabeth de Cardonnel, 1729, and (2)
Lady Anne Lumley, 1739.
Canvas: 50 x 40 in. Painted about 1740.
Coll.: Frankland of Thirkleby; Leon.
Acq.: 1934, (34.04).

Benjamin Hoadly, Bishop of Winchester (P)
Bishop Hoadly, friend of Hogarth, was successively
bishop of Hereford, Salisbury, and Winchester; he
was a noted controversialist. Bishop Hoadly is
wearing the robes of Garter Prelate.
Canvas: 24 x 19 in. Painted about 1740.
Coll.: D'Oyley; Thomas. *Acq.:* 1956, (56.17).

Mrs. Hoadly (P)
Probably Sarah Curtis, first wife of Bishop Hoadly
(see his portrait above).
Canvas: 24 x 19 in. Painted about 1740.
Coll.: D'Oyley; Thomas. *Acq.:* 1956, (56.18).

Hoppner, John (1758–1810)
The Godsal Children: The Setting Sun (U)
Susanne (1772–1852), Philip Lake (1784–1858),
Maria (born 1785), children of Mr. Godsal of Iscoyd
Park near Whitchurch, Flintshire.
Canvas: 54 x 60½ in. Painted in 1789.
Coll.: Godsal; J. Pierpont Morgan; Mrs. H. L.
Satterlee. *Acq.:* 1978 (Adele S. Browning
Memorial Collection), (78.20.31).

Isabella, marchioness of Hertford (H)
Isabella (1760–1834), daughter of Charles, 9th
Viscount Irvine; married Francis Seymour, earl of
Yarmouth and 2d marquess of Hertford, 1776. She
was the mistress of the prince regent.
Canvas: 29½ x 24½ in. Painted 1784.
Coll.: Ramsden. *Acq.:* 1924, (24.31).

Hudson, Thomas (1701–79)
Mary, Duchess of Ancaster (O)
Mary (d. 1793), daughter of Thomas Panton;
married (as his second wife) Peregrine, 3d duke of
Ancaster, 1750. She was mistress of the robes to
Queen Charlotte in 1761.
Canvas: 49½ x 39½ in. *Acq.:* 1938 (gift of
Florence M. Quinn), (44.100).

14

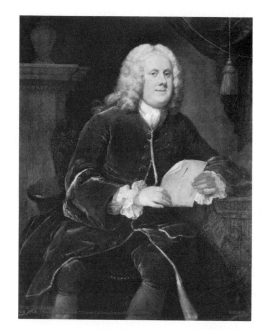

(34.04)

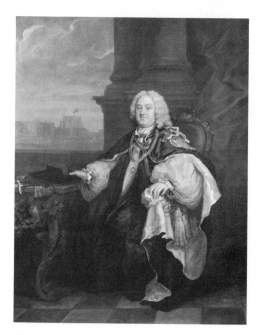

(56.17)

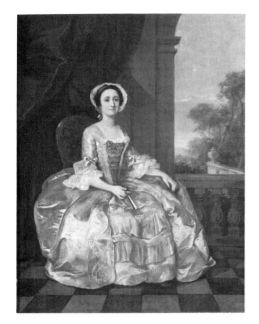

(56.18)

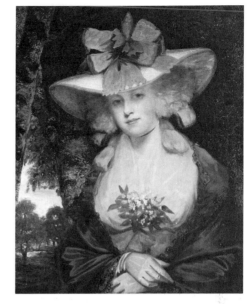

(24.31)

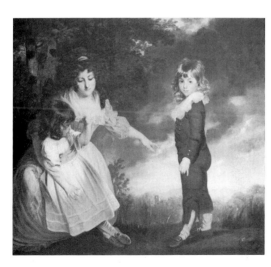

(78.20.31)

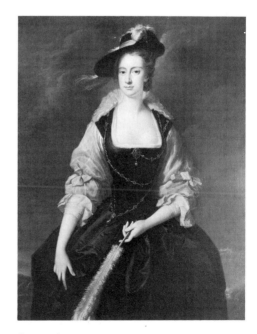

(44.100)

Dr. Isaac Schomberg (O)
Dr. Isaac Schomberg (1714–80), well-known
physician.
Canvas: 30 x 25 in. *Coll.:* S. Edwards.
Acq.: 1933, (33.01).

Ibbetson, Julius Caesar (1759–1817)
Landscape with Mountain Brook
Canvas: 22½ x 29 in. *Acq.:* 1941 (gift of Mr. and
Mrs. Max Farrand, (41.1).

Kettle, Tilly (1735–86)
Charles James Fox (Trustees Room, Main Library)
A leading British politician of the late eighteenth
century.
Canvas: 50 x 40 in. *Coll.:* R. Holden.
Acq.: 1953, (53.03).

Kneller, Godfrey (1646–1723)
Sir William Robinson (E)
Canvas: 50 x 40½ in. Signed "G.K. 1693."
Coll.: Coningsby of Hampton Court, Herefordshire;
Evans. *Acq.:* 1934 (gift of Beatrix Farrand),
(34.02).

Lawrence, Thomas (1769–1830)
Emily Anderson: "Little Red Riding Hood" (E)
Emily (b. about 1805), daughter of William
Anderson.
Canvas: 62¼ x 44 in. Painted about 1821.
Coll.: Anderson. *Acq.:* 1918, (18.18).

Mrs. Bishop (O)
attributed to Sir Thomas Lawrence. Elizabeth Harris
(1780–1838) married the Hon. Henry Bishop, chief
justice of the Common Pleas of St. Michael.
Canvas: 29½ x 24½ in. *Coll.:* Carter. *Acq.:* 1938
(gift of Florence M. Quinn), (44.97).

Mrs. Cunliffe-Offley (E)
Emma Crewe (1780–1850), daughter of John, 1st
Baron Crewe; married Foster Cunliffe-Offley, 1809.
Canvas: 49½ x 39½ in. Painted after 1809.
Coll.: Houghton; Crewe. *Acq.:* 1917, (17.29).

Lady Jane Long (U)
Daughter of James Maitland, 7th earl of Lauderdale.
Canvas: 30 x 25 in. Painted in 1793.
Coll.: Mrs. Hugh Elliot; William Randolph
Hearst. *Acq.:* 1978 (Adele S. Browning Memorial
Collection), (78.20.32).

16

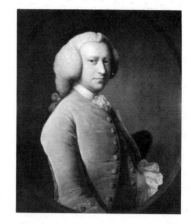

(33.01)

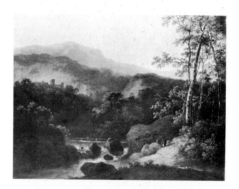

(41.1)

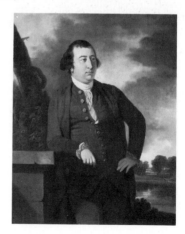

(53.03)

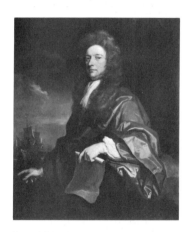

(34.02)

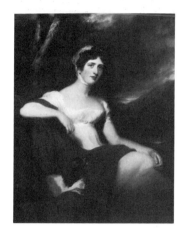

(17.29)

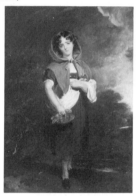

(18.18)

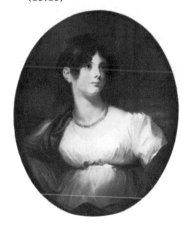

(44.97)

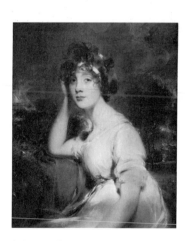

(78.20.32)

17

Sarah Barrett Moulton: "Pinkie" (H)
Sarah (1783–95), daughter of Charles Barrett
Moulton. The family name was later changed
to Moulton-Barrett; Edward, brother of Sarah, was the
father of Elizabeth Barrett Browning.
Canvas: 57½ x 39¼ in. Painted 1794.
Coll.: Moulton-Barrett; Michelham. *Acq.:* 1927,
(27.61).

Arthur Wellesley, 1st Duke of Wellington, K.G. (O)
attributed to Thomas Lawrence. Arthur Wellesley
(1769–1852), son of the 1st earl of Mornington;
created duke of Wellington, 1814; victor of
Waterloo, 1815; prime minister, 1828–30.
Canvas: 36 x 27¾ in. *Coll.:* Jennens. *Acq.:* 1938
(gift of Florence M. Quinn), (44.102).

Woman and Child (sketch) (O)
follower of Thomas Lawrence.
Canvas: 14½ x 16½ in. Painted about 1810.
Acq.: 1938 (gift of Florence M. Quinn), (44.104).

Lely, Peter (1618–80)
Essex Finch, Later Countess of Nottingham (L)
Canvas: 45 x 37 in. *Coll.:* Finch; Hanbury;
Kahn. *Acq.:* 1951, (51.13).

Linnell, John (1792–1882)
Jacob's Well (Q)
Panel: 10 x 8 in. Painted 1828. *Acq.:* 1966, (66.55).

Loutherbourg, Philip James De (1740–1812)
Wagon outside an Inn (W)
Canvas: 14¾ x 20½ in. Signed. *Coll.:* Geoffrey
Bourne-May. *Acq.:* 1979, (79.10).

Marshall, Benjamin (1767–1835)
Sailor with Mr. Thomas Thornhill (W)
Canvas: 40 x 50 in. Signed and dated 1819.
Coll.: Thornhill; Dermot McCalmont; Marshall
Field. *Acq.:* 1958, (58.03).

Sam with Sam Chifney, Jr., Up (W)
Canvas: 40 x 50 in. Signed and dated 1818.
Coll.: Thornhill; Dermot McCalmont; Marshall
Field. *Acq.:* 1958, (58.02).

The Trimmed Cock (V)
Canvas: 29½ x 24½ in. Signed and dated
1821. *Coll.:* Mrs. Felix Leach. *Acq.:* 1974 (gift
of Audrienne Moseley), (74.61.01).

18

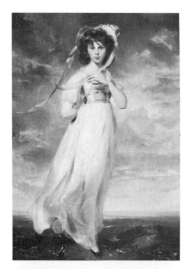

(27.61)

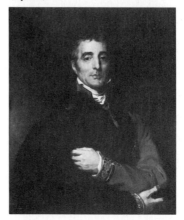

(44.102)

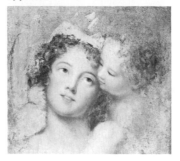

(44.104)

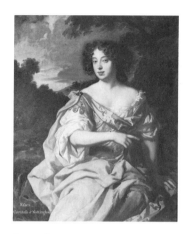

(51.13)

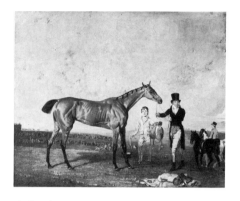

(58.03)

(66.55)

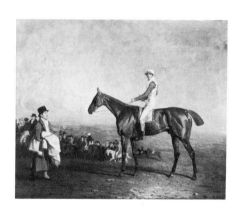

(58.02)

(79.10)

(74.61.01)

Morland, George (1763–1804)
The Farmyard (W)
Canvas: 39½ x 55 in. Signed and dated
1792. *Coll.:* Baker; Gibson Fleming. *Acq.:* 1960
(60.06).

The Lucky Sportsman and
The Unlucky Sportsman (Q)
Panels: each 12 x 10 in. Each signed and dated
1791. *Coll.:* Louis Huth. *Acq.:* 1958 (gift of the
Friends) (58.04 and 58.05).

Summer and *Autumn*
Canvas: each 7¼ x 6 in. *Acq.:* 1938 (gift of
Florence M. Quinn), (44.110 and 111).

Mortimer, John Hamilton, (1740–1779)
*Edward the Confessor Spoiling His Mother of Her
Effects and Treasures* (M)
Canvas: 24¼ x 19¾ in. Probably painted in
1763. *Coll.:* Charles Lambert. *Acq.:* 1978,
(78.08).

Muller, William James (1812–45)
Montfaloot, Egypt
Panel: 10¾ x 15¾ in. Signed, inscribed, and dated
1841. *Acq.:* 1975, (75.42).

Northcote, James (1746–1831)
Mrs. Anne King (O)
Canvas: 30 x 24½ in. Signed. Painted 1789.
Coll.: King. *Acq.:* 1962, (62.84).

Owen, William (1769–1806)
Master Mordaunt Ricketts
Canvas: 36 x 28 in. *Coll.:* Ricketts Batson.
Acq.: 1938 (gift of Florence M. Quinn), (44.98).

Peters, Matthew William (1742–1814)
The Flageolet Players (E)
Perhaps part of a series of music pictures painted
by this artist.
Canvas: 64½ x 49½ in. *Acq.:* 1921, (21.03).

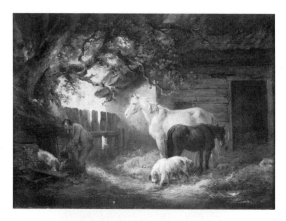

(60.06)

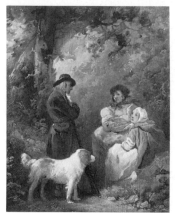

(58.04)

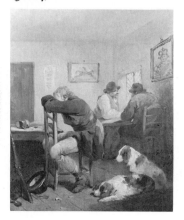

(58.05)

(44.110)

(44.111)

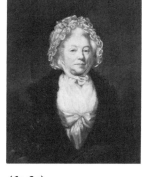

(62.84)

(78.08)

(44.98)

(75.42)

(21.03)

Pine, Robert Edge (1730?–88)
David Garrick (1717–79)
Canvas: 27 x 22 in. *Coll.:* Thomas B.
Clarke. *Acq.:* 1919, (19.4).

Raeburn, Henry (1756–1823)
Lieutenant Andrew Agnew
attributed to Raeburn
Canvas: 30 x 25 in. Painted about 1791.
Coll.: Agnew. *Acq.:* 1938 (gift of Florence M.
Quinn), (44.99).

Master William Blair (H)
William (1799–1873), son of Robert Blair of
Avontoun; married Jane Christian Nourse, of Cape
Town, 1826; was chief justice in Corfu.
Canvas: 29½ x 24¾ in. Painted about 1814 for
George Home; a replica of an earlier portrait that
remained with the Blair family until the 1930s.
Coll.: Home. *Acq.:* 1922, (22.39).

Sir William Miller (*Lord Glenlee*) (J)
William (1755–1846), son of Sir Thomas Miller,
first Lord Glenlee; succeeded to baronetcy, 1789;
Scottish judge, lord of session, 1795–1840.
Canvas: 83 x 57½ in.
Coll.: Miller. *Acq.:* 1908, (08.01).

Mrs. Scott Moncrieff
attributed to Raeburn. A replica of the painting in
the National Gallery of Scotland.
Canvas: 30 x 25 in. *Coll.:* T. J. Barrett; E. H. Gray;
Mrs. Henry Walters. *Acq.:* 1978 (Adele S.
Browning Memorial Collection), (78.20.33).

Mrs. John Pitcairn (K)
Mrs. Pitcairn, nee Jean Robertson, was the wife of
the chief magistrate of Dundee, Scotland.
Canvas: 35 x 27½ in.
Coll.: A. R. Wilson Wood; W. Averell Harriman.
Acq.: 1944 (gift of W. Averell Harriman), (44.150).

James Watt (MAIN LIBRARY)
The inventor of the steam engine.
Canvas: 30 x 25 in. Painted in 1815.
Coll.: by family descent to G. A. Thomas.
Acq.: 1963, (63.38).

22

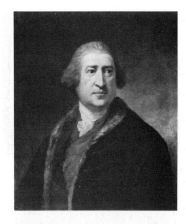

(19.4)

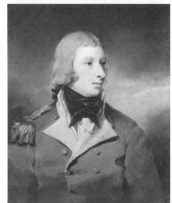

(44.99)

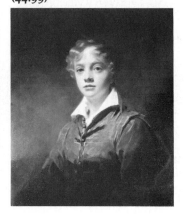

(22.39)

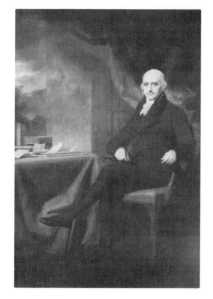

(08.01)

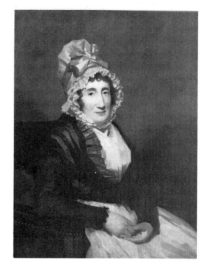

(44.150)

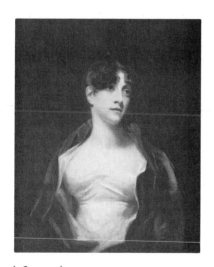

(78.20.33)

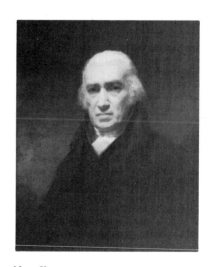

(63.38)

Ramsay, Allan (1713–84)
Anne, Countess Winterton (G)
Anne (d. 1775), daughter of Thomas, 1st Baron
Archer of Umberslade; married 1756 (as his first
wife) Edward Turnour Garth-Turnour, later created
Viscount Turnour of Gort and Earl Winterton.
Canvas: 30 x 25 in. Signed and dated 1762.
Coll.: Winterton; Mrs. Duckworth. *Acq.:* 1958,
(58.20).

Youth with Cap and Gown (O)
attributed to Allan Ramsay.
Canvas: 30¼ x 25⅛ in. Painted about 1750.
Acq.: 1933, (33.05).

Reynolds, Joshua (1723–92)
Frances, Marchioness Camden (D)
Frances (d. 1829), daughter of William Molesworth;
married John, 1st marquess Camden, 1785. Her
cousin was Lavinia, Lady Spencer, whose portrait
is in this collection.
Canvas: 54½ x 44½ in. Painted 1777.
Coll.: Lucan; Spencer. *Acq.:* 1924, (24.32).

Diana, Viscountess Crosbie (H)
Diana (1756–1814), daughter of George, 1st
viscount Sackville; married John, Viscount Crosbie
(2d earl of Glandore), 1777.
Canvas: 93 x 57 in. Painted 1777.
Coll.: Crosbie; Tennant. *Acq.:* 1923, (23.13).

Georgiana, Duchess of Devonshire (H)
Georgiana (1757–1806), daughter of John, 1st earl
Spencer; married William, 5th duke of Devonshire,
1774; leading spirit in the social and political life
of her time; champion of Charles James Fox.
Canvas: 93¼ x 57 in. Painted 1775–76.
Coll.: Spencer. *Acq.:* 1925, (25.20).

Jane, Countess of Harrington (H)
Jane (1755–1824), daughter of Sir John Fleming,
Bart.; married Charles, 3d earl of Harrington, 1779.
See also Reynolds' portrait of her mother, Mrs.
Lascelles (Lady Harewood).
Canvas: 92¾ x 57 in. Painted 1777–79.
Coll.: Harrington. *Acq.:* 1913, (13.03).

24

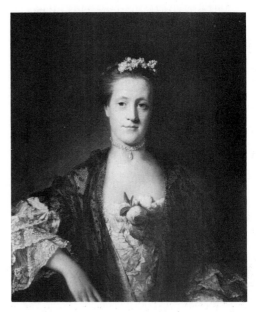

(58.20)

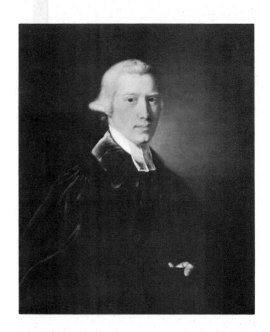

(33.05)

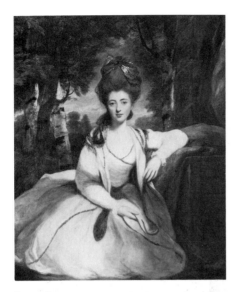

(24.32)

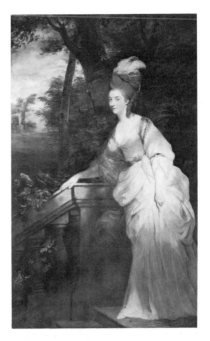

(25.20)

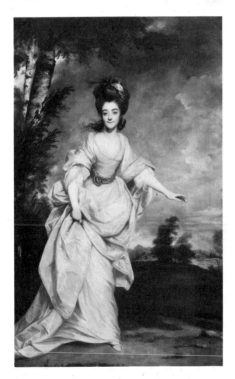

(23.13)

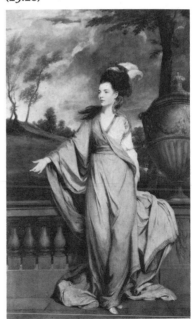

(13.03)

The Holy Family
after Reynolds.
Canvas: 76 x 58 in.
A studio copy of the painting in the National
Gallery, London. *Acq.:* 1910, (10.09).

Francis, 10th Earl of Huntingdon (O)
Francis Hastings (1728–89), son of Theophilus, 9th
earl of Huntingdon; carried the sword of state at
the coronation of George III, 1761; lord lieutenant
of West Riding of Yorkshire, 1762–65.
Canvas: 49½ x 39½ in. Painted 1754.
Coll.: Hastings; Loudoun; André; Adams.
Acq.: 1938 (gift of Florence M. Quinn), (44.101).

Mrs. John Irwin
Anne (c1732–67), only daughter of Sir Edward
Barry of Dublin, married Lieutenant-Colonel John
Irwin in 1760.
Canvas: 30½ x 25½ in. Painted in 1761.
Acq.: 1978 (Adele S. Browning Memorial
Collection), (78.20.34).

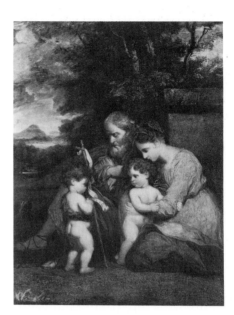

(10.09)

Mrs. Edwin Lascelles (*Lady Harewood*) (J)
Jane (1732–1813), daughter of William Colman;
married (1) Sir John Fleming, Bart., 1753, and (2)
Edwin Lascelles, 1st baron Harewood, 1770. See
also Reynolds' portrait of her daughter Jane,
Countess of Harrington.
Canvas: 92½ x 57 in. Painted about 1777.
Coll.: Harrington. *Acq.:* 1913, (13.02).
(destroyed by fire, October 1985)

Theresa Parker (G)
Theresa (1775–1855), daughter of John, 1st baron
Boringdon; married the Hon. George Villiers, 1798.
Canvas: 30 x 25 in. Painted 1787.
Coll.: Morley. *Acq.:* 1926, (26.85).

Sarah Siddons as the Tragic Muse (H)
Sarah (1755–1831), daughter of Roger Kemble, the
actor; married William Siddons, 1773. She was
considered the greatest actress of the English stage.
A replica, painted about 1789, is in the Dulwich
Gallery, London.
Canvas: 93 x 57½ in. Signed and dated 1784.
Coll.: De Calonne; Watson Taylor; Westminster.
Acq.: 1921, (21.02).

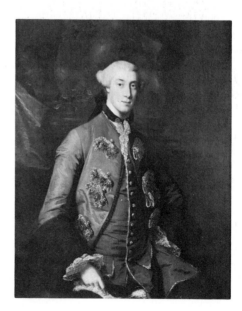

(44.101)

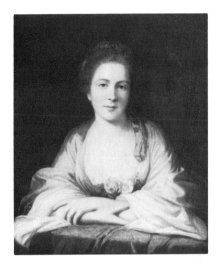

(78.20.34)

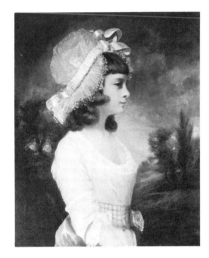

(26.85)

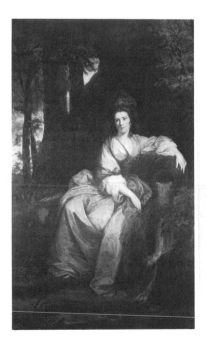

(13.02)

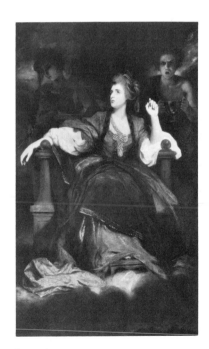

(21.02)

Lavinia, Countess Spencer, and Viscount Althorp (H)
Lavinia (1762–1831), daughter of Sir Charles
Bingham, Bart., 1st earl of Lucan; married George,
2d earl Spencer, 1781. Her son, John Charles,
viscount Althorp (1782–1845), became 3d earl
Spencer and married Esther, daughter of Richard
Acklom, in 1814.
Canvas: 57½ x 43 in. Painted 1783–84.
Coll.: Spencer. *Acq.:* 1924, (24.33).

Lavinia, Countess Spencer
after Sir Joshua Reynolds.
Canvas: 29½ x 24½ in.
Coll.: Earl of Bessborough. *Acq.:* 1926, (26.107).

The Van der Gucht Children (O)
Said to be the children of Thomas Van der Gucht.
Canvas: 30½ x 25 in. Painted about 1785.
Coll.: Van der Gucht; Willcox.
Acq.: 1938 (gift of Florence M. Quinn), (44.108).

The Young Fortune Teller (C)
Children of George, 4th duke of Marlborough: Lord
Henry Spencer (1770–95) and Lady Charlotte
(1769–1802). See also Romney's portrait of their
sisters, Lady Clifden and Lady Elizabeth Spencer.
Canvas: 55 x 43 in. Painted 1775.
Coll.: Marlborough; Tennant.
Acq.: 1923, (23.62).

**Richardson, Jonathan Sr. (1665–1745) attributed
to**
John Gay
Canvas: 50 x 39½ in. *Acq.:* 1920 (20.24).

Romney, George (1734–1802)
Penelope Lee Acton (H)
Penelope (1764–1819), daughter of Sir Richard
Rycroft, Bart.; married (as his second wife)
Nathaniel Lee Acton, 1791. See also Romney's
portrait of Susannah Lee Acton.
Canvas: 93¾ x 57½ in. Painted 1791.
Coll.: Lee Acton; Broke; De Saumarez.
Acq.: 1916, (16.01).

28

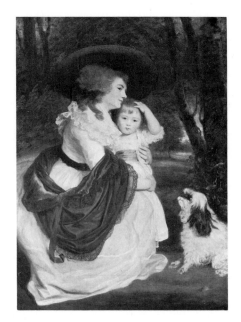

(24.33)

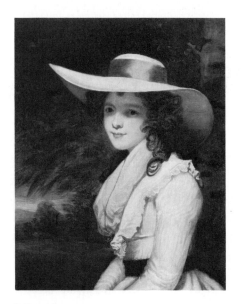

(26.107)

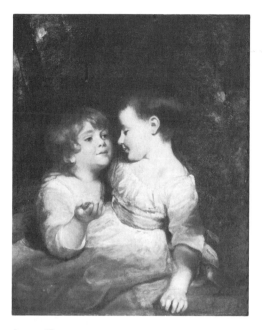

(44.108)

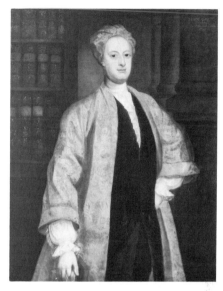

(20.24)

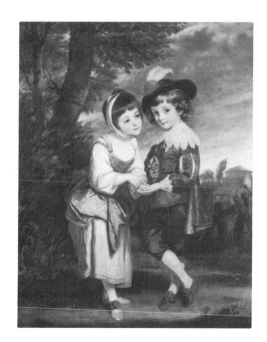

(23.62)

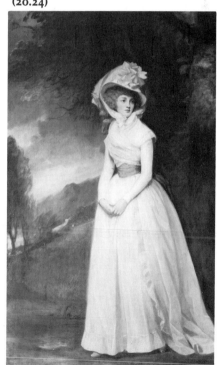

(16.01)

Susannah Lee Acton (G)
Susannah (d. 1789), daughter of Sir Thomas Miller, Bart.; married (as his first wife) Nathaniel Lee Acton, 1787. See also Romney's portrait of Penelope Lee Acton.
Canvas: 49½ x 39½ in. Painted 1786–87.
Coll.: Lee Acton; De Saumarez. *Acq.:* 1917, (17.25).

Mary, Lady Beauchamp-Proctor (H)
Mary (d. 1847), daughter of Robert Palmer; married Sir Thomas Beauchamp-Proctor, 2d Bart., 1778.
Canvas: 94¼ x 57½ in. Painted 1782–83.
Coll.: Beauchamp-Proctor; Burton; E. L. Raphael. *Acq.:* 1926, (26.86).

The Beckford Children (C)
Children of William Beckford of Fonthill, author and collector: Margaret (1784–1819), married Colonel Orde, 1811; Susan (1786–1859), married her cousin, Alexander, 10th Duke of Hamilton, 1810.
Canvas: 59½ x 47½ in. Painted 1789–91.
Coll.: Beckford; Hamilton. *Acq.:* 1920, (20.09).

Mrs. Francis Burton (C)
Daughter of Nicholas Halhead; married Francis Burton, 1788.
Canvas: 36¼ x 28 in. Painted 1789.
Coll.: Burton; G. G. Maitland; Mansel Lewis. *Acq.:* 1925, (25.17).

The Clavering Children (U)
Thomas John (1771–1853) and Catherine May (died 1785), children of George Clavering of Greencroft.
Canvas: 60 x 48 in. Painted in 1777.
Coll.: Clavering; John McCormack; George G. Baker. *Acq.:* 1978 (Adele S. Browning Memorial Collection), (78.20.35).

30

*Caroline, Viscountess Clifden, and
Lady Elizabeth Spencer* (M)
Daughters of George, 4th duke of Marlborough: Lady Caroline (1763–1813), married Henry Welbore, 2d Viscount Clifden, 1792; Lady Elizabeth (1764–1812), married her cousin John Spencer, 1790. See also Reynolds' portrait of their young brother and sister.
Canvas: 56 x 72 in. Painted 1786–92.
Coll.: Marlborough; Clifden. *Acq.:* 1911, (11.44).

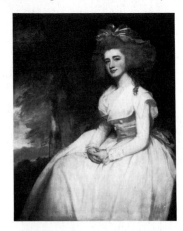

(17.25)

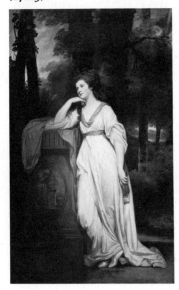

(26.86)

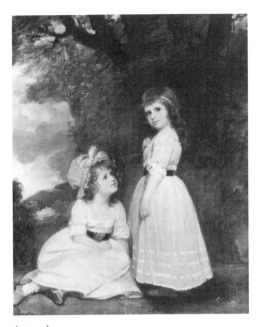

(20.09)

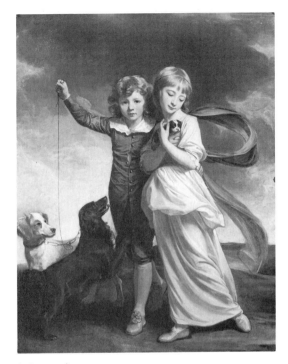

(78.20.35)

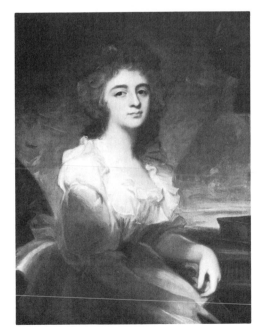

(25.17)

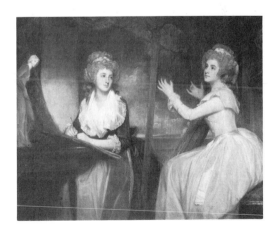

(11.44)

Mrs. Thomas Grove (M)
Charlotte (died 1828), daughter of Admiral Pilfold
of Effingham, Surrey, married Thomas Grove in
1781.
Canvas: 51½ x 39½ in. Painted in 1788.
Coll.: Grove; Charles Sedelmeyer; E. R. Bacon.
Acq.: 1978 (Adele S. Browning Memorial
Collection), (78.20.36).

Lady Hamilton in a Straw Hat (H)
Emma (1761?–1815), daughter of Henry Lyon, a
blacksmith; known as Mrs. Hart; married Sir
William Hamilton, 1791; later Nelson's mistress.
Canvas: 29½ x 24½ in. Painted not later than 1785.
Coll.: Tankerville Chamberlayne; Alfred de
Rothschild; Lady Carnarvon. *Acq.:* 1924, (24.05).

Lady Hamilton in a White Turban (D)
See above.
Canvas: 31½ x 25¼ in. Painted about 1785.
Coll.: Bromley-Davenport. *Acq.:* 1926, (26.109).

Jeremiah Milles (J)
Jeremiah (1751–97), eldest son of Jeremiah Milles,
D.D.; married Rose Gardiner, 1780. See her portrait
by Romney (below).
Canvas: 93¾ x 57½ in. Painted 1780–83.
Coll.: Milles; Alston. *Acq.:* 1914, (14.03).

Mrs. Jeremiah Milles (J)
Rose (1757–1835), daughter of Edward Gardiner;
married Jeremiah Milles, 1780. See his portrait by
Romney (above).
Canvas: 93 x 57 in. Painted 1780–83.
Coll.: Milles; Alston. *Acq.:* 1914, (14.04).

Mrs. Ralph Willett (D)
Charlotte (1746–1815), daughter of Locke of
Clerkenwell; married (1) Samuel Strutt, 1771, and
(2) Ralph Willett, 1786.
Canvas: 29¾ x 24¾ in. Painted 1787–90.
Coll.: Willett; Ripon. *Acq.:* 1922, (22.56).

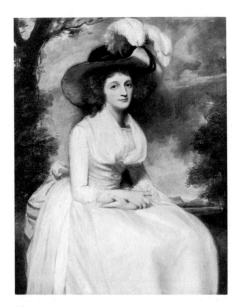

(78.20.36)

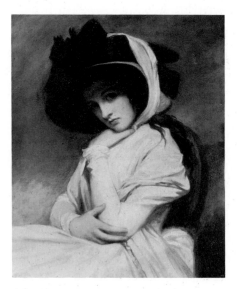

(24.05)

32

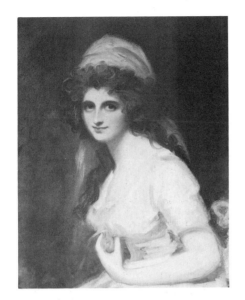

(26.109)

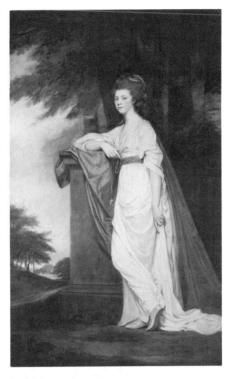

(14.04)

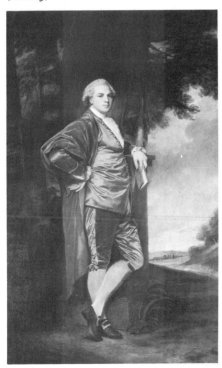

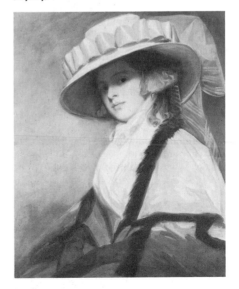

(14.03)

(22.56)

Sartorius, John N. (1759–1828)
A Match at Newmarket, No. 1 (W)
Canvas: 21 x 37 in. Signed and dated 1790.
Coll.: Charles H. Strub. *Acq.:* 1958 (bequest of
Charles H. Strub), (58.12).

A Match at Newmarket, No. 2
Canvas: 21 x 37 in. Signed and dated 1790.
Coll.: Charles H. Strub. *Acq.:* 1958 (bequest of
Charles H. Strub), (58.13).

Shee, Martin Archer (1769–1850)
Mrs. William Grenfell and
Her Son, Pascoe Norman (K)
Frances (about 1770–1851), daughter of Samuel
Woodis; married (1) Walter Borlase, 1784, and (2)
William Grenfell, 1809. Pascoe Norman was born
in 1798 and died in 1830.
Canvas: 93 x 58 in. *Coll.:* Grenfell; J. J. M.
Chabot. *Acq.:* 1920, (20.04).

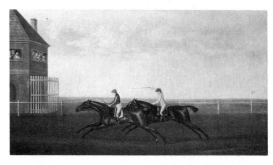

(58.12)

Stubbs, George (1724–1806)
Baronet with Sam Chifney Up (W)
Baronet was foaled in 1785, owned by George IV
when Prince of Wales, later sent to America. Sam
Chifney wears the royal colors.
Canvas: 37⅜ x 50 in. Signed and dated 1791.
Coll.: Duke of Rutland; Hutchinson; Charles H.
Strub.
Acq.: 1958 (bequest of Charles H. Strub), (58.08).

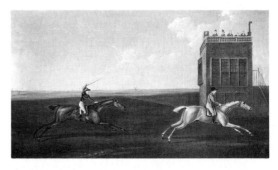

(58.13)

Horses and Groom (Pavilion)
Panel: 20½ x 29 in. Signed and dated 1789.
Coll.: Charles H. Strub. *Acq.:* 1958 (bequest of
Charles H. Strub), (58.09).

Thornhill, James (1676–1754)
Juno, Minerva, and Venus dispatching Mercury with
the Apple of Discord (A preliminary sketch for the
ceiling of Charborough Park, Dorset.)
Canvas mounted on panel: 11¾ x 8 in. *Acq.:* 1978,
(78.14).

34

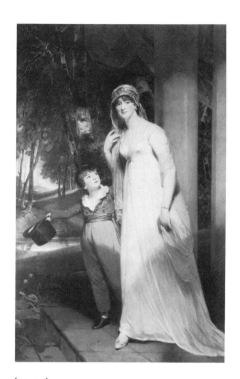

(20.04)

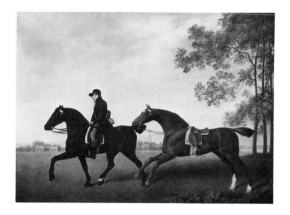

(58.09)

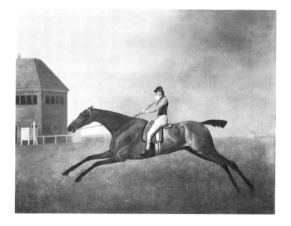

(58.08)

(78.14)

Turner, Joseph Mallord William (1775–1851)
The Grand Canal, Venice: Shylock (C)
The title refers to an episode depicted in the lower
right-hand corner of the picture:
 Scene—a street in Venice
 Antonio. Hear me yet, good Shylock.
 Shylock. I'll have my bond. . . .
 —*Merchant of Venice,* Act III, Scene iii
The painting was erroneously renamed "The
Marriage of the Adriatic."
Canvas: 58¼ x 43½ in. Painted about 1837.
Coll.: Ruskin; Brocklebank. *Acq.:* 1922, (22.52).

*Neapolitan Fisher Girls Surprised Bathing by
Moonlight* (U)
Canvas: 25½ x 31½ in. Exhibited 1840.
Coll.: Robert Vernon; Fuller; John Miller; C. E.
Flavell; Phyllis Woolner. *Acq.:* 1981 (Adele S.
Browning Memorial Collection), (81.13).

Vanderbank, John (1694–1739)
Scene from Don Quixote (*vol. I, bk. III, ch. IV*) (L)
Panel: 15⅞ x 11⅝ in. *Acq.:* 1968 (gift of the
Friends) (68.01).

Scene from Don Quixote (*vol. II, ch. XXXIII*) (L)
Panel: 15⅞ x 11¾ in. Signed and dated 1735.
Acq.: 1968, (68.02).

Watts, Frederick W. (1800–62)
Village Landscape
Oil on millboard: 11 x 16 in. *Acq.:* 1975 (gift of
the Friends), (75.38).

Wheatley, Francis (1747–1801)
The Ferry (W)
Canvas: 18¾ x 22 in. *Acq.:* 1976, (76.27).

*Mrs. Ralph Winstanley Wood and
Her Two Daughters* (P)
Ralph Winstanley Wood (1745–1831) married
Mary Margaretta Pearce (1746–1808) and in 1785
purchased Pierrepont Place, Frensham, Surrey,
which may be the estate represented in the
background of the painting.
Canvas: 36 x 28½ in. Signed with initials and dated
1787. *Coll.:* Major John Winstanley Cobb.
Acq.: 1956, (56.22).

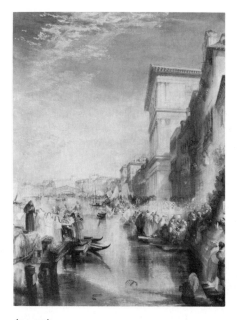

(22.52)

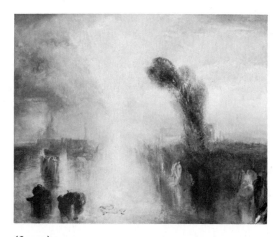

(81.13)

36

(68.01)

(75.38)

(76.27)

(68.02)

(56.22)

Wilkie, David (1785–1841)
Woman at a Confessional (Q)
Panel: 7 x 6¼ in. Signed and dated 18(16?).
Coll.: Sir Willoughby Gordon and descendants.
Acq.: 1982, (82.3).

Wilson, Richard (1714–82)
River Scene: Bathers and Cattle (G)
Another version, called "Landscape with Bathers,"
is in the Tate Gallery, London.
Canvas: 35⅛ x 56⅛ in. Painted about 1770–75.
Coll.: Danson Park, Kent. *Acq.:* 1934, (34.03).

Wolstenholme, Dean (1798–1883)
Surplice (winner of the Derby in 1849) (V)
Canvas: 13½ x 17½ in. Signed. *Acq.:* 1980
(bequest of Audrienne Moseley), (74.61.6).

Wood, John (1801–70)
Mother and Child
Canvas: 34 in. diameter (tondo).
Coll.: Henry Wallis; Sir Thomas Glen-Coats.
Acq.: 1978 (Adele S. Browning Memorial
Collection), (78.20.39).

**Wright, Joseph (Wright of Derby) (1734–97),
attributed to**
Two Boys by Candlelight, Blowing a Bladder (W)
Canvas: 35 x 27½ in. *Coll.:* Bemrose.
Acq.: 1958, (58.16).

Unattributed, British School
Calton Hill, Edinburgh, from
St. Anthony's Chapel (D)
formerly attributed to J. M. W. Turner.
Conspicuous features in the picture are: a high slope
on the left, leading to Arthur's Seat; the castle
silhouetted against the sky, beyond; the crowned
church tower of St. Giles; the old prison, on an
abrupt cliff, just right of center; above it, to the
right, the high school, the Nelson Monument, and
Waterloo Memorial; below them, in the middle
ground, Holyrood Palace.
Canvas: 33¼ x 43⅞ in. *Coll.:* Col. Grant(?); Percy
Moore Turner. *Acq.:* 1937, (37.01).

38

(82.3)

(34.03)

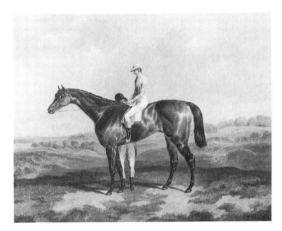

(74.61.6)

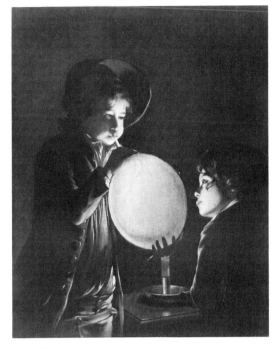

(58.16)

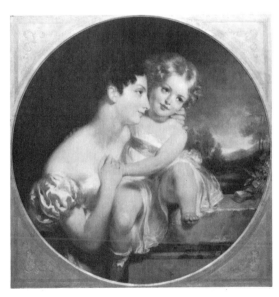

(78.20.39)

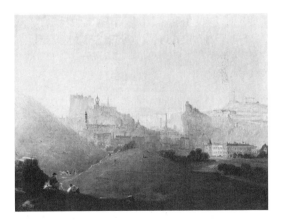

(37.01)

Girl in Pink
probably painted in the 1740s.
Canvas: 55 x 40½ in.
Coll.: Mrs. James R. Page; Mrs. John Wilson.
Acq.: 1975, (gift of Mrs. John Wilson) (84.40).

John Milton (eighteenth century; after the Faithorne engraving).
Canvas: 51½ x 38½ in. *Acq.:* 1922, (22.55).

John Eliot (1604–90) (Main Library)
Canvas: 43½ x 36 in. *Inscr.:* John Eliot, Preacher to the Indians of New England Aetatis Suae 55. *Coll.:* S. G. Stein. *Acq.:* 1927, (27.219).

Portrait of a Man (called Lawrence Sterne)
Canvas: 36 x 28 in. *Acq.:* before 1927 (14.93).

Unattributed (follower of Reynolds)
Portrait of a Man (called R. B. Sheridan).
Canvas: 29 x 24 in. *Acq.:* 1911 (11.16).

Unattributed (Dutch? early seventeenth century)
Portrait of a Lady (called Lady Jane Grey)
Canvas: 40 x 28½ in. *Acq.:* 1907 (07.13).

Unattributed (manner of Raeburn)
Lady Elizabeth Penelope Creighton
Canvas: 35½ x 28 in. *Coll.:* Norman Forbes-Robertson. *Acq.:* 1912 (12.11).

Unattributed (nineteenth century, English)
Horse and Jaunting Cart (a pair)
Canvas: 12½ x 16¼ in. each. *Acq.:* 1958 (gift of Charles H. Strub), (58.10 & 11).

Unattributed (follower of Van Dyck)
Duchess of Richmond
Canvas: 46½ x 37 in. *Acq.:* 1925 (25.21).

Unattributed (follower of Lawrence)
Duke of Wellington
Canvas: 48¾ x 29 in. *Acq.:* 1910 (10.158).

Unattributed (early nineteenth century; German?)
Portrait of a Man (previously thought to represent P. B. Shelley)
Canvas: 50 x 40 in. *Acq.:* 1921 (21.4).

Unattributed (seventeenth century? English?)
Jeremy Taylor
Canvas: 28½ x 22½ in. *Acq.:* 1920 (20.27).

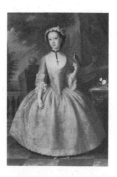

(84.40)

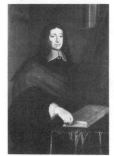

(22.55)

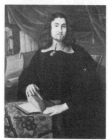

(27.219)

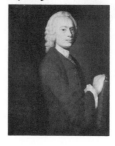

(14.93)

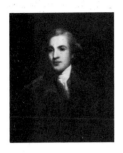

(11.16)

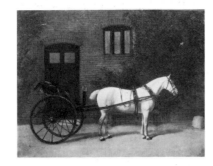

(58.10)

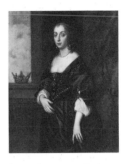

(25.21)

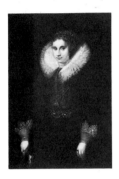

(07.13)

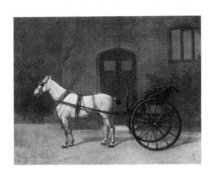

(58.11)

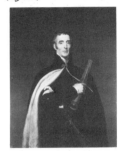

(10.158)

(21.4)

(12.11)

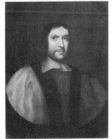

(20.27)

41

BRITISH MINIATURE portraits first appeared on illuminated manuscripts and documents. The earliest separate portraits in miniature of which there is a definite record were painted in the sixteenth century. Henry VIII employed a number of miniaturists, among whom Hans Holbein was the most famous. The miniature art flourished thereafter and provided a lucrative field for painters both native and foreign. Shortly after the middle of the eighteenth century, with augmented activity in all the arts, the number of miniaturists increased amazingly. By painting on ivory, instead of vellum or cardboard as was customary in earlier times, and by the use of transparent color, the artist could achieve a soft peachblow skin texture and far greater delicacy of execution than ever before. This new attractiveness of the miniature was enhanced by the opulence of its mounting in gold, enamel, diamonds, and pearls. The Huntington collection is devoted primarily to this last brilliant period of miniature painting in England, although during recent years some examples from the seventeenth century have been added.

In 1967 the collection was carefully studied by the distinguished expert in the field, Graham Reynolds, of the Victoria and Albert Museum. The attributions in the following list are those made by Mr. Reynolds and embody a substantial modification in information given about the miniatures in earlier publications.

There are just over one hundred miniatures in the collection. The following list includes the more important and identifiable items from which the pieces on exhibition at any particular time are selected. All miniatures are on ivory unless otherwise stated, and all are displayed in the North Passage (G).

Burch, Edward (active late eighteenth century), attributed to.
Master William Lamb; c. 1790; 2¼ x 1⅝ in.; *Acq.:* 1925, (25.9).

Cooper, Samuel (1609–72).
Portrait of a man; signed and dated 1646; on vellum; 2⅛ x 1⁹⁄₁₆ in.; *Acq.:* 1967, (67.5).

Cosway, Richard (1742–1821).
Miss Sophia Bankes; c. 1795; 3½ x 2¾ in.; *Acq.:* 1926, (26.9).

Princess Sophia Matilda of Gloucester; c. 1795; 3 x 2⅜ in.; *Acq.:* 1926, (26.10).

Margaret Bingham, Countess of Lucan; c. 1795; 2¾ x 2¼ in.; *Acq.:* 1926, (26.11).

Mary, Countess of Breadalbane; signed and dated 1794; 2⅞ x 2¼ in.; *Acq.:* 1926, (26.13).

Frederica, Duchess of York; c. 1790; 3⁷⁄₁₆ x 2½ in.; *Acq.:* 1926, (26.15).

Earl of Carrick; c. 1790; 3 x 2½ in.; *Acq.:* 1926, (26.16).

Maria Eleanor, Countess of Clarendon; 1782; 2⅜ x 2 in.; *Acq.:* 1926 (26.18).

Countess of Eglington; c. 1790; 2⅜ x 1¹⁵⁄₁₆ in.; *Acq.:* 1926, (26.20).

Mrs. Fitzgerald; signed and dated 1794; 3¼ x 2⅝ in.; *Acq.:* 1926, (26.21).

George, Prince of Wales; signed and dated 1787; 3½ x 2¾ in.; *Acq.:* 1926, (26.22).

Les Demoiselles d'Orville as Flora and Diana; c. 1780–5; 2¼ in. diam.; *Acq.:* 1926, (26.30).

Lady William Russell; c. 1790; 2⅝ x 2⅛ in.; *Acq.:* 1926, (26.31).

Augustus Frederick, Duke of Sussex; c. 1800; on paper; 3⅞ x 3¼ in.; *Acq.:* 1926, (26.36).

Lady Hill-Trevor; signed and dated 1789; 2 x 1⅝ in.; *Acq.:* 1926, (26.38).

Susan, Lady Carbery; c. 1790; 2⅞ x 2¼ in.; *Acq.:* 1924, (24.16).

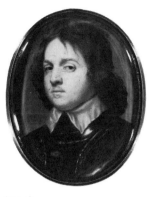

(67.5)

(26.16)

(26.9)

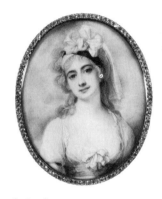

(26.21)

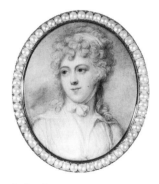

(26.11)

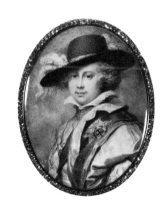

(26.22)

A Lady, called Mrs. Fitzherbert; c. 1790–5; 2⅜ x 1¾ in.; *Acq.:* 1924, (24.18).

Georgiana, Duchess of Devonshire, and Her Son; 4¼ x 3¹⁄₁₆ in.; c. 1780; *Acq.:* 1924, (24.25).

A Lady; on paper; 3½ x 2¾ in.; *Acq.:* 1924, (24.26).

Maria Cosway, the artist's wife; 3 x 2¾ in.; (U); *Acq.:* 1978 (Adele S. Browning Memorial Collection), (78.20.40).

Crosse, Peter (active 1661–1716).
Portrait of a Lady; c. 1700; 2¹⁵⁄₁₆ x 2⁷⁄₁₆ in.; *Acq.:* 1970, (70.11).

Engleheart, George (1750–1829).
Lady Dalrymple; c. 1790; 1⅞ x 1⅝ in.; *Acq.:* 1926, (26.42).

A Lady; 2⅝ x 2⅛ in.; *Acq.:* 1926, (26.43).

Hon. Mary Monckton; c. 1790–5; 2¼ x 1³⁄₁₆ in.; *Acq.:* 1926, (26.44).

Countess of Roden; c. 1795; 2⅞ x 1¹⁵⁄₁₆ in.; *Acq.:* 1926, (26.45).

Countess of Seafield; 1¹⁵⁄₁₆ x 1⁹⁄₁₆ in.; *Acq.:* 1926, (26.46).

Col. Warburton; c. 1790; 2¼ x 1¾ in.; *Acq.:* 1926, (26.47).

Mrs. Warburton; c. 1795; 2⁵⁄₁₆ x 1⅞ in.; *Acq.:* 1926, (26.48).

Lady Conyngham; c. 1795; 3 x 2⅜ in.; *Acq.:* 1926, (26.78).

Flatman, Thomas (1635–1688).
Portrait of a Man (said to be Thomas, Earl of Wharton [1648–1715]); on vellum; 3¼ x 2½ in.; *Acq.:* 1968, (68.05).

Hilliard, Nicholas (1547–1619)
Queen Elizabeth I; on vellum; 1⅞ x 1⁹⁄₁₆ in.; *Coll.:* Spencer Compton, earl of Wilmington; Horace Walpole; earls of Derby; *Acq.:* 1971, (71.08).

Hoskins, John (c. 1595–1665).
Portrait of a Lady; signed with monogram; c. 1640; on vellum; 2⅝ x 2⅛ in.; *Acq.:* 1969, (69.05).

Charles I; signed; c. 1640–45; on vellum; 3⅛ x 2¾ in.; *Acq.:* 1973, (73.03).

Huet-Villiers, Jean Francois Marie (1772–1813)
Portraits of a Man and a Woman (a pair); signed; c. 1810; 2¼ x 1⅞ in.; *Acq.:* 1978 (gift of Mr. and Mrs. J. K. Horton), (78.01).

Lens, Bernard, III (1682–1740)
Portrait of a Man; signed and dated 1710; 3⅛ x 2⁷⁄₁₆ in.; *Acq.:* 1970, (70.12).

Monogramist DM (active third quarter of the seventeenth century).
Portrait of a Man; on vellum; 2¹⁄₁₆ x 1¹¹⁄₁₆ in.; *Acq.:* 1970 (gift of Miss Sue Woodford), (70.01).

Mee, Mrs. Joseph (c. 1770–1851).
Hon. Frances Dillon; 2⅞ x 2⅜ in.; *Acq.:* 1926, (26.19).

Hon. Mrs. Frederick West; c. 1795; 2¾ x 2 in.; *Acq.:* 1926, (26.39).

Lady Hamilton; c. 1795; 3 x 2⅜ in.; *Acq.:* 1926, (26.53).

Meyer, Jeremiah (1735–1789).
Mary Sackville, Countess of Thanet; c. 1780; 2⅞ x 2⅜ in.; *Acq.:* 1925, (25.11).

Norgate, Edward (c. 1581–1650), attributed to
Judith Norgate, c. 1613; 2⅛ x 1¹¹⁄₁₆ in.; *Acq.:* 1985 (Adele S. Browning Memorial Collection), (85.1).

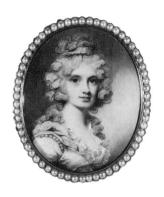

(26.46)

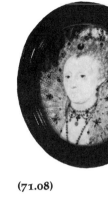

(71.08)

(26.47)

(73.03)

(68.05)

(85.1)

45

Oliver, Isaac (c. 1560–1617).
Portrait of a Man; c. 1605–10; on vellum; 1⅝ x
1⅜ in.; *Acq.:* 1968, (68.3).

Paillou, Peter (active 1763–1820).
Mrs. Ball of Rocksborough; signed and dated 1785;
2 x 1⅝ in.; *Acq.:* 1926, (26.54).

Palmer, Sir James (1584–1657).
Lord Herbert of Cherbury; on vellum; 2 x 1¾
in.; *Acq.:* 1968, (68.04).

Plimer, Andrew (1763–1837).
Lady Frances Butler of Garryricken; c. 1795; 3⁵⁄₁₆ x
2¾ in.; *Acq.:* 1926, (26.14).

Sir Robert Wilmot; c. 1790; 2¼ x 1¾ in.;
Acq.: 1926, (26.40).

Miss Juliana Burrell; c. 1795; 3 x 2⅜ in.; *Acq.:*
1926, (26.55).

Hon. Jean Drummond; c. 1795; 2⅞ x 2¼ in.;
Acq.: 1926, (26.59).

Lady Mary Erskine and Miss Cheape; signed and
dated 1786; 3⅛ x 2⅝ in.; *Acq.:* 1926, (26.60).

Countess of Essex; signed and dated 1787; 2½ x
1¹⁵⁄₁₆ in.; *Acq.:* 1926, (26.61).

Countess of Derby and Her Daughter; c. 1790; 2⅞
x 2⅜ in.; *Acq.:* 1926, (26.62).

Lady Georgiana Fitzroy; c. 1790; 2½ x 2³⁄₁₆ in.;
Acq.: 1926, (26.63).

A Gentleman; c. 1790; 2⅞ x 2⁵⁄₁₆ in.; *Acq.:* 1926,
(26.64).

A Gentleman; 3 x 2⅜ in.; *Acq.:* 1926, (26.65).

Viscount Hill; 3⅛ x 2³⁄₁₆ in.; *Acq.:* 1926, (26.66).

Miss Isabel Ker; 1784; 2⅝ x 2¼ in.; *Acq.:* 1926,
(26.67).

Mrs. Lovell; c. 1790; 3 x 2⅜ in.; *Acq.:* 1926,
(26.68).

Miss Lukin; c. 1795; 3⅛ x 2½ in.; *Acq.:* 1926,
(26.69).

Lady Ravensworth and Her Sisters; c. 1795; 4⅞ x
3⅞ in.; *Acq.:* 1926, (26.71).

Lady Anne Horatia Seymour; c. 1790; 2½ x 2⅛
in.; *Acq.:* 1926, (26.72).

The Misses Tyrrell; signed and dated 1787; 3⅛ x
2½ in.; *Acq.:* 1926, (26.73).

Lady Waldegrave; 1795; 3 x 2⅜ in.; *Acq.:* 1926,
(26.74).

Lady Affleck and Her Daughters; c. 1795; 4⅛ x 3½
in.; *Acq.:* 1924, (24.20).

Duchess of Northumberland; c. 1790; 3 x 2⁷⁄₁₆
in.; *Acq.:* 1924, (24.21).

Daughters of Lord Northwick (The Three Graces); 5¾
x 4¾ in.; *Acq.:* 1924, (24.22).

Hon. Elizabeth Rushout; 3 x 2⁷⁄₁₆ in.; *Acq.:* 1924,
(24.23).

Mr. Lionel Tollemache; c. 1790–5; 3¹⁄₁₆ x 2⅝
in.; *Acq.:* 1924, (24.24).

A Boy; c. 1790; 3 x 2⅜ in.; *Acq.:* 1924, (24.28).

Shelley, Samuel (c. 1750–1808).
Captain William Paget; c. 1790; 3¼ x 2½ in.;
Acq.: 1925, (25.10).

Smart, John (1742/3–1811).
Robert Woolf (the artist's son-in-law); signed and
dated 1786; 2 x 1⁹⁄₁₆ in.; *Acq.:* 1945 (gift of the
Friends) (45.01).

Stubble, Henry (active 1770–1792).
Richard Cosway (a copy inscribed and dated 1792;
after Cosway's self-portrait in the National Portrait
Gallery, London); 3¾ x 2⅞ in.; *Acq.:* 1924,
(24.27).

Wood, William (1769–1810).
Miss Mary Parkhurst; 2⅝ x 2³⁄₁₆ in.; *Acq.:* 1926,
(26.84).

46

(68.04)

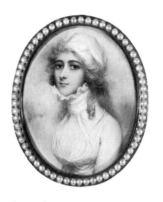

(24.21)

(26.62)

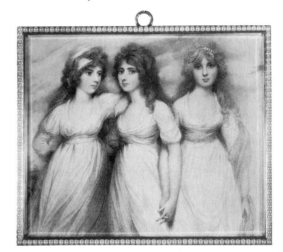

(24.22)

(26.66)

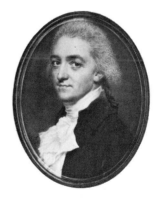

(45.01)

THERE ARE APPROXIMATELY thirteen thousand British drawings and watercolors in the Huntington Art Collections and Library, one of the most impressive collections of British draftsmanship to be found outside of London. The drawings range in date from the early seventeenth to the early twentieth century, with the major concentration in the period 1780 to 1850. Much of this material has entered the gallery since 1959.

Mr. Huntington was not greatly attracted by drawings as such. Most of those he did acquire were closely associated with his library; either they were illustrations for books, or drawings that had become physically bound into extra-illustrated volumes. It was not until thirty years after Mr. Huntington's death that a program was launched to acquire a well-balanced collection of drawings as a supplement to the major group of British paintings he had assembled. The project received a great boost with two large en bloc purchases: the Gilbert Davis Collection in 1959, and a substantial portion of the Sir Bruce Ingram Collection in 1963.

British drawings and watercolors have an attraction not always shared by British paintings. The drawings, and particularly the landscape watercolors, frequently have an air of freshness, directness, and spontaneity that is less apparent in the more carefully devised and elaborated paintings. Prior to 1750 most British drawings were preparatory studies for work to be carried out in some other medium, particularly painting or engraving. But from the mid-eighteenth to the mid-nineteenth century drawing became more and more an art in its own right. The period is particularly distinguished by the development of watercolor as the dominant medium and landscape as the dominant theme. By the beginning of the nineteenth century almost every young British lady or gentleman was expected to be able to turn out a respectable sketch. There was a correspondingly large professional class of artists to support this amateur interest, and the level of performance, both amateur and professional, is astonishingly high. The same period also saw the full flowering of English caricature and comic art, with watercolor again making an essential contribution to the attraction of the drawings.

Approximately five hundred artists are represented in the Huntington collection of British drawings. All the important phases of British draftsmanship for the period 1600 to 1900 are included, and nearly all the major masters are present, some with up to forty or fifty examples. The collection of drawings by Thomas Rowlandson numbers over five hundred items. Many publications concerned with the collection are available, ranging from a full, formal catalogue of the drawings 1600–1750, through monographs on the drawings by Blake, Rowlandson, and Isaac Cruikshank, to exhibition pamphlets on material by Constable, Gainsborough, Edward Lear, and others.

The drawings are the one major portion of the art collection of which only a small part is normally on exhibition. Drawings not on display may be seen by prior application to the curator of the Huntington Art Collections. Unfortunately, however, the space and facilities available for the study of the drawings are such that only qualified students with specific requests can be accommodated. The following sampling of British drawings and watercolors are grouped thematically.

Wilson, Richard (1714–82)
Monte Cavo in the Alban Hills
Black and white chalk: 11½ x 16⅜ in. Signed and dated 1754
Coll.: Earl of Dartmouth *Acq.:* 1957, (57.6)

Constable, John (1776–1837)
Study for Dedham Mill
Pencil: 4¼ x 7 in.
Coll.: Gilbert Davis *Acq.:* 1959, (59.55.257)

Turner, Joseph Mallord William (1775–1851)
Beaumaris Castle
Watercolor: 11⅝ x 16¾ in. *Acq.:* 1965, (65.10)

Girtin, Thomas (1775–1802)
Rainbow on the Exe
Watercolor: 11½ x 19¾ in. Signed and dated 1800
Coll.: Walter Turner; Gilbert Davis *Acq.:* 1959,
(59.55.595)

Lear, Edward (1812–88)
Cliffs at Grammatico, Paxos
Pen and watercolor: 12⅝ x 9¼ in.
Coll.: Gilbert Davis *Acq.:* 1959, (59.55.830)

(59.55.830)

(57.6)

(59.55.257)

(65.10)

(59.55.595)

Palmer, Samuel (1805–81)
The Lonely Tower
Watercolor: 6½ x 9¼ in.
Coll.: Gilbert Davis *Acq.:* 1959, (59.55.984)

Cozens, Alexander (died 1786)
View in a Wood
Wash: 4 x 5½ in. Signed and dated 1764
Coll.: Randall Davies; Gilbert Davis *Acq.:* 1959,
(59.55.372)

Cozens, John Robert (1752–99)
Coast of Vietri from Salerno
Watercolor: 14½ x 21 in.
Coll.: J. H. Riveley; C.R.N. Routh *Acq.:* 1958,
(58.1)

Gainsborough, Thomas (1727–88)
Diana and Actaeon
Black and white wash: 11 x 14½ in. *Acq.:* 1961,
(61.27)

Scott, Samuel (1703–72)
Men O' War in the Thames
Pen and wash: 7¾ x 12 in.
Coll.: Esdaile; Thane; Gilbert Davis *Acq.:* 1959,
(59.55.1155)

Cotman, John Sell (1782–1842)
Seapiece, Mouth of the Thames
Watercolor: 10½ x 18 in.
Coll.: Sir Arthur Colegate *Acq.:* 1957, (57.5)

Loggan, David (1635–1700)
Portrait of a Woman
Pencil: 5⅞ x 4⅜ in. Signed and dated 166[?]
Coll.: Sir Bruce Ingram *Acq.:* 1963, (63.52.136)

Cotes, Francis (1726–70)
Portrait of a Lady (B)
Pastel: 23 x 17½ in. Signed and dated 1751
Coll.: C. Wertheimer. *Acq.:* 1911, (11.35).

50

(59.55.984)

(59.55.372)

(58.1)

(61.27)

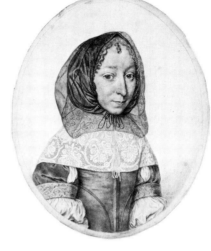

(63.52.136)

(59.55.1155)

(57.5)

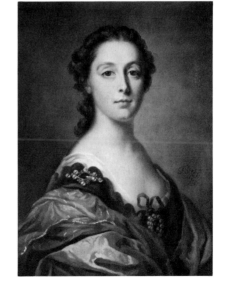

(11.35)

Russel, John (1745–1806)
Anne Garnett (U)
Pastel: 24½ x 19¼ in. oval; signed and dated
1790. *Acq.:* 1978 (Adele S. Browning Memorial
Collection), (78.20.38).

Wilkie, Sir. David (1785–1841)
Mrs. Grant, Knitting
Pencil and watercolor: 13¼ x 10¾ in. Signed and
dated 1834
Coll.: Gilbert Davis *Acq.:* 1959, (59.55.1451)

Blake, William (1757–1827)
Conversion of Saul
Pen and watercolor: 16⅛ x 14⅛ in.
Coll.: Thomas Butts *Acq.:* 1919, (000.29)

Hogarth, William (1697–1764)
Satire on False Perspective
Pen and wash: 8⅜ x 6⅝ in. *Acq.:* 1975, (75.19)

Rowlandson, Thomas (1756–1827)
*A French Frigate Towing an English Man O' War
into Port*
Pen and watercolor: 10½ x 8¼ in.
Coll.: Henry Reveley; Gilbert Davis *Acq.:* 1959,
(59.55.1105)

Thornhill, James (1675–1784)
Bacchus and Erigone
Wash: 6¼ x 6 in.
Coll.: Gilbert Davis *Acq.:* 1959, (59.55.1264)

Barlow, Francis (c. 1626–1704)
An Elephant, Camel, and two Monkeys
Pen and wash: 5¾ x 8⅛ in. *Acq.:* before 1927,
(60.21)

Ward, James (1769–1859)
Wild Boar
Pen: 11 x 13⅜ in. Signed with initials and dated
1814 *Acq.:* 1967, (67.38)

52

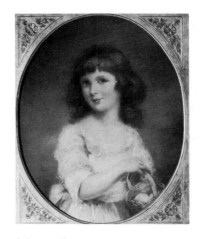

(78.20.38)

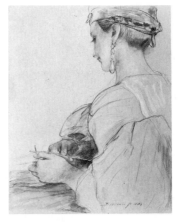

(59.55.1451)

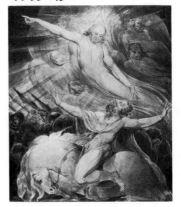

(000.29)

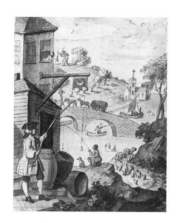

(75.19)

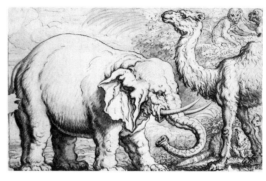

(60.21)

(59.55.1105)

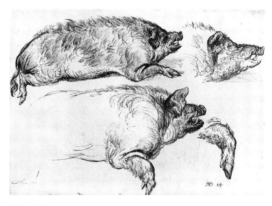

(67.38)

(59.55.1264)

Until the mid-1960s there was no British sculpture in the Huntington collection, a puzzling situation in view of the rich holdings of the gallery in other areas of British art. To be sure, sculpture is not an art form in which the British ever excelled; but certainly a considerable amount of respectable quality was produced. During the late 1960s a good start was made toward assembling a small, representative collection of British sculpture from the seventeenth to the early nineteenth century, and further additions are hoped for in the next few years.

During the seventeenth century and the first half of the eighteenth, British sculpture, like British painting, was dominated by foreign-born artists. Among the better-known names are Cibber (a Dane), Grinling Gibbons and Quellin (both Dutch), Rysbrack, Scheemakers, and Delvaux (all Flemings), and Roubiliac (a Frenchman). With the second half of the eighteenth century native artists came to the fore, and by the end of the century a purely English sculptor such as John Flaxman enjoyed an international reputation as high as that of his contemporary compatriots in painting.

Most English sculpture is in the form of portrait busts or funerary monuments. The latter are not generally available or appropriate for museum display, so less variety is possible than in other forms. Decorative pieces, such as the "Bacchanal" by Roubiliac and the reclining figures by Delvaux, are attractive rarities and a welcome change of pace.

Baily, Edward Hodges (1788–1867).
Portrait Medallion of Sir Thomas Lawrence (I); bronze; diam. 14½ in.: signed. *Acq.:* 1969, (69.03).

Chantrey, Sir Francis (1781–1841).
William Howley, Archbishop of Canterbury (M); marble; H. 22 in.: inscribed, signed and dated 1832. *Coll.:* by family descent to William Howley Kingshull. *Acq.:* 1967, (67.04).

54

Cibber, Caius Gabriel (1630–1700).
Portrait of a Man (J); marble; H. 33 in. *Acq.:* 1967, (67.17).

Delvaux, Laurent (1696–1778).
Cleopatra (M); marble; L. 23 in.; signed. *Acq.:* 1968 (Schweppe Fund), (68.10A).

attributed to Laurent Delvaux
Adriadne (M); marble; L. 24 in. *Acq.:* 1968 (Schweppe Fund), (68.10B).

English School (possibly by William Stanton), mid-seventeenth century.
Cherub (fragment from a tomb), (W); limestone; L. 19⅝ in. *Acq.:* 1969, (69.12).

Flaxman, John (1755–1826).
The Shield of Achilles (W); silver-gilt; diam. 36½ in.; cast by Rundell, Bridge & Rundell, 1821. *Coll.:* Duke of York; Duke of Cambridge; Doheny; Battson. *Acq.:* 1973 (Abigail von Schlegell Fund), (73.11).

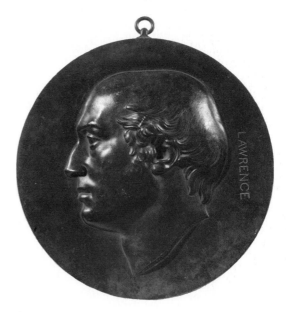

(69.03)

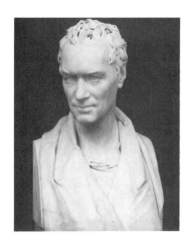

(67.04)

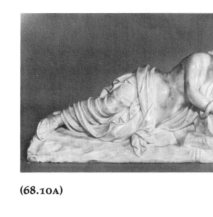

(68.10A)

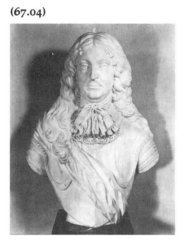

(67.17)

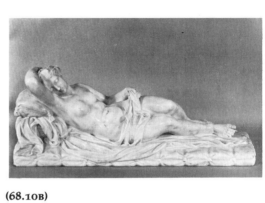

(68.10B)

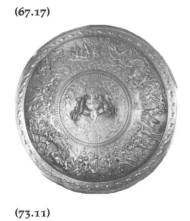

(73.11)

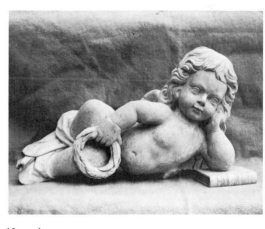

(69.12)

Gahagan, Lawrence (active 1756–1820).
Lord Nelson (M); lead; H. 20 in.; c. 1798.
Acq.: 1968 (gift of the Friends), (68.17).

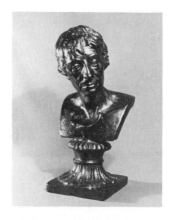

Gibbons, Grinling (1648–1721)
Charles II; fruitwood 8⅞ x 6½ in. (oval)
Coll.: Lord Walpole *Acq.:* 1985 (Adele S.
Browning Memorial Collection), (85.2)

(68.17)

Gibson, John (1790–1866).
Head of a Young Girl (E); marble; H. 21 in.; signed;
c. 1820. *Acq.:* 1968 (Page Fund), (68.42).

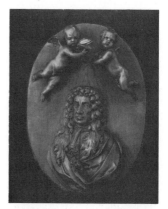

Gott, Joseph (1785–1860).
Spaniel and Kitten (K); marble; H 12½ in.; signed
and dated 1827 *Acq.:* 1976, (76.28).

Milligan, J. (active 1817–34).
Lord Byron (M); bronze; H 23 in. *Acq.:* 1967 (gift
of the Friends), (67.52).

(85.2)

Nollekens, Joseph (1737–1823).
Laurence Sterne (E); marble; H. 21¼ in.
Acq.: 1924, (24.36).

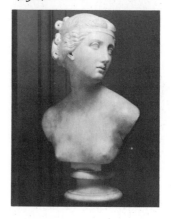

Jane Braddyll (J); marble; H. 29 in.; signed and dated
1793. *Acq.:* 1969 (Page Fund), (69.70).

William Pitt the Younger (J); marble; H. 28 in.; signed
and dated 1807. *Acq.:* 1965, (65.13).

Head of a Boy (U); marble; H 16 in. (with base);
signed and dated 1796. *Acq:* 1980 (Adele S.
Browning Memorial Collection), (80.17).

(68.42)

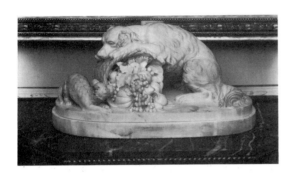

(76.28)

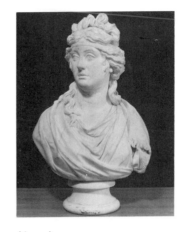

(69.70)

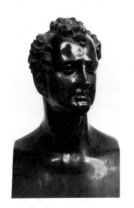

(67.52)

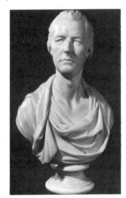

(65.13)

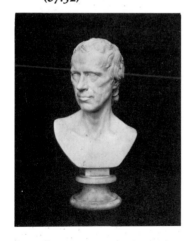

(24.36)

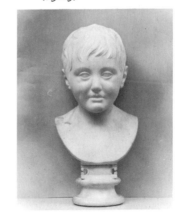

(80.17)

Nost, John Van, The Younger (died 1787), attributed to.
David La Touche (*Irish Huguenot banker*) (J); marble; H. 26 in.
Coll.: from Bellevue, Delgany, Co. Wicklow (the country house of the La Touches). *Acq.:* 1967, (67.54).

Roubiliac, Louis François (c. 1705–62).
Bacchanal (I); marble; H. 38 in.; signed and dated 1758.
Coll.: Wertheimer; Jonas. *Acq.:* 1967, (67.03).

Sir Peter Warren (*naval officer*) (J); marble; H. 33 in.
Coll.: Sir Charles Lockhart-Ross. *Acq.:* 1967, (67.53).

George Frederick Handel (K); plaster; H. 34½ in. *Acq.:* 1972, (72.49).

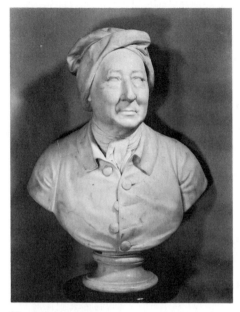

(67.54)

Rysbrack, John Michael (1694–1770).
John Milton (H); terra-cotta; H. 22 in.; signed. Modelled by Rysbrack at the time he made the Milton memorial in Westminster Abbey, c. 1737.
Coll.: Duke of Marlborough. *Acq.:* 1966, (66.11)

John Hampden (M); marble; H. 24½ in.; *Acq.:* 1980 (Adele S. Browning Memorial Collection), (80.18).

Oliver Cromwell (M); marble; H. 23½ in. *Acq.:* 1980 (Adele S. Browning Memorial Collection), (80.19).

Scheemakers, Peter (1691–1781).
Prudence (U); terra-cotta; H. 19½ in. *Acq.:* 1982 (Adele S. Browning Memorial Collection), (82.34).

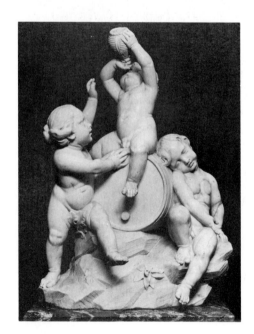

(67.03)

58

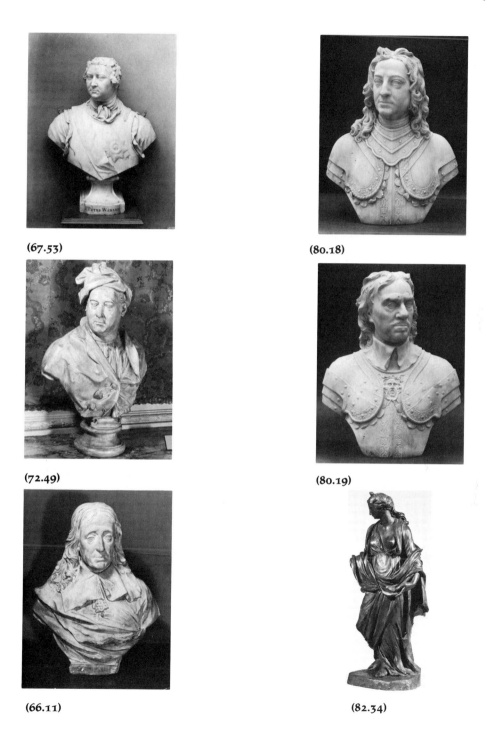

(67.53)

(80.18)

(72.49)

(80.19)

(66.11)

(82.34)

Stevens, Alfred George (1817–75).
Doorknocker (I); bronze; H. 11 in. *Acq.:* 1967, (67.34).

Valour and Cowardice, Truth and Falsehood (I); casts from the models for the Wellington Monument); bronze; H. 25¼, 23½ in. *Coll.:* Brian Thomas. *Acq.:* 1977 (77.12 A&B.)

Pair of nude male figures as fire dogs (W); bronze; H. 15½ in. *Coll.:* Brian Thomas. *Acq.:* 1977, (77.13 A&B).

Pair of child figures holding cornucopias (W); bronze; H. 15⅛, 15⅜ in. *Coll.:* Brian Thomas. *Acq.:* 1977, (77.14 A&B).

Turnerelli, Peter (1774–1839)
George III (E); marble; H. 17⅜ in.; signed and dated 1815 *Acq.:* 1974 (gift of the Friends), (74.51).

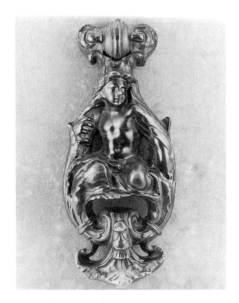

(67.34)

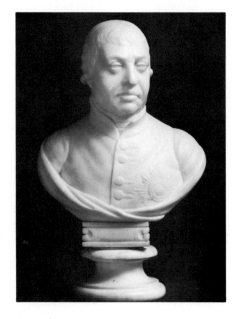

(74.51)

60

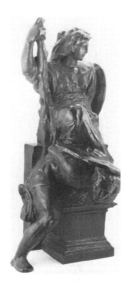

(77.12A)

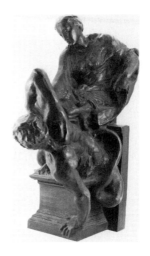

(77.12B)

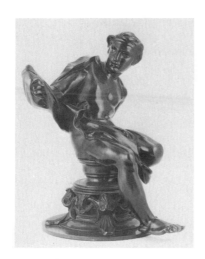

(77.13A)

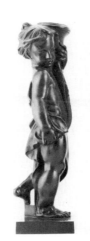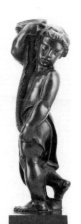

(77.14A&B)

61

THE BRITISH SILVER in the Huntington Gallery ranges in date from the fifteenth to the mid-nineteenth century and covers a wider span chronologically than any other facet of British art in the gallery. The silver is also a comparatively recent addition to the gallery's holdings; nearly all of it has come by gift or bequest since 1955. The quality and extent of the collection are a tribute to the taste and diligence of several southern California collectors, notably Mr. and Mrs. W. B. Munro, Mr. and Mrs. James R. Page, Mrs. Richard Schweppe, Miss Abigail von Schlegell, and Mrs. and Mrs. C. C. Moseley.

The silver collection now contains about four hundred items and continues to grow. Not all of this material is kept constantly on exhibition, and that which is shown is changed from time to time. Cases for the display of silver are distributed over both floors, with the most important concentrations in the North Passage and the Dining Room.

Most silver, like furniture, is intended for practical use as well as display. Much of the attraction rests in the way the silversmith has adapted his design to the function of the object. Thus, when looking at silver, it is always natural to ask what the object was used for, a question which for many early pieces cannot now be answered as definitely as one would like. But even granting some uncertainties, the silver provides us a closer and more intimate view than any other art form in the gallery of the society for which these objects were produced. Most of the objects have to do with eating and drinking, two of the basic activities of human existence. The silver encourages us to speculate on and visualize these activities.

Among the earliest pieces in the collection are spoons—broad, flat-bowled utensils that look a little like modern soup spoons but which in those days before forks would have been used to convey anything to the mouth that couldn't be held with the fingers. During the seventeenth and eighteenth centuries attention was given to designing special spoons for particular purposes; interesting and entertaining examples in the collection include spoons for extracting marrow from bones, skimming tea leaves off tea, measuring out tea from a caddy, ladling punch, and warming brandy.

The richest variety in early silver objects occurs in the general category of drinking vessels. As these were frequently passed from one guest to another at banquets, the containers are often fairly large and are sometimes equipped with two handles and with covers. Among the vessels for use by an individual, mugs and tumbler cups were particularly popular, especially from the late seventeenth century on. There are impressive groups of two-handled cups, mugs, and tumblers in the Munro Collection.

The advent of tea, coffee, and chocolate brought a demand for additional forms that greatly increase in number and variety during the eighteenth century. Particular care and ingenuity was lavished on the smaller items of the tea equipage, such as cream jugs and caddy spoons. Extensive coverage is given to both these forms in the Munro Collection.

With the later eighteenth century, large, covered serving dishes become a prominent feature of the well-dressed dining table. The Huntington Gallery has a handsome group of these through the generosity of Mr. and Mrs. James R. Page.

The following list of fifty objects, arranged chronologically, includes some of the more important and unusual pieces in the collection. Most of these objects are normally on exhibition, along with many others. A fully illustrated catalog of all the British silver in the Huntington collection is available at the Bookstore.

Mazer (G); silver-gilt mounts; unmarked, c.1480 (Munro Collection), (71.03).

Wrythen Knop Spoon (G); London, 1503; maker's mark: a phaen (Munro Collection), (65.18).

The Munro Apostle Spoons (The Master and Twelve) (G); London, 1527; maker's mark: a fringed S (Munro Collection), (66.01).

Communion Cup (G); London, 1561; maker's mark: sun in splendor (Munro Collection), (68.15.3).

Tiger Ware Jug with Silver-gilt Mounts (G); London, 1584; maker: Richard Brooke (Munro Collection), (63.94).

Coconut Cup (G); London, 1586; maker's mark: CB (Munro Collection), (64.13).

Bell Salt (G); London, 1603; maker's mark: TS (Munro Collection), (68.15.1).

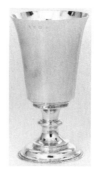

(68.15.3)

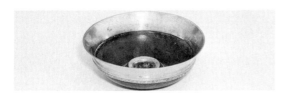

(71.03)

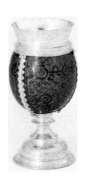

(64.13)

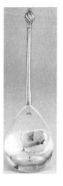

(65.18)

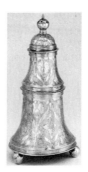

(68.15.1)

Rosewater Ewer and Basin (G); London, 1607; maker's mark: IA (Munro Collection), (67.63).

Beaker (G); London, 1608; maker's mark: GC (Munro Collection), (65.19).

Spice Box (G); London, 1615; maker's mark: TL, a star below (Munro Collection), (68.15.2).

Standing Cup and Cover (*The Cunliffe Cup*) (G); London, 1616, maker's mark: TC (Munro Collection), (72.15).

Standing Salt (*The Swaythling Salt*) (G); London, 1626, maker's mark: a tree (Munro Collection), (75.01).

Wine Cups, a pair (G); London, 1636; maker's mark: WC (Munro Collection), (65.22 A&B).

Fruit Dish (G); London, 1638; maker's mark: IM bear below (Munro Collection), (63.83).

Tazza (G); London, 1638; maker's mark: HW (Munro Collection), (65.24).

Beaker (W); London, 1660; maker's mark: RS between mullets (Munro Collection), (63.56).

Silver Medal for the Restoration of Charles II (G); 1660; maker; John Roettier (Munro Collection). One of fifteen silver commemorative medals of the seventeenth century, (80.20.5).

Two-handled Cup (W); London, 1661; maker: Henry Greenway (Munro Collection), (63.114).

Standing Cup and Cover (*Steeple Cup*) (W); London, 1661; maker's mark: AF (Munro Collection), (69.24).

Tumbler (W); London, 1663; maker's mark: WN (Munro Collection). One of a dozen tumblers in the collection, (63.71).

Two-handled Cup (W); London, 1668; maker's mark: IB, crescent below (Munro Collection), (63.115).

Double Cup (pair of tumblers fitting together by rims) (W); London, 1672; maker's mark: RN (Munro Collection), (63.74).

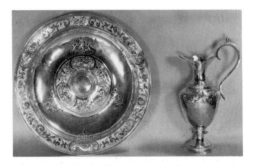

(67.63)

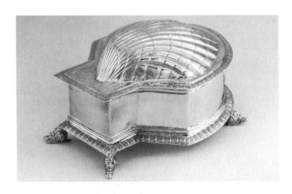

(68.15.2)

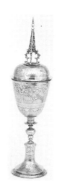

(72.15)

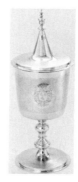

(69.24)

(75.01)

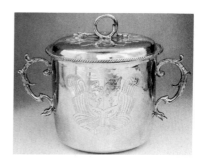

(63.115)

(80.20.5)

(63.74)

65

Tankard (G); York, 1673, by John Plummer (Munro Collection), (71.09).

Toilet Service, ten pieces, silver and silver-gilt (P); unmarked, c. 1670–1680, attributed to George Bowers (Munro Collection), (77.19).

Pair of Ginger Jars (G); London, c. 1675; maker's mark: IB, crescent below (Munro Collection), (63.96).

Bowl (G); London, 1677; maker's mark: AR, mullet and two pellets below (Munro Collection), (63.58).

Tankard (G); London, 1677; maker's mark: crowned S (Munro Collection), (67.20).

Chinoiserie Casket (G); London, 1682; maker's mark: ID (Munro Collection), (67.06).

Pair of Candlesticks (G); London, 1684; maker: Pierre Harache (Munro Collection), (65.23 A&B).

Wine Taster (W); London, 1684; maker: Pierre Harache (Munro Collection), (69.69.1).

Two Candlesticks (G); London, 1685 and 1693; makers: 1685 by WE, mullet above and below; 1693 by DB, mullet above and crescent below (Munro Collection). These are part of a famous series of which eleven other pairs of the same two years are in the possession of the British Treasury and Privy Council. All bear the royal arms and the monogram of William and Mary, (63.66).

Caster; London, c. 1690; maker: Pierre Harache (Munro Collection), (63.97).

Salver (W); London, 1691; maker's mark: IR crowned (Page Collection), (56.11).

Monteith (W); London, 1697; maker: Isaac Dighton (Munro Collection), (63.59).

Mug (W); London, 1700; maker: Isaac Dighton (Munro Collection). One of two dozen mugs in the collection, (59.32).

Sugar Bowl and Cover; silver-gilt (P); London, 1704; maker: Pierre Harache (Munro Collection), (68.15.12).

66

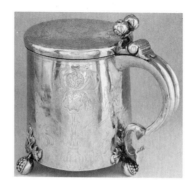

(71.09)

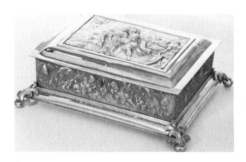

(77.19)

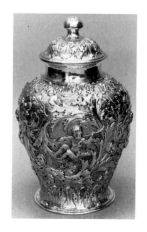

(63.96)

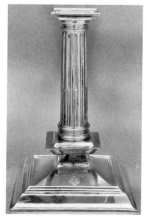

(63.66)

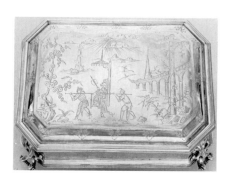

(67.06)

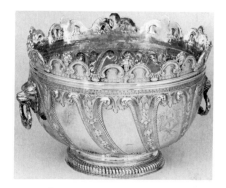

(63.59)

Teapot and Stand (P); London, 1709; maker: Richard Bayley, (Moseley Collection), (84.32.2).

Two-handled Cup and Cover (P); gilt; London, 1710; maker: Jacob Margas, (Moseley Collection), (77.02).

Coffee Pot (P); London, 1716; maker: Thomas Farren (Munro Collection), (57.10).

Coffee Pot (E); Dublin, 1717 (Page Collection), (59.28).

Sideboard Dish (E); Dublin, 1725; maker: Philip Kinnersley (Page Collection), (56.4).

Salver (E); London, 1729; maker: Augustine Courtauld, (61.17).

Cup and Cover (P); London, c. 1730; maker: Charles Kandler (gift of Robert Smallwood), (56.01).

Teapot (W); London, 1731; maker: Thomas Tearle (Schweppe Collection), (59.56.1).

Inkstand (P); London, 1741; maker: Edward Feline (Moseley Collection), (84.32.21).

Coffee Pot; London, 1736; maker: Paul de Lamerie (Page Collection), (56.07).

Cream Jug (M); London, 1738; maker: Paul de Lamerie (Munro Collection). One of fifty-five cream jugs in the collection, (69.69.14).

Pair of Sauceboats (E); London, 1746; maker: David Willaume (Schweppe Collection), (61.14 & 15).

Tureen (E); London, 1750; maker: Paul de Lamerie (Page Collection), (56.05).

Pair of Sauceboats (E); Dublin, c. 1750; (Page Collection), (59.22 & 23).

Basket (E); Newcastle, 1751; maker: James Kirkup (Page Collection), (56.12).

Hot-water Jug; London, 1763; maker: Alexander Johnston (gift of Geoffrey Mayo), (62.82).

Candelabra, a pair (E); London, 1765; maker: Thomas Heming (acquired from the Abigail von Schlegell Fund), (68.16 A&B).

Coffee Urn (E); London, 1765; makers: Thomas Whipham and Charles Wright (Schweppe Collection), (56.10).

Coffee Urn (E); London, 1767; makers: Thomas Whipham and William Williams (Page Collection), (66.10.19).

Pair of Tureens (E); London, 1770; maker: Augustus Le Sage (Page Collection), (66.10.18).

Epergne; London, 1774; maker: Thomas Pitts I (Munro Collection), (68.15.6).

Set of Three Condiment Urns (P); London, 1777; maker: Thomas Heming (Page Collection), (66.10.39).

Patriotic Fund Vase (W); London, 1805; maker: Digby Scott and Benjamin Smith (Abigail von Schlegell Fund), (72.09).

Pair of Entree Dishes (E); London, 1806; maker: Paul Storr (Page Collection), (66.10.14).

Teapot (W); London, 1808; maker: Paul Storr (Schweppe Collection), (56.08).

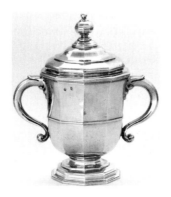

(77.02)

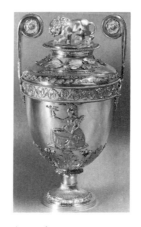

(72.09)

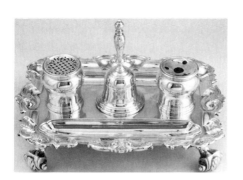

(84.32.21)

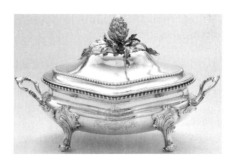

(66.10.18)

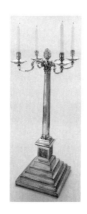

(68.16A)

69

MUCH OF THE British furniture in the Huntington Art Gallery was acquired in the first instance for use rather than show. The gallery was originally the Huntington residence, and the British furniture was actually in day-to-day service. The furniture makes an important contribution to the general appearance of the building, helping to create the effect of an eighteenth-century house in which the paintings and other works of art might be found. Much of it is of good and even excellent quality, but comparatively few pieces reach the level of artistic interest of the British paintings, drawings, silver, or sculpture, or of the French furniture and decorative art. Also, Mr. Huntington, following the standards of his own and earlier generations, was much less squeamish about modern reproductions of old furniture than we are today. If he saw an object he liked that was not available to him, or if he wanted a matching piece to fill out a pair or a set, he had no hesitation about having a fine reproduction made. These reproductions are now being gradually replaced with authentic period pieces; but several still remain around the building, offering valuable instruction to those visitors who wish to test their powers of connoisseurship!

A puzzling circumstance connected with the British furniture is that the interests of Mr. and Mrs. Huntington were focused on the early and mid-eighteenth-century styles. There are few important pieces of British furniture in the gallery that are contemporary in date with the major paintings, that is, from the last quarter of the century. This is, however, a circumstance gradually bring corrected.

The amount of British furniture in the gallery was greatly enlarged in 1938 when Mrs. Charles H. Quinn of Los Angeles presented her collection of furniture, paintings, and Chinese porcelain, most of which is now installed in a panelled period room on the second floor of the gallery. Mrs. Quinn also supplied the funds for the purchase and installation of the paneling. The walls are from a room at Castle Hill, Devonshire; the mantelpiece from Grove House, Chiswick; the double doorway and overmantel from a house in Arlington Street, St. James's. The material, which all dates from about 1740, combines to create an appropriate setting for the furniture, most of which is from the first half of the eighteenth century. Included with Mrs. Quinn's gift were several British paintings, listed in that section of this handbook, and a small group of Chinese porcelain objects, listed in the Miscellaneous section. The Quinn collection was opened to the public in November of 1944.

Normally about one hundred and forty pieces of British furniture are on display throughout the Huntington Gallery. The following illustrations have been selected to indicate the character and chronological range of the collection.

Chair ("Turned Chair") (K)
Oak; early seventeenth century; H. 32 in. *Acq.:* 1972 (gift of Calvin L. Helgoe), (72.18A).

Chair (O)
Walnut; late seventeenth century; H. 47½ in. *Acq.:* 1944 (gift of Florence M. Quinn), (44.21).

Chair (from a set of six side chairs and two arm chairs) (M) Backs and seats covered in needlework; brass mountings on knees and feet; c. 1700; H. 40½ in. *Acq.:* 1944 (gift of Florence M. Quinn), (44.49–56).

Chair (one of two) (V)
Walnut; c. 1730; H. 39 in. *Acq.:* 1944 (gift of Florence M. Quinn), (44.2–3).

Chair (from a set with seven chairs, two settees, and two stools) (M)
Mahogany; c. 1740; H. 39½ in.
Coll.: Lord Clifton *Acq.:* 1910, (10.168–174).

Chair (from a set of twelve plus two reproductions) (E)
Mahogany; c. 1745; H. 39¾ in. *Acq.* 1910, (10.87–100).

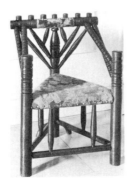

(72.18A)

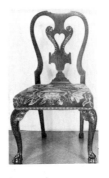

(44.2–3)

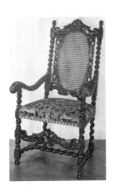

(44.21)

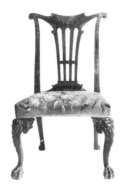

(10.168–174)

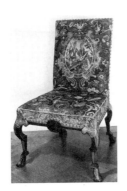

(44.49–56)

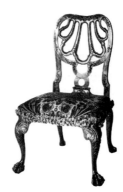

(10.87–100)

Chair (one of two) (O)
Mahogany; c. 1760; H. 37 in. *Acq.:* 1944 (gift of
Florence M. Quinn), (44.73–74).

Chair (one of two, style of John Linnell) (T)
Carved giltwood; c. 1775; H. 37½ in.
Coll.: from a suite made for Edward Morant;
Brockenhurst Park *Acq.:* 1983 (Adele S. Browning
Memorial Collection), (83.2).

Chair (one of two, made by Morel and Hughes)
(W)
Aburra wood with gilding; 1823; H. 34½ in.
Coll.: Duke of Northumberland; Wateringbury
Place *Acq.:* 1979, (79.1).

Desk (one of a pair, attributed to William Vile) (G)
Mahogany with gilt bronze mounts; c. 1740;
H. 31¾ L. 63¼ D. 33¾ in. *Acq.:* 1970, (70.3).

Double Desk (manner of Thomas Chippendale) (P)
Mahogany; c. 1765; H. 31¼ L. 69¾ D. 56 in. *Acq.:*
1965, (65.14).

Library or Sofa Table (W)
Rosewood with brass banding; early nineteenth
century; H. 29⅜ L. 50⅜ D. 20 in. *Acq.:* 1976,
(76.29).

Stands (a pair, attributed to Benjamin Goodison)
(H)
Giltwood; mid-eighteenth century; H. 51 in. *Acq.:*
1975, (75.47).

Stand (one of two, style of Robert Adam) (H)
Giltwood; c. 1770; H. 60 in. *Acq.:* 1976, (76.2).

Side Table (after designs by Matthias Lock) (H)
Decorated in green and gold with marble top; c.
1740; H. 34 L. 84 D. 30 in. *Acq.:* 1976, (76.1).

Side Table (one of two) (H)
Mahogany with marble top; c. 1765; H. 33 L. 73
D. 31 in. *Acq.:* 1964, (64.5).

72

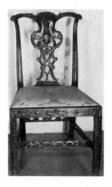

(44.73–74)

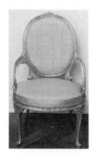

(83.2)

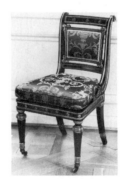

(79.1)

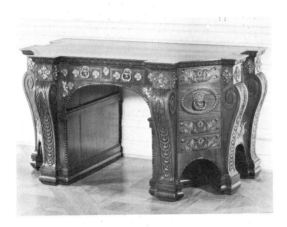

(70.3)

(76.2)

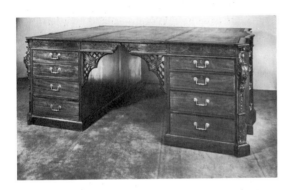

(65.14)

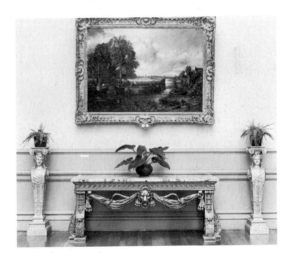

(75.47) (76.1)

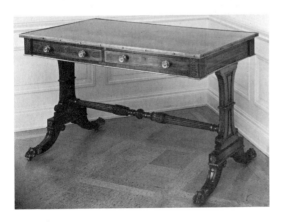

(76.29)

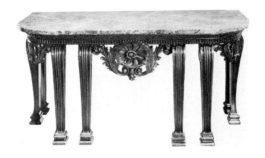

(64.5)

Side Table (one of two, designed by Robert Adam) (H)
Giltwood with inlaid marble top; c. 1764; H. 35 L. 66 D. 30 in.
Designed for Sir Lawrence Dundas; made by France and Bradburn *Coll.:* Dundas; A. E. Worswick; Delphine Elizabeth Paul *Acq.:* 1971 (one table given by Mrs. Jane E. Tower), (71.4).

Side Table (one of two, manner of Robert Adam, attributed to Henry Clay) (U)
Black with painted "Etruscan" decoration; c. 1775; H. 31 L. 36 D.15 in. *Acq.:* 1980 (Adele S. Browning Memorial Collection), (80.21).

Chest (attributed to Pierre Langlois) (G)
Marquetry of various woods with gilt bronze mounts; mid-eighteenth century; H. 33 L. 60 D. 26 in. *Acq.:* 1910, (10.196)

Chest (U)
Chinese black and gold lacquer panels with gilt bronze mounts; c. 1760; H. 36 L. 43 D. 22¾ in.
Coll.: Philip Blairman
Acq.: 1982 (Adele S. Browning Memorial Collection), (82.4)

Chest (manner of John Linnell) (U)
Satinwood and marquetry; c. 1775; H.35 L. 60 D. 24 ¼ in.
Acq.: 1982 (Adele S. Browning Memorial Collection), (82.33)

Chest (by G. & R. Gillow) (W)
Rosewood with inlay and brass banding; 1801; H. 37 L. 54 D. 18¾ in..
Coll.: made for Luke Dillon, 2nd earl of Clonbrock *Acq.:* 1977, (77.3).

Bonheur-du-Jour (attributed to John McLean) (T)
Rosewood with brass banding; c. 1815; H.44½ L.32½ D. 19 in.
Acq.: 1985 (Adele S. Browning Memorial Collection), (85.39).

74

Chandelier (E)
Crystal, twenty-light; H. 72 Diam. 50 in.; c. 1785
Coll.: Goring Castle, Sussex *Acq.:* 1959, (59.54).

Chandelier (U)
Crystal, eight-light; H. 46 in.; c. 1810 *Acq.:* 1984 (Adele S. Browning Memorial Collection), (84.46).

(71.4)

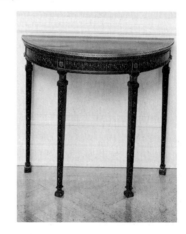

(80.21)

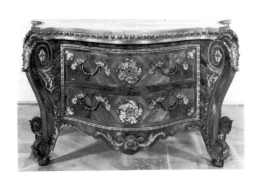

(10.196)

(77.3)

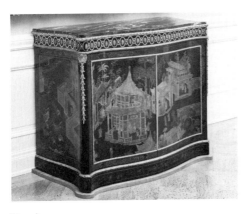

(82.4)

(85.39)

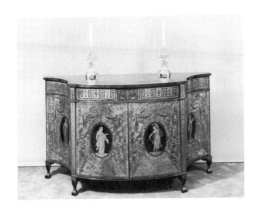

(82.33)

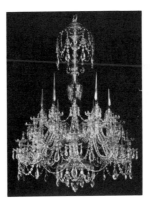

(59.54)

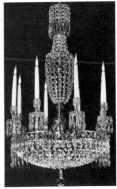

(84.46)

Mirror (one of two) (J)
Giltwood, mid-eighteenth century; H. 75 in. *Acq.:*
1940 (gift of the Friends), (40.1).

Mirror (Overseers Room)
Giltwood; early eighteenth century; H. 63¼
in. *Acq.:* 1944 (gift of Florence M. Quinn),
(44.45).

Harpsichord (H)
Mahogany; 1773; H. 36 L. 86 D. 37 in.
Single manual; made in London in 1773 by Jacob
and Abraham Kirkman *Acq.:* 1979, (79.2).

Wine Cooler (sarcophagus form) (W)
Mahogany; early-nineteenth century; H. 27½ L. 36
D. 21½ in. *Coll.:* Ingworth Hall *Acq.:* 1977,
(77.1).

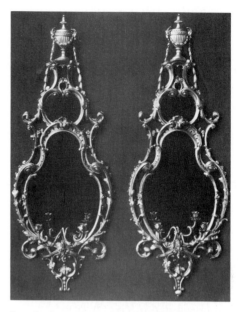

(40.1)

Clock (by Vulliamy) (D)
Marble, biscuit, and gilt bronze; late eighteenth
century; H. 16 in. *Acq.:* 1913, (13.16).

Clock (by Vulliamy) (D)
Marble, bronze, and Wedgwood plaque; late
eighteenth century; H. 19 in. *Acq.:* 1913, (13.24).

Candelabrum (one of two) (by Vulliamy) (U)
Bronze and gilt bronze; early nineteenth century;
H. 25 in. *Acq.:* 1982 (Adele S. Browning Memorial
Collection), (82.1).

Cassolettes (a pair; manufactured by Matthew
Boulton c. 1773) (S)
Marble and gilt bronze; H. 9 in. *Acq.:* 1982 (gift
of George Levy), (82.2).

(44.45)

(79.2)

(13.24)

(77.1)

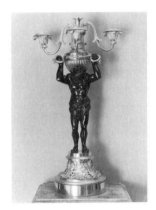

(82.1)

(13.16)

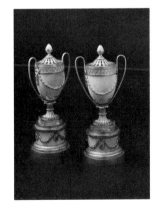

(82.2)

THE BRITISH CERAMICS in the Huntington Gallery consist primarily of an important collection of mid-eighteenth century pieces from the Chelsea factory. A smaller but growing collection of early Wedgwood is taking form through the generosity of Mr. and Mrs. Stuart Kadison of Los Angeles.

The Chelsea porcelain factory in England began operations about 1743, continuing until 1770. The output of the factory took in a wide range, but much of its fame was to come from ornamental pieces such as the vases, potpourri jars, and small figures shown in rooms (F) and (J) in four wall cases. Chelsea figures were often made in imitation of those produced at Sèvres and at Meissen, but original works of grace and distinction were also produced. Some of the factory's most ambitious productions in figure groups, elaborately decorated in colors and gold, are to be seen in the case in the Main Hall (J). Frequently they are designed as candleholders. In one case in the West Hall (F) are shown vases and potpourri jars with the claret ground color, an invention of the Chelsea factory. It will be noted that this color varied from soft rose pink to near crimson. Most of the pieces show a lavish use of gold to match in luxuriance the extreme rococo swirls with which they are ornamented. In the second case in the West Hall the vases have a mazarine-blue ground, also a Chelsea invention, intended as an imitation of the *bleu de roi* of Sèvres. The gold anchor mark on many of these pieces indicates that they were made between 1758 and 1770.

CHELSEA

MAIN HALL (J) SOUTH WALL CASE

Top Shelf

Two-Figure Groups, a pair; each with a huntsman and a lady, with dog and gun, seated in a bower; gold anchor mark; H. 11 in.
Coll.: Sir Edward J. Dean Paul, Bart.; R. M. Wood. *Acq.:* 1923, (23.40 and 41).

78

Figure Group; boy playing flageolet, girl playing hurdy-gurdy, in peasant costumes, seated in a bower; mark: crossed swords in dark blue; probably Bow; H. 8½ in.
Coll.: John Williams. *Acq.:* 1923, (23.35).

Second Shelf

Figure Groups; infant Bacchus seated on a leopard's back, before a trellis; the companion figure, a Cupid on a lion's back, with foliage background; probably Bow; H. 12 in. *Acq.:* 1923, (23.31 and 32).

Figures, a pair; a shepherdess seated in a bower of wild roses, a sheep at her feet; the companion figure, a youth likewise seated in a bower, a dog at his feet; gold anchor mark; also "R" impressed; H. 9½ in.
Coll.: Baron Gustave de Rothschild. *Acq.:* 1923, (23.36 and 37).

Third Shelf

Two-Figure Groups, a pair; a young girl representing "Summer," a young man, "Autumn"; the companion piece shows a man, heavily appareled, depicting "Winter," a maiden carrying flowers, representing "Spring"; gold anchor mark; also "R" impressed; H. 12½ in. *Acq.:* 1922, (22.01 and 02).

Figure; a youth standing in a bower of flowers, playing the bagpipes; a lamb is at his side, a dog at his feet; probably Bow; H. 16 in. *Acq.:* 1923, (23.46).

Bottom Shelf

Figures, a pair; Ganymede, with eagle, symbolizing "Sight"; woman, with falcon and tortoise, representing "Touch"; gold anchor mark; H. 17¼ in.
Coll.: Sir Moses Montefiore; Edward Robson. *Acq.:* 1923, (23.38 and 39).

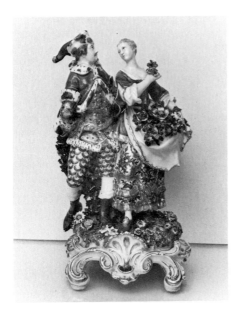

(22.02)

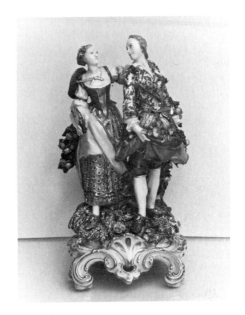

(22.01)

(23.31–32)

(23.38–39)

(23.36–37)

WEST HALL (F), SOUTH CASE

*Chelsea Porcelain with Mazarine-Blue
Ground Color*

Top Shelf

Potpourri Jars with lids, a pair; oviform; panels
decorated wtih birds and with groups of children
in costumes suggesting Watteau; gold anchor mark;
H. 11½ in.
Coll.: Martin T. Smith; Edward Robson. *Acq.:*
1923, (23.17 and 18).

Potpourri Vase with lid; baluster shape; ground
decorated with gold-imbrication pattern, front
medallion of classical figure-subject in russet color;
H. 14½ in.
Coll.: John Cockshutt. *Acq.:* 1923, (23.16).

Vases, a pair; oviform; ornamented with grape
bunches, vines, and leaves, in high relief and in
burnished gold; H. 12 in.
Coll.: Edward Robson. *Acq.:* 1923, (23.14 and 15).

Second Shelf

Potpourri Vases with lids, a pair; baluster shape;
brightly colored flowers painted on a burnished gold
ground; gold anchor mark; H. 12½ in.
Coll.: Lord Henry Thynne. *Acq.:* 1923, (23.19 and
20).

Potpourri Vases with dome-shaped lids, a pair; pear
shape; panels of rustic scenes, with figures;
H. 16 in.
Coll.: Earl of Dudley. *Acq.:* 1923, (23.21 and 22).

Potpourri Vase with lid and pedestal; baluster
shape; panels of rural scenes in the manner of
Boucher; gold anchor mark; H. 17 in.
Coll.: T. Stafford Walker; Earl of Dudley.
Acq.: 1924, (24.06).

Third Shelf

Vases with lids, a pair; pear shape; rich
ornamentation of exotic birds and foliage, in gold;
gold anchor mark; H. 16½ in.
Coll.: Lord Henry Thynne. *Acq.:* 1922, (22.47 and
48).

Vases, a pair; baluster shape; mottled ground, richly
ornamented with exotic birds and foliage, in gold;
H. 18½ in.
Coll.: T. W. Waller; Lady Ludlow. *Acq.:* 1923,
(23.23 and 24).

Bottom Shelf

Vases with lids, a pair; oviform; mottled ground;
medallions decorated with figure-subjects and
exotic birds and trees; H. 20 in.
Coll.: Edward Robson; John Cockshutt. *Acq.:*
1923, (23.25 and 26).

Vases with lids, set of three; baluster shape; panels
decorated with figure-subjects, exotic birds, and
butterflies; center, H. 13 in.; side, 11 in.
Coll.: Lord Fisher. *Acq.:* 1922, (22.49, 50 and 51).

(23.19–20)

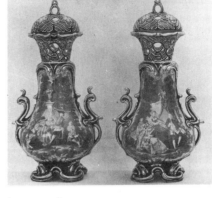

(23.21–22)

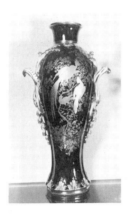

(23.24)

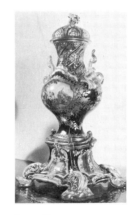

(24.06)

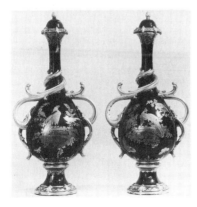

(22.47–48)

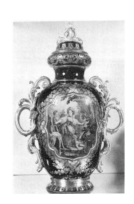

(23.25)

WEST HALL (F), NORTH CASE

Chelsea Porcelain with Claret Ground Color

Top Shelf

Vases with lids, a pair; oviform urn shape; medallions decorated wtih *amorini* on clouds, after Boucher; H. 14 in.
Coll.: Ralph Lambton. *Acq.:* 1922, (22.45 and 46).

Vases, set of three; baluster shape; front panels decorated with rustic scenes in the manner of Boucher; center, H. 13 in.; side, 10½ in.
Coll.: John Cockshutt. *Acq.:* 1923, (23.57, 58 and 59).

Second Shelf

Potpourri Vases with lids, a pair; pear shape; reserves decorated with flowers. H. 15½ in.
Coll.: Sir Samuel Scott; Sir George Donaldson. *Acq.:* 1922, (22.40 and 41).

Potpourri Vase with lid; pear shape; front panel decorated with scene representing Cupid and Psyche, after Boucher; H. 15½ in.
Coll.: Edward Robson. *Acq.:* 1923, (23.56).

Vases, a pair; pear shape; panel decorations, "Leda and the Swan" and "Venus and Cupid"; H. 9 in.
Coll.: Edward Robson. *Acq.:* 1923, (23.54 and 55).

Third Shelf

Vases with lids, a pair; oviform urn shape; panels decorated with bacchanalian subject; H. 11¾ in.
Coll.: Baroness Burdett-Coutts. *Acq.:* 1922, (22.20 and 21).

Urns with lids, a pair; decoration, in high relief, of festooned drapery in white; H. 9¾ in.
Coll.: Edward Robson; John Cockshutt. *Acq.:* 1923, (23.51 and 52).

Potpourri Vase with lid; pear shape; reserves decorated with flowers; H. 15 in.
Coll.: Edward Robson; John Cockshutt. *Acq.:* 1923, (23.53).

Bottom Shelf

Potpourri Vases with lids, a pair; oviform; exotic bird-and-flower decoration; H. 14 in.
Coll.: Sir Samuel Scott; Sir George Donaldson. *Acq.:* 1922, (22.42 and 43).

Potpourri Vase with lid; baluster shape; decoration of exotic birds against a setting of foliage and fruit; H. 15½ in.
Coll.: Sir Samuel Scott; Sir George Donaldson. *Acq.:* 1922, (22.44).

WEST HALL (F) CHINA CABINET

Top Shelf

Vases with lids and handles, a pair; urn shape; claret ground, with laurel festoons in gold; H. 7 in.
Coll.: Edward Robson. *Acq.:* 1923, (23.49 and 50).

Vases with ring handles, a pair; urn shape; claret ground; drape form caught up in a bow in front; H. 10 in.
Coll.: Edward Robson. *Acq.:* 1923, (23.47 and 48).

Middle Shelf

Vases with covers, a pair; baluster shape; mazarine-blue ground; large circular reserves, with classical scenes in sylvan settings; scroll handles; H. 13 in.
Coll.: John Cockshutt. *Acq.:* 1922, (22.53 and 54).

Two-Figure Groups, a pair; representing the seasons; girl with wheat sheaf symbolizes "Summer"; the youth at her side, with a basket of fruit, "Autumn"; in the other group, the youth on skates in heavy clothing represents "Winter"; the maiden with a basket of flowers, "Spring"; gold anchor mark; H. 10½ in.
Coll.: Sir Edward J. Dean Paul, Bart. *Acq.:* 1923, (23.42 and 43).

Bottom Shelf

Vases with lids, a pair; urn shape; turquoise ground; circular panels, decorated with classical figure groups and landscapes; H. 9½ in.
Coll.: Edward Robson; John Cockshutt. *Acq.:* 1923, (23.29 and 30).

Vases with lids, a pair; oviform, with flutings;
turquoise ground; shield-shape panels, decorated
with figure groups in the manner of Teniers;
H. 12½ in.
Coll.: Edward Robson; John Cockshutt.
Acq.: 1923 (23.33 and 34).

DINING ROOM (E), MANTEL

Vases with lids, a pair; chinoiserie design;
H. 11 in.
Coll.: Edward Robson. *Acq.:* 1923, (23.44 and 45).

(23.53)

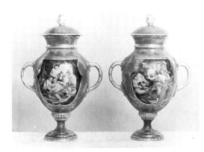

(22.20–21)

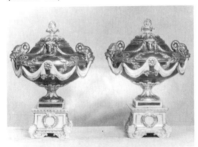

(23.51–52)

(22.42)

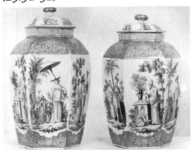

(23.44–45)

(22.44)

WEDGWOOD

Josiah Wedgwood (1730–95) began producing pottery in the mid-eighteenth century at Burslem. He established a second factory, to which he gave the name "Etruria," in 1769. The technical excellence of the wares he produced together with the distinction and vitality of the designs quickly brought international fame. By the end of the eighteenth century Wedgwood pottery was among the most popular and successful in Europe. The factory has continued in production through the nineteenth century and down to the present day.

Although Wedgwood is primarily associated with the famous blue and white jasper, he produced a great variety of wares. His early fame was based on a more utilitarian cream ware for normal table use. The factory was also early noted for sculptured pieces in a bronze-like ware called "black basaltes."

Examples of Wedgewood pottery are shown in two wall cases in Room (Q) on the second floor of the Huntington Gallery. All are generously given or lent by Mr. and Mrs. Stuart Kadison of Los Angeles.

Tureen, with crest and arms of Isted impaling Brabant
Creamware; H. 9½ L. 15⅜ D. 11⅜ in. (including underdish); impressed: WEDGWOOD; c. 1800
Acq.: 1978, (gift of Mr. and Mrs. Stuart Kadison), (78.18.2).

Heracles in the Garden of the Hesperides (after D'Hancarville)
Three-color jasper dip; 7⅜ x 20¼ in.; impressed: WEDGWOOD; c. 1800.
Acq.: 1980, (gift of Mr. and Mrs. Stuart Kadison), (80.16.1).

Vase, an imitation of a Greek red figure vase, with a scene (after Flaxman) representing Ulysses at the table of Circe.
Black basaltes; H. 12⅛ in.; impressed: WEDGWOOD; c. 1800
Acq.: 1980, (gift of Mr. and Mrs. Stuart Kadison), (80.16.4).

Milton
Black basaltes; H. 13½ in.; impressed: WEDGWOOD; c. 1800.
Acq.: 1954 (gift of the Friends), (54.2A).

GLASS

The Huntington Gallery contains a small but representative collection of Anglo-Irish glass from the late eighteenth century and the early nineteenth. A sampling from this material is displayed in room (V) on the second floor of the Gallery. All of the glass is part of the bequest of Mr. and Mrs. C. C. Moseley.

Cutglass Bowl and Cover
H. 9 in.
Acq.: 1974 (gift of Mr. and Mrs. C. C. Moseley), (74.54.93).

Gadrooned Jug
H. 6 in.
Acq.: 1974 (gift of Mr. and Mrs. C. C. Moseley), (74.54.82).

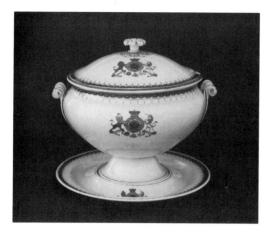

(78.18.2)

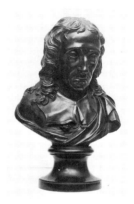

(54.2A)

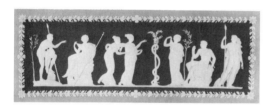

(80.16.1)

(74.54.93)

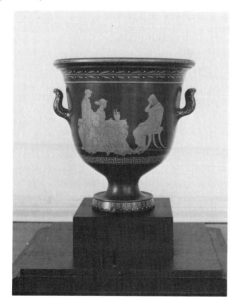

(80.16.4)

(74.54.82)

FRENCH PAINTINGS in the Huntington Art Gallery are primarily from the eighteenth century and mostly in the Adele S. Browning Memorial Collection, bequeathed by Judge and Mrs. Lucius P. Green in 1978. Chronologically the French paintings are roughly contemporary with the Huntington's British paintings. The two groups suggest interesting differences and connections between art on either side of the English Channel.

But caution is necessary when drawing conclusions from the evidence at hand. English painting at the Huntington emphasizes the late eighteenth century and the large-scale, grand-manner, public exhibition portraits. French painting in the Browning Collection emphasizes an earlier part of the century and the small scale, elegant, decorative paintings intended for the private rooms of the wealthy.

French art as seen in the Browning Collection is sensuous, seductive, and charming. English painting, as seen in the Huntington's full-length portraits, is relatively stately and reserved. Yet it would be easy to over-emphasize the differences. There was much interaction between French and English painting during the eighteenth century. Many British artists, including Hogarth, Ramsay, and Gainsborough, absorbed some of the decorative appeal of the French. Late in the century French painters, including David, absorbed some of the British seriousness and emotional resonance. A similar interaction between England and France is evident in other art forms, such as architecture and furniture. The predilections of the two countries provided some of the principal threads that are woven into the general fabric of eighteenth-century European art.

The bequest of Judge and Mrs. Green, in which French eighteenth-century painting is dominant, was a particularly welcome addition to the Huntington Gallery. French eighteenth-century sculpture and decorative art have always been important parts of the Huntington art collection, second only to the British material. But French eighteenth-century painting

had been previously unrepresented. The arrival of the Browning Collection (which also includes Italian eighteenth-century paintings) enables the Huntington to present one of the most comprehensive views of eighteenth-century European art to be found in America.

Curatorial research on the Browning Collection is in progress. Information on the paintings given here is preliminary and subject to revision.

Boucher, François (1703–70)
Venus and Cupid (R)
Canvas: 27½ x 22½ in., oval; signed and dated 1769
Coll.: Baroness von Seidlitz *Acq.:* 1978 (Adele S. Browning Memorial Collection), (78.20.01).

David, Jacques-Louis (1748–1825)
Rabaut Saint-Etienne (A sketch for "The Oath in the Tennis Court") (R)
Canvas: 21¾ x 16¾ in.
Coll.: (?) Hippolyte Walferdin; Tuffier; Comte de Chavagnac *Acq.:* 1978 (Adele S. Browning Memorial Collection), (78.20.02).

Drouais, François-Hubert (1727–75)
Boy with Peaches (R)
Canvas: 28 x 22 in., oval; signed and dated 1760
Coll.: Comtesse Renée de Béarn; Gabriel Cognac *Acq.:* 1978 (Adele S. Browning Memorial Collection), (78.20.03).

Duplessis, Joseph-Siffrède (1725–1802), attributed to
Benjamin Franklin (Library Main Exhibition Hall)
Pastel; 30 x 25 in., oval
Coll.: Samuel Latham Mitchill Barlow; Brayton Ives; Clarence S. Bement *Acq.:* 1953, (53.04).

Fragonard, Jean-Honoré (1732–1806)
Head of a Boy (probably the artist's son) (R)
Canvas: 8½ x 7¼ in., oval
Coll.: Hippolyte Walferdin; Hans Wendland *Acq.:* 1978 (Adele S. Browning Memorial Collection), (78.20.05).

Cupid between Roses (R)
Canvas: 21½ x 18 in. oval; signed
Coll.: J. Beasley; J. Insley Blair *Acq.:* 1978 (Adele S. Browning Memorial Collection), (78.20.04).

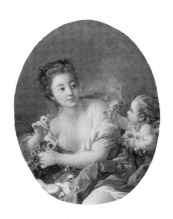

(78.20.01)

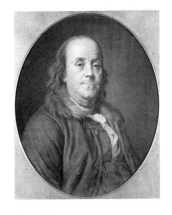

(53.04)

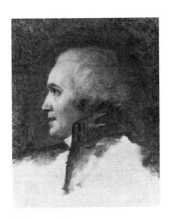

(78.20.02)

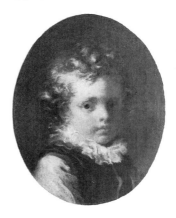

(78.20.05)

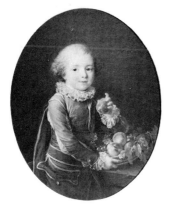

(78.20.03)

(78.20.04)

Gellée, Claude (Le Lorrain) (1600–82)
Seaport at Sunrise (Liber Veritatis no. 2) (T)
Canvas: 28½ x 38 in.; dated 1636
Coll.: Peilhon; Lord Palmerston; Lord Mount
Temple; Evelyn Ashley; earl of Iveagh *Acq.:* 1978
(Adele S. Browning Memorial Collection),
(78.20.06).

Gérard, Marguerite (1761–1837)
Park Scene with Women and Children (R)
Canvas: 18¼ x 21¾ in.; signed
Coll.: Baron Donino *Acq.:* 1978 (Adele S.
Browning Memorial Collection), (78.20.07).

Greuze, Jean-Baptiste (1725–1805)
Young Knitter Asleep (R)
Canvas: 26¾ x 21¾ in.
Coll.: Chevalier d'Armengaud; Prince de Caraman
Chimay; Comtesse de Greffulhe *Acq.:* 1978 (Adele
S. Browning Memorial Collection), (78.20.08).

Hilaire, Jean-Baptiste (1753–1822)
Two Scenes in Parc Monceau (S)
Panel: each 12¼ x 16 in.; each signed
Coll.: Lelong *Acq.:* 1978 (Adele S. Browning
Memorial Collection), (78.20.09 A & B).

Lancret, Nicolas (1690–1743)
Woman and Child at a Fountain (S)
Canvas: 19½ x 25 in.; oval
Coll.: Colin Agnew *Acq.:* 1978 (Adele S.
Browning Memorial Collection), (78.20.10).

Largillière, Nicolas De (1656–1746) by or after
La Marquise de Dreux-Breze (reduced version of the
portrait in the Montreal Museum of Fine Arts)
Canvas: 24¼ x 19¾ in.
Coll.: Spitzer; Coche de la Ferté; Edmond de
Rothschild; L. Schumann *Acq.:* 1978 (Adele S.
Browning Memorial Collection), (78.20.11).

Lusurier, Catherine (1753–81) by or after
The Young Scholar
Canvas: 19¼ x 13⅜ in.; oval
Coll.: Philippe Wiener *Acq.:* 1944 (Florence M.
Quinn Collection), (44.109).

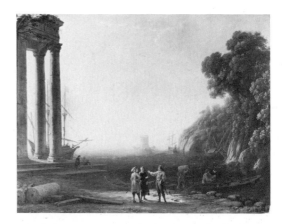

(78.20.06)

(78.20.07)

(78.20.08)

(78.20.10)

(78.20.09A)

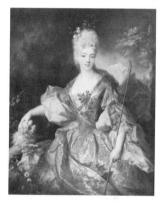

(78.20.11)

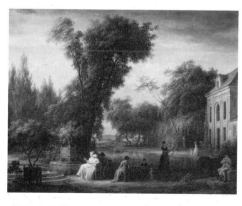

(78.20.09B)

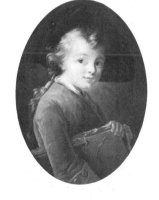

(44.109)

Moreau, Louis-Gabriel (1739–1803)
View in the Park of Saint Cloud (R)
Panel: 28⅜ x 20⅞ in.; signed with initials;
exhibited at the Salon of 1804. *Acq.:* 1978 (Adele
S. Browning Memorial Collection), (78.20.12).

Nattier, Jean-Marc (1685–1766)
Portrait of a Lady as Diana (sometimes called Mme
Bonnier de La Mosson) (R)
Canvas: 39 x 31½ in.; signed and dated 1742
Coll.: Comte de Behague; Fischof; W. B.
Leeds *Acq.:* 1978 (Adele S. Browning Memorial
Collection), (78.20.13).

Pater, Jean-Baptiste (1695–1736)
The Swing (R)
Canvas: 18 x 21½ in.
Coll.: Lord Campden; Sir Robert Holford; Henry
E. Stehli and Lilli Stehli Bonner *Acq.:* 1978 (Adele
S. Browning Memorial Collection), (78.20.14).

Musical Trio
Canvas: 18¼ x 14¾ in.
Coll.: A. Rosenheim *Acq.:* 1978 (Adele S.
Browning Memorial Collection), (78.20.15).

Prud'hon, Pierre-Paul (1758–1823)
Bathing Nymph (R)
Canvas: 15½ x 12½ in.; signed and dated 1787
Coll.: Fauconnier; Pelée *Acq.:* 1978 (Adele S.
Browning Memorial Collection), (78.20.16).

Robert, Hubert (1733–1808)
Women Washing at a Fountain (R)
Canvas: 32 x 46 in.
Coll.: Count Chorinsky; Robert Herzig *Acq.:* 1978
(Adele S. Browning Memorial Collection),
(78.20.18).

Van Loo, Charles-Amédée-Philippe (1715–95)
The Artist's Son, Louis
Canvas: 23¼ x 20⅛ in., oval; signed and dated
1764 *Acq.:* 1944 (Florence M. Quinn Collection),
(44.105).

**Vigée-Lebrun, Elisabeth-Louise (1755–1842),
after, (probably by Jean-Baptiste Rivière)**
Princesse Pélagie Potocka
Panel: 7 x 6 in.
Coll.: Count Vincent Potocka *Acq.:* 1978 (Adele
S. Browning Memorial Collection), (78.20.17).

Watteau, Antoine (1684–1721)
Country Dance (R)
Panel: 17 x 12¾ in. (the figure group on a circular
panel approximately 8 in. in diameter set into the
larger panel)
Coll.: M. de Monmarqué; Poullain; Marquise de
Plessis-Bellière; H. Michel-Levy; H. Meyer; Nicolas
Ambatielos; Alvin Schmid *Acq.:* 1978 (Adele S.
Browning Memorial Collection), (78.20.19).

(78.20.12)

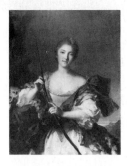

(78.20.13)

(78.20.14)

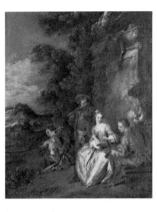

(78.20.15)

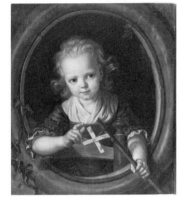

(44.105)

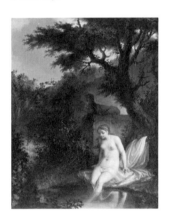

(78.20.16)

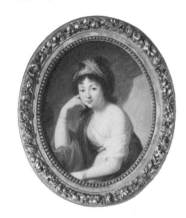

(78.20.17)

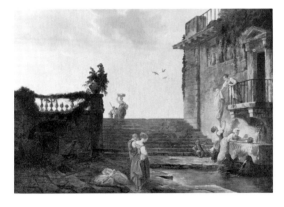

(78.20.18)

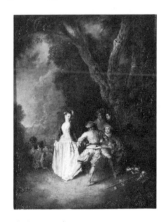

(78.20.19)

BARBIZON AND
RELATED PAINTING

THE OPENING OF the entrance Pavilion in 1981 provided an opportunity to place on semi-public exhibition several works of art that had previously been in private offices or storage. The most important artistically are mid- and late-nineteenth century paintings of the Barbizon and related schools. All of these were bequeathed to the institution by Mr. and Mrs. Huntington and had been part of the furnishings of the gallery when it had been the Huntington residence. Following is a checklist of these paintings, most of which are exhibited in the Friends' Hall of the Pavilion.

(07.15)

Breton, Jules (1827–1906)
The Last Gleanings
Canvas: 36½ x 55 in.; signed and dated 1895
Acq.: 1907, (07.15).

Corot, Jean-Baptiste-Camille (1796–1875)
Hauling in the Net, Twilight (Robaut II,1071)
Canvas: 32 x 23 in.; signed *Acq.:* 1926, (26.117).

Couture, Thomas (1816–1879)
Study of a Woman's Head
Canvas: 18½ x 15 in.; signed with initials
Acq.: 1926, (26.110).

Daubigny, Charles-Francois (1817–78)
After the Storm
Panel: 15 x 26¾ in. *Acq.:* 1908, (08.2).

Diaz De La Pena, Narcisse Virgile (1807–76)
The Pets
Canvas: 20½ x 28¾ in.; signed and dated
1856 *Acq.:* 1926, (26.118).

Under the Trees
Panel: 23½ x 18¾ in.; signed and dated
1871 *Acq.:* 1907, (07.11).

Harpignies, Henry Joseph (1819–1916)
Landscape
Canvas: 32 x 25¾ in.; signed and dated 1902
Acq.: 1907, (07.12).

Israels, Jozef (1824–1911)
The Sleeping Baby
Canvas: 49¾ x 63 in.; signed *Acq.:* 1907, (07.19).

(26.117)

92

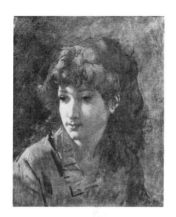

(26.110)

(07.11)

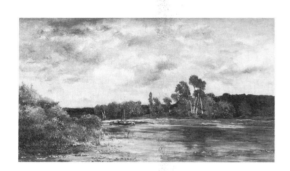

(08.2)

(07.12)

(26.118)

(07.19)

Jacque, Charles-Emile, (1813–94)
Interior, Sheep and Shepherd
Canvas: 26 x 39½ *Acq.:* 1907, (07.10).

Sheep at Pasture
Canvas: 27 x 39½ in. *Acq.:* 1907, (07.14).

Maris, Jacob Henricus (1837–99)
Dutch Cityscape
Panel: 9¾ x 11 in.; signed *Acq.:* 1911, (11.18).

Merle, Hugues (1823–81)
Charlotte Corday
Canvas: 24½ x 20½ in.; signed and dated
1875 *Acq.:* 1914, (14.61).

Navier, Gabriel (died 1912)
Family Scene
Canvas: 21 x 25½ in.; signed *Acq.:* 1914, (14.58).

Piot, Adolphe (active 1850–1909)
An Italian Beauty
Canvas: 25½ x 20½; signed *Acq.:* 1926, (26.111).

Troyon, Constant (1810–65)
Milking Time at La Celle near St. Cloud
Canvas: 45½ x 65 in.; signed and dated 1857
Acq.: 1926, (26.116).

Van Marcke, Emil (1827–90)
Homeward Bound
Canvas: 19¾ x 29 in.; signed *Acq.:* 1926,
(26.119).

(07.10)

(07.14)

94

(11.18)

(26.111)

(14.61)

(26.116)

(14.58)

(26.119)

THE FRENCH SCULPTURE in the Huntington collection consists of marbles, bronzes, and terra-cottas, mostly from the second half of the eighteenth century—the same period to which much of the French furniture and most of the British paintings belong. This is the time of the "ancien régime" just prior to the French Revolution, and the sculpture, like the furniture, reflects the aristocratic elegance and refinement generally associated with that epoch. The principal sculptor was Jean-Antoine Houdon, one of the great artists of the eighteenth century. The Huntington is fortunate to own four examples of his work, well chosen to give a fair idea of his range and virtuosity. There are also important groups of objects by or designed by J. B. Pigalle, Falconet, and Clodion. The French sculpture in the Huntington collection is one of the richest assemblages of its kind in this country, and it deserves more popular attention than it receives.

Allegrain, Christophe-Gabriel (1710–95) by or after
Bather (S); marble, H. 30 in.
Acq.: 1978 (Adele S. Browning Memorial Collection), (78.20.55).

Boizot, Louis-Simon (1743–1809), possibly by.
Louis XVI (Z); marble, H. 34 in.
Coll.: Mme Wilkinson; George J. Gould.
Acq.: 1927, (27.84).

Caffieri, Jean-Jacques (1725–92).
Portrait of a Young Girl (Z); marble, H. 31 in.
Coll.: George J. Gould. *Acq.:* 1927, (27.93).

Clodion (Claude Michel), (1738–1814).
Woman Playing with a Child (C); terra-cotta, H. 18 in.
Coll.: Ernest W. Beckett; J. Pierpont Morgan.
Acq.: 1916, (16.5).

Woman and Child (C); terra-cotta, H. 18½ in.
Coll.: J. Pierpont Morgan. *Acq.:* 1916, (16.6).

Standing Girl (Y); terra cotta, H. 17½ in.
Coll.: George J. Gould. *Acq.:* 1927, (27.123).

Reclining Girl (Y); terra-cotta, H. 9½ in.
Acq.: 1927, (27.99).

Vases (a pair) (J); marble, H. 49½ in., one signed and dated 1782.
Coll.: Baron Adolphe de Rothschild. *Acq.:* 1912, (12.16 & 17).

(78.20.55)

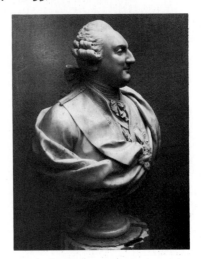

(27.84)

96

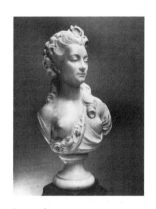

(27.93)

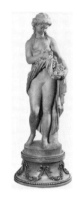

(27.123)

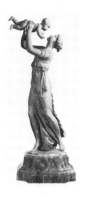

(16.5)

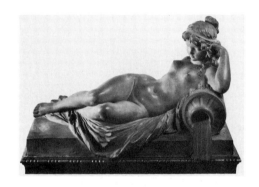

(27.99)

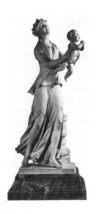

(16.6)

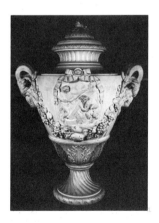

(12.16)

by or after Clodion
Nymph and Satyr (T); bronze; H 13 in.
Coll.: John Jacob Astor *Acq.:* 1978 (Adele S.
Browning Memorial Collection), (78.20.54).

**Falconet, Etienne-Maurice (1716–1791),
attributed to.**
Bather (Z); marble, H. 10 in.
Acq.: 1927, (27.85).

Venus and Cupid (Z); marble, H. 14½ in.
Acq.: 1916, (16.8).

Venus and Cupid (Z); marble, H. 15¼ in.
Acq.: 1916, (16.7).

Venus and Cupid (Z); marble, H. 17¾ in.
Acq.: 1927, (27.91).

Venus and Cupid (Z); marble, H. 15¾ in.
Acq.: 1918, (18.13).

Bather (Z); marble, H. 12¼ in.
Acq.: 1927, (27.94).

Bather (R) same model as preceding; marble;
H. 11 in.
Coll.: Baron Nathaniel de Rothschild; Werner
Weisbach. *Acq.:* 1978 (Adele S. Browning
Memorial Collection), (78.20.50).

French, Eighteenth Century.
Standing Bather (Z); marble, H. 54 in.
Acq.: 1927, (27.89).

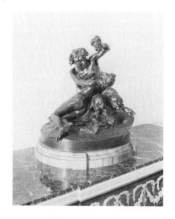

(78.20.54)

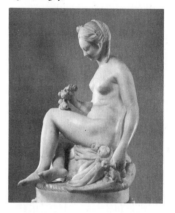

(27.85)

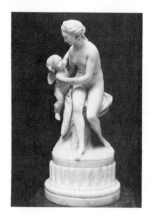

(16.8)

98

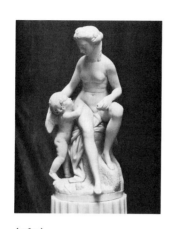

(16.7)

(27.94)

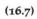

(27.91)

(78.20.50)

(18.13)

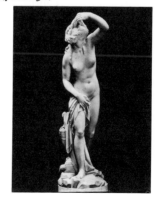

(27.89)

Busts of a Young Girl and Boy (a pair) (Y); bronze, H. 14½ in.
Coll.: Sir Philip Sassoon. *Acq.:* 1927, (27.97 & 98).

French, Nineteenth Century
Shivering Figure; bronze, H. 54 in.
Coll.: Marquis de Levis Mirepoix; George J. Gould. *Acq.:* 1927 (27.26).

Houdon, Jean-Antoine (1741–1828).
Portrait of a Lady (so-called Baroness de la Houze) (Z); marble, H. 39 in., signed and dated 1777.
Coll.: Marquis Auguste du Blaixel; Maurice de Rothschild. *Acq.:* 1927, (27.92).

Diana Huntress (J); bronze, H. 82 in., signed and dated 1782.
Coll.: Girardot de Marigny; Aguado; marquis of Hertford; Sir John Murray Scott; Yerkes; Guinle. *Acq.:* 1927, (27.186).

Unknown Man (Z); terra-cotta, H. 17⅛ in.
Coll.: Comte d'Albenas; Edouard Kann.
Acq.: 1927, (27.82).

Sabine Houdon (Z); marble, H. 17¾ in., signed.
Coll.: Claudine Rochette; Raoul Perrin; George J. Gould. *Acq.:* 1927, (27.95).

after Houdon
George Washington; bronze, H. 79 in.
Acq.: before 1927, (24.12).

La Rue, Louis-Felix De (1731–65), by or after.
Girl with Doves (Z); marble, H. 18⅛ in.
Coll.: George J. Gould. *Acq.:* 1927, (27.88).

Boy with Grapes (Z); marble, H. 17⅛ in.
Coll.: George J. Gould. *Acq.:* 1927, (27.87).

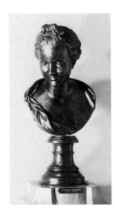

(27.97)

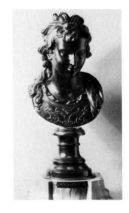

(27.98)

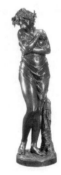

(27.26)

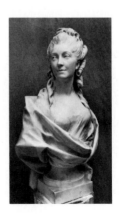

(27.92)

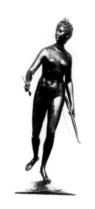

(27.186)

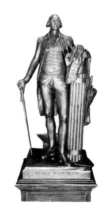

(24.12)

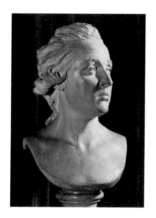

(27.82)

(27.88)

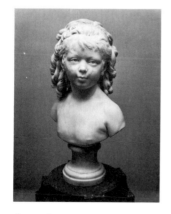

(27.95)

(27.87)

Lemoyne, Jean-Baptiste (1704–78), by or after.
Flore-Baigneuse (Z); marble, H. 29¾ in.
Acq.: 1927, (27.90).

Monnot (Monot), Martin-Claude (1733–1803).
Bacchante (Z); marble, H. 20¼ in.
Coll.: George J. Gould. *Acq.:* 1927, (27.86).

Pigalle, Jean-Baptiste (1714–85).
Child with Bird Cage (C); bronze, H. 18¾ in., signed
and dated 1749. *Acq.:* 1911, (11.39). A marble,
atelier version of this figure, the bird cage missing,
is in the Arabella Huntington Memorial Collection,
acquired 1927, (27.83).

Child with Bird and Apple (C); bronze, H. 17½ in.,
signed and dated 1784. *Acq.:* 1911, (11.40).

Vasse, Louis-Claude (1716–72)
Bust of a Boy (S); marble, H. 19 in.
Coll.: Paul Dutasta *Acq.:* 1978 (Adele S. Browning
Memorial Collection), (78.20.51)

Bust of a Girl (S); marble, H. 18½ in. signed.
Coll.: Joseph E. Widener *Acq.:* 1978 (Adele S.
Browning Memorial Collection), (78.20.52).

(27.90)

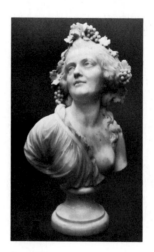

(27.86)

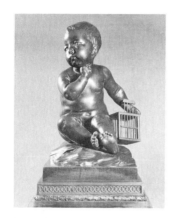

(11.39)

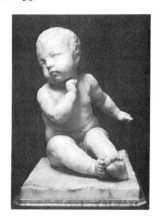

(27.83)

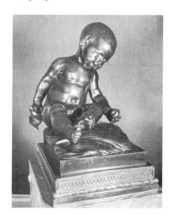

(11.40)

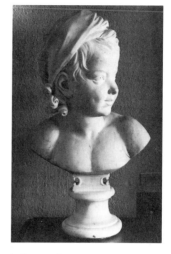

(78.20.51)

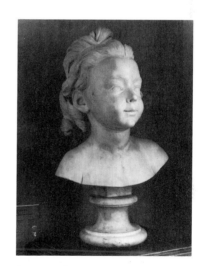

(78.20.52)

LATER FRENCH SCULPTURE

Barye, Antoine-Louis (1796–1875)
Mounted Arab Killing a Lion
Bronze; H 14½ in.; signed
Acq.: 1911, (11.13).

Carrier-Belleuse, Albert Ernest (1824–87)
John Milton
Bronze; H 22 in.
Acq.: 1925, (25.11).

Charpentier, Alexandre (1856–1909)
Nursing Mother
Bronze relief; 46 x 33½ in.
Acq.: 1910, (10.148).

David d'Angers, Pierre Jean (1788–1856) by or after
George Washington
Marble; head and shoulders; H. 33½ in. (with base)
Acq.: 1919, (19.5).

Itasse, Adolphe (1830–93)
Frightened Baby (U); marble, H 18 in.
Acq.: 1978 (Adele S. Browning Memorial Collection), (78.20.53).

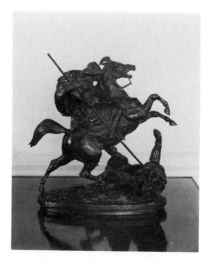

(11.13)

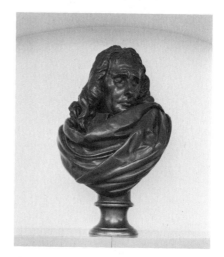

(25.11)

104

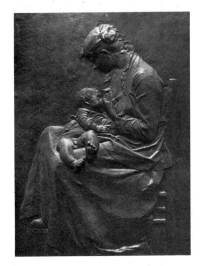

(10.148)

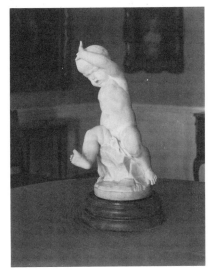

(78.20.53)

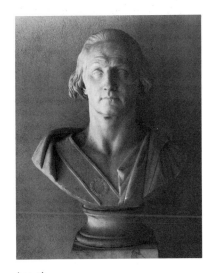

(19.5)

105

FRENCH DECORATIVE ART

The FRENCH FURNITURE and decorative art in the Huntington collection is mostly from the eighteenth century, and comprises one of the finest ensembles of this sort of material to be found in America. It is interesting that Mr. and Mrs. Huntington should have lavished such care on this part of their collection when the English furniture is much more routine and utilitarian in character. It is also interesting that the French furniture, most of which is from the late 1700s, is closer in date than the English furniture to the great group of British paintings in the gallery.

Probably at no time in history has more skill and genuine artistry gone into the design and construction of fine furniture than in France during the half century before the revolution. All the crafts concerned with the decorative arts, and especially furniture making, tapestry weaving, and porcelain manufacture, were extensively patronized by the court and aristocracy. Time and money were no object in the production of these articles; the artistic demands of the patrons were very high, and the quality of the finished product is nearly always splendid. We know, for instance, from the records of the factories weaving the tapestries of the period, that a craftsman would be working at a normal rate if he took a year to weave a square yard of a complicated passage. The manufacture of a major piece of furniture or the decorating of an important object of porcelain proceeded at a comparable speed.

The guild system concerned with the making of furniture became particularly complicated, with often as many as a half-dozen specialists being involved in supplying the marquetry, bronze mounts, gilding, and painting appearing on a single object. During the latter part of the century it was also customary for the craftsman responsible for the object as a whole to stamp it in some inconspicuous place with a metal die that gave his name or initials. By this means we can often tell who made a given piece—a possibility that is rare at other times in the history of furniture.

A more elaborate system of marking prevailed for porcelain made at the Sèvres factory. The painted symbols that frequently occur on the bottom of one of these objects will confirm not only the factory, but also indicate the year of manufacture and the various decorators concerned. There was frequently more than one artist if different types of painting and gilding were required.

The talents of some of the major artistic figures of the time were involved in the production of these decorative objects, and the designs accordingly are an accurate index to the shifting tastes of the period. In particular, it is possible to follow in considerable detail the gradual transformation of the elaborate, curvilinear, "rococo" style of the mid-eighteenth century into the much more restrained and rectilinear "neo-classic" style of the years immediately preceding the revolution. This evolution is clearly apparent in the series of large library tables (bureaux plats) and chests (commodes) in the Huntington collection.

A fully-illustrated catalog on the French decorative art in the Huntington collections is available at the Bookstore.

TAPESTRIES AND FABRICS

Five Hangings from "Italian Village Scenes" (Y); designed by François Boucher; woven at the Beauvais factory, mid-eighteenth century.

The Quack Doctor and *The Peep Show,* 8 ft. 11½ in. by 16 ft. 2½ in. (Woven as one hanging.)

The Fortune Teller, 8 ft. 9 in. by 6 ft. 11½ in.

The Hunters and *Girls with Grapes,* 8 ft. 9 in. by 6 ft. 11½ in. (Woven as one hanging.)

The Fisher Maid, 8 ft. 9 in. by 6 ft. 11½ in.

The Luncheon, 8 ft. 9 in. by 6 ft. 11½ in. *Acq.:* the last four in 1920, the first in 1927, (20.5,6,7,8, and 27.127).

Five Hangings from *The Noble Pastoral* (A); designed by François Boucher; woven at the Beauvais factory, mid-eighteenth century.

The Fountain of Love, 10 ft. 10 in. by 19 ft. 3½ in.

The Bird Catchers, 10 ft. 10 in. by 19 ft.

The Luncheon, 10 ft. 10 in. by 11 ft.

The Flute Player, 10 ft. 10 in. by 12 ft. 4 ½ in.

The Fisherman, 10 ft. 10 in. by 12 ft. 2½ in.
Coll.: Earl Somers, Rodolphe Kann. *Acq.:* 1909, (09.1,2,3,4,5).

Floral Tapestry Panel (A); 29 by 23 in.; woven at the Gobelins factory, mid-eighteenth century.
Coll.: Florence M. Quinn. *Acq.:* 1944 (bequest of Florence M. Quinn), (44.112).

Tapestry Fire Screen (A); 36 by 45 in.; designed by François Boucher; woven at the Gobelins or Beauvais factories, mid-eighteenth century.
Coll.: Mme d'Yvon; Chauchard. *Acq.:* 1909, (09.32).

Set of Tapestries for Ten Chairs and Two Settees (A); designed by François Boucher and Jean-Baptiste Oudry; woven at the Gobelins factory, mid-eighteenth century. The chair frames are nineteenth century.
Coll.: Mme d'Yvon; Chauchard. *Acq.:* 1909, (09.20–31).

Two Carpets (A); 15 ft. 8 in. by 26 ft. 8 in. and 16 ft. 8 in. by 24 ft. 8 in.; woven at the Savonnerie factory, late seventeenth century. Part of a series for the Grande Galerie of the Louvre.
Coll.: Charles J. Wertheimer; J. Pierpont Morgan. *Acq.:* 1915, (15.2&3).

Sixfold Screen (A); each panel 69½ by 24 in.; probably designed by Alexandre-François Desportes; woven at the Savonnerie factory, mid-eighteenth century. The frame is nineteenth century.
Coll.: Duke of Sutherland; Charles J. Wertheimer. *Acq.:* 1911, (11.41).

Wallpaper (French; manufactured by Joseph Dufour c. 1798)
The Journeys of Antenor (divided arbitrarily into six panels). Acq.: 1944 (gift of Florence M. Quinn), (44.123)

(09.3)

(09.20–31)

(11.41)

107

FURNITURE

Library Table (A); L. 74 in. W. 35 in. H. 30¼ in.;
veneered with purplewood; ormolu mounts; early
eighteenth century.
Coll.: De Farve. *Acq.:* 1925, (25.12).

Library Table (A); L. 70½ in. W. 33 in. H. 31 in.;
veneered with purplewood; ormolu mounts;
surmounted by a cartonnier; first half of the
eighteenth century.
Coll.: Comte de la Riboisière. *Acq.:* 1911, (11.27).

Library Table (Y); L. 69½ in. W. 36½ in. H. 29½
in.; veneered with kingwood and tulipwood; ormolu
mounts; manner of Charles Cressent; second quarter
of the eighteenth century.
Coll.: L. Neumann. *Acq.:* 1927, (27.18).

Library Table (A); L. 77 in. W. 39 in. H. 32 in.;
marquetry of kingwood; ormolu mounts; attributed
to Charles Cressent; second quarter of the
eighteenth century. *Acq.:* 1913, (13.04).

Library Table (A); L. 62 in. W. 31¾ in. H. 32½
in.; veneered with kingwood; ormolu mounts and
porcelain plaques; stamped: Joseph (mid-eighteenth
century).
Coll.: Duke of Buccleuch. *Acq.:* 1927, (27.137).

Library Table (X); L. 62½ in. W. 32 in. H. 30¼
in.; veneered with kingwood; ormolu mounts and
porcelain plaques; stamped: Joseph and C. C.
Saunier (third quarter of the eighteenth century).
Coll.: Alfred de Rothschild; Lady Carnarvon.
Acq.: 1927, (27.132).

Library Table (C); L. 63½ in. W. 38½ in. H. 30¼
in.; veneered with purplewood; ormolu mounts;
stamped: P. Garnier; third quarter of the eighteenth
century.
Coll.: Comtesse de Terray. *Acq.:* 1911, (11.28).

Library Table (W); L. 59½ in. W. 32½ in. H. 31½
in.; veneered with kingwood and satinwood; ormolu
mounts; early nineteenth century. *Acq.:* before
1915, (14.19).

108

Chest (R); L. 52½ in. W. 25 in. H. 33 in.; marquetry
of kingwood; ormolu mounts; second quarter of the
eighteenth century. *Acq.:* 1978 (Adele S.
Browning Memorial Collection), (78.20.61).

Chest (Y); L. 64 in. W. 29 in. H. 35½ in.; marquetry
of kingwood, tulipwood, boxwood, and sycamore;
ormolu mounts; stamped: J. Schmitz; mid-
eighteenth century.
Coll.: Mrs. Barnard. *Acq.:* 1927, (27.124).

Chest (Y); L. 66 in. W. 29 in. H. 34½ in.; marquetry
of kingwood, tulipwood, boxwood, and sycamore;
ormolu mounts; attributed to J. Schmitz; mid-
eighteenth century.
Coll.: Alfred de Rothschild; Lady Carnarvon.
Acq.: 1927, (27.118).

Chest (R); L. 50 in. W. 25½ in. H. 36 in.; marquetry
of various woods; ormolu mounts; mid-eighteenth
century style.
Coll.: Stanley Mortimer *Acq.:* 1978 (Adele S.
Browning Memorial Collection), (78.20.60).

Chest (U); L. 59 in. W. 26 in. H. 35¼ in.; marquetry
of various woods; stamped: P. A. Foulet.; third
quarter of the eighteenth century.
Coll.: Comte Henri de Greffulhe; Duchesse de
Gramont; Mrs. M. Ballock. *Acq.:* 1978 (Adele S.
Browning Memorial Collection), (78.20.57).

Chest (S); L. 48½ in. W. 21 in. H. 33¾ in.;
marquetry of various woods; ormolu mounts;
stamped: P. Garnier; third quarter of the eighteenth
century. *Acq.:* 1978 (Adele S. Browning Memorial
Collection), (78.20.58).

Chest (U); L. 48½ in. W. 20 in. H. 32¾ in.;
marquetry of various woods; ormolu mounts;
stamped: J. L. Cosson; third quarter of the
eighteenth century.
Acq.: 1978 (Adele S. Browning Memorial
Collection), (78.20.59).

Chest; L. 42 in. W. 18 in. H. 37 in.; marquetry of
various woods; ormolu mounts; late eighteenth
style, but probably made in the nineteenth century.
Coll.: Baron Max von Goldschmidt-
Rothschild *Acq.:* 1978 (Adele S. Browning
Memorial Collection), (78.20.62).

(25.12)

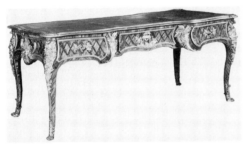

(27.18)

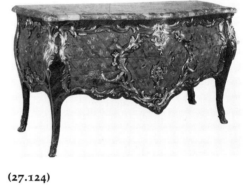

(27.124)

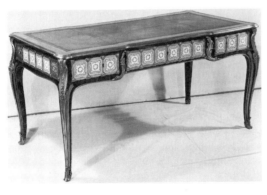

(27.132)

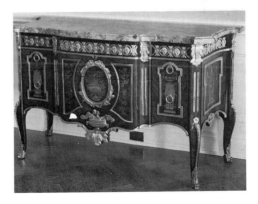

(78.20.57)

109

Chest (Y); L. 56½ in. W. 24 in. H. 34½ in.; marquetry of tulipwood, rosewood, sycamore, and other woods; ormolu mounts; stamped: F. Rubestuck; third quarter of the eighteenth century. *Coll.*: E. Cronier; George A. Kessler. *Acq.*: 1927, (27.103).

Chest (Y); L. 56½ in. W. 23 in. H. 34½ in.; marquetry of tulipwood, rosewood, sycamore, and other woods; ormolu mounts; stamped [partially obliterated]: Paul P. Charpentier; third quarter of the eighteenth century. *Acq.*: 1927, (27.104).

Chest (C); L. 57½ ins. W. 23¼ in. H. 34½ in.; marquetry of mahogany, tulipwood, satinwood, and purplewood; ormolu mounts; stamped: D. De. Loose; overstamped: J. H. Riesener; third quarter of the eighteenth century.
Coll.: Robert Kirkman Hodgson. *Acq.*: 1911, (11.26).

Chest (C); L. 60 in. W. 23¾ in. H. 39 in.; marquetry of tulipwood and purplewood; ormolu mounts; stamped: M. Carlin; late eighteenth century.
Coll.: Charles J. Wertheimer. *Acq.*: 1911, (11.31).

Chest (C); L. 56½ in. W. 24 in. H. 45 in.; veneered with mahogany and ebony; ormolu mounts; porcelain plaques; c. 1800. *Acq.*: before 1910, (10.3).

Secretary (S); L. 38½ in. W. 15½ in. H. 57 in.; marquetry of various woods; ormolu mounts; third quarter of the eighteenth century.
Coll.: Edouard, marquis de Colbert *Acq.*: 1978 (Adele S. Browning Memorial Collection), (78.20.63).

Secretary (C); L. 36 in. W. 15 in. H. 52½ in.; marquetry of tulipwood and purplewood; ormolu mounts; stamped: M. Carlin; late eighteenth century.
Coll.: Charles J. Wertheimer. *Acq.*: 1911, (11.32).

Secretary (Y); L. 34 in. W. 16½ in. H. 56 in.; marquetry of tulipwood, kingwood, sycamore, and boxwood; porcelain plaques; stamped Molitor; late eighteenth century.
Coll.: Alfred de Rothschild. *Acq.*: 1927, (27.22).

Secretary (Y); L. 31 in. W. 16½ in. H. 52 in.; ebony with inlay of Japanese gold-lacquer panels; attributed to Adam Weisweiler; late eighteenth century. *Acq.*: 1927, (27.21).

Writing Desk with Cylinder Front (Y); L. 38 in. W. 21 in. H. 39 in.; marquetry of tulipwood, fiddleback sycamore, boxwood, and other woods; ormolu mounts; porcelain plaques; stamped: J. F. Leleu; third quarter of the eighteenth century. *Acq.*: 1927, (27.128).

Small Upright Writing Cabinet (Y); L. 18½ in. W. 13 in. H. 39¼ in.; marquetry of tulipwood, purplewood, boxwood, and other woods; ormolu mounts; possibly by Pierre Roussel; third quarter of the eighteenth century.
Coll.: Mrs. Wyndham Baring. *Acq.*: 1927, (27.101).

Small Work Table (Y); L. 12 in. W. 9½ in. H. 28½ in.; marquetry of tulipwood and boxwood; ormolu mounts; stamped: L. Peridiez; third quarter of the eighteenth century. *Acq.*: 1927, (27.19).

Music Stand (Y); L. 13¾ in. W. 10¼ in. H. 30¼ in.; veneered with tulipwood; ormolu mounts and porcelain plaques; attributed to Martin Carlin; late eighteenth century.
Coll.: Kings of Saxony. *Acq.*: 1927, (27.20).

Writing Table (A); L. 37 in. W. 18 in. H. 27½ in.; marquetry of kingwood, tulipwood, coromandel wood, and other woods; ormolu mounts; possibly by Jean-Francois Oeben; third quarter of the eighteenth century.
Coll.: Lord W. Talbot Kerr. *Acq.*: 1927, (27.185).

Small Writing Table (Y); L. 23¾ in. W. 15¾ in. H. 26¼ in.; marquetry of satinwood and sycamore; ormolu mounts; possibly by M. G. Cramer; late eighteenth century.
Coll.: Sir John Murray Scott; Alfred Wertheimer. *Acq.* 1927, (27.108).

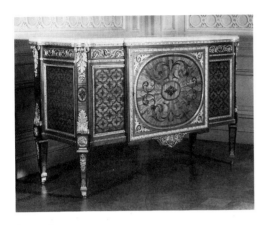

(11.31)

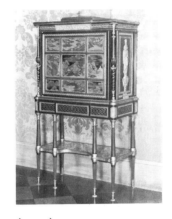

(27.21)

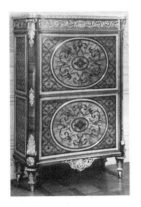

(11.32)

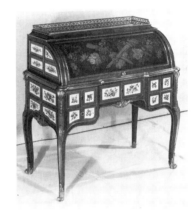

(27.128)

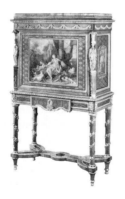

(27.22)

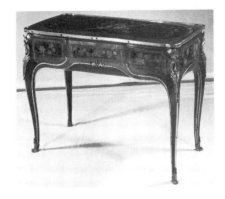

(27.185)

Pair of Small Writing Tables (Y); L. 26¼ in. W. 15¾ in. H. 31¾ in.; veneered with tulipwood; ormolu mounts; porcelain plaques; stamped: M. Carlin; third quarter of the eighteenth century. *Acq.: 1927, (27.121 & 122).*

Small Table (T); L. 27½ in. W. 15½ in. H. 29 in.; marquetry of various woods; ormolu mounts; stamped: MIGEON; mid-eighteenth century. *Coll.:* Duke of Leeds *Acq.: 1978 (Adele S. Browning Memorial Collection), (78.20.66).*

Small Table (R); L. 29½ in. W. 14½ in. H. 28½ in.; marquetry of various woods; mid-eighteenth century. *Acq.: 1978 (Adele S. Browning Memorial Collection), (78.20.67).*

Small Table (S); L. 12¾ in. W. 10½ in. H. 28¼ in.; marquetry of various woods; ormolu mounts; stamped: L. BOUDIN.; third quarter of the eighteenth century.
Coll.: Paul Dutasta; George Blumenthal; James W. Barney *Acq.: 1978 (Adele S. Browning Memorial Collection), (78.20.65).*

Small Table with Sèvres Top (S); L. 14 in. W. 11¾ in. H. 28¼ in.; marquetry of various woods; ormolu mounts; the Sèvres tray bears the date letter for 1761, and appears to be genuine. The rest of the piece probably dates from the nineteenth century.
Coll.: Charles Louis; Otto Kahn *Acq.: 1978 (Adele S. Browning Memorial Collection), (78.20.70).*

Small Table with Tambour Front (T); L. 20⅜ in. W. 15¼ in. H. 28½ in.; marquetry of various woods; ormolu mounts; third quarter of the eighteenth century.
Coll.: Earl of Lichfield *Acq.: 1978 (Adele S. Browning Memorial Collection), (78.20.69).*

Small Table with Tambour Front (T); L. 21 in. W. 15½ in. H. 29 in.; marquetry of various woods; Ormolu mounts; third quarter of the eighteenth century; stamped: N. PETIT. *Acq.: 1978 (Adele S. Browning Memorial Collection), (78.20.68).*

Small Lean-to Secretary (S); L. 27 in. W. 15½ in. H. 34 in.; marquetry of various woods; mid-eighteenth century. *Acq.: 1978 (Adele S. Browning Memorial Collection), (78.20.64).*

Writing Table (A); L. 31¾ in. W. 17 in. H. 27¾ in.; marquetry of satinwood, purplewood, sycamore, ebony, holly, and tulipwood; ormolu mounts; stamped: B. Molitor; late eighteenth century.
Coll.: Oppenheim (?). *Acq.: 1916. (16.12).*

Small Tier Table (D); L. 18⅝ in. W. 12 in. H. 27¾ in.; mahogany; stamped: Gamichon; c. 1800.
Coll.: Kate Van Nuys Page. *Acq.: 1966 (bequest of Kate Van Nuys Page), (66.63).*

Console Table (Y); L. 51 in. W. 18½ in. H. 34¾ in.; mahogany; ormolu mounts; stamped: J. H. Riesener; late eighteenth century.
Coll.: Demidoff; George J. Gould. *Acq.: 1927, (27.100).*

Set of Four Chairs (R); covered with tapestry; H. 38½ in.; mid-eighteenth century. *Acq.: 1978 (Adele S. Browning Memorial Collection), (78.20.71A,B,C,D).*

Pair of Small Chairs (C); covered in modern silk; H. 31¼ in. third quarter of the eighteenth century; stamped: J. DELAUNAY. *Acq.: 1966 (bequest of Kate Van Nuys Page), (66.65).*

Pair of Chairs (T); covered in tapestry; H. 36 in.; late eighteenth century. *Acq.: 1978 (Adele S. Browning Memorial Collection), (78.20.72A & B).*

Mantel Clock (C); H. 24½ in.; late eighteenth century. *Acq.: 1927, (27.182).*

Mantel Clock (A); H. 21 in.; maker: Philibert (Pont St. Michel à Paris); c. 1800. *Acq.: 1910, (10.107).*

Mantel Clock (U); H. 15 in.; maker: Cronier; late eighteenth century. *Acq.: 1978 (Adele S. Browning Memorial Collection), (78.20.74).*

Mantel Clock (R); H. 15 in.; maker: Le Paute; late eighteenth century. *Acq.: 1978 (Adele S. Browning Memorial Collection), (78.20.73).*

Mantel Clock (R): H. 13¾ in.; maker: Maniere; about 1800. *Acq.: 1978 (Adele S. Browning Memorial Collection), (78.20.75).*

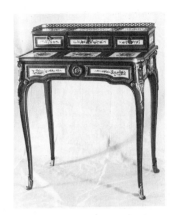

(27.121)

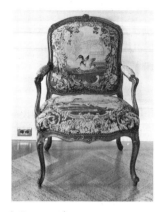

(78.20.71A)

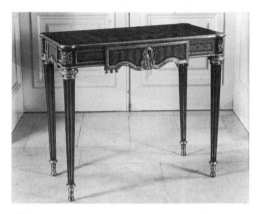

(16.12)

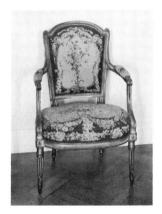

(78.20.72A)

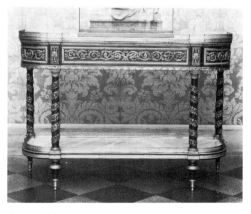

(27.100)

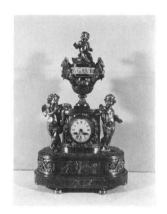

(27.182)

Mantel Clock (D); H. 25 in.; decorated with porcelain plaques and miniature portrait of a bishop; maker: N. Sotiau; works dated May 1783.
Coll.: J. Pierpont Morgan. *Acq.:* 1927, (27.110).

Mantel Clock in the Form of the Graces Supporting a Globe (T); H. 21 in.; maker: Louis Montjoy; late eighteenth century.
Coll.: J. Pierpont Morgan. *Acq.:* 1927, (27.113).

Mantel Clock (Y); H. 14½ in.; maker: Lepaute Hger du Roi; late eighteenth century.
Coll.: J. Pierpont Morgan. *Acq.:* 1916, (16.9).

Mantel Clock (Y); H. 16½ in.; maker: Roque à Paris; late eighteenth century.
Coll.: Vicomte de Saint-Seine. *Acq.:* 1927, (27.102).

Mantel Clock (C); H. 22¼ in.; maker: E. P. Guydamour; late eighteenth century.
Coll.: Rosa Peterson *Acq.:* 1974 (gift of Rosa Peterson), (74.05).

Wall Clock and Thermometer; H. 44 in.; maker: Gilles Lainé à Paris; third quarter eighteenth century. *Acq.:* before 1911, (11.12).

Pair of Four-light Candelabra (Y); H. 55 in.; white marble and ormolu; the figures after models by Lorta; c. 1800.
Coll.: J. Pierpont Morgan. *Acq.:* 1927, (27.106 & 107).

Pair of Five-light Candelabra (Y); H. 50 in.; bronze and ormolu; the figures after models by Clodion; late eighteenth century.
Coll.; George J. Gould. *Acq.:* 1927, (27.119 & 120).

Four Candlesticks (A and C); H. 11¾ in.; ormolu; stamped: Martincourt; late eighteenth century.
Acq.: 1927, (27.133–136).

Pair of Eight-light Candelabra (C); H. 38 in.; marble and ormolu; manner of Pierre Gouthière; late eighteenth century, (27.111 & 112). *Acq.:* 1927.

Pair of Three-light Candelabra (D); H. 33 in.; porcelain and ormolu; late eighteenth century.
Coll.: Ponsonby. *Acq.:* 1913, (13.17 & 18).

Pair of Three-light Candelabra (C); H. 27 in.; ormolu and enameled bronze; late eighteenth century. *Acq.:* 1927, (27.183 & 184).

Pair of Six-light Candelabra (C); H. 37½ in.; ormolu and enameled bronze; possibly by Pierre Gouthière.
Coll.: Alfred de Rothschild. *Acq.:* 1927, (27.180 & 181).

Pair of Three-light Candelabra (Y); H. 23 in.; Meissen porcelain bitterns modeled by J. J. Kaendler in 1753; set in French gilt bronze candelabra.
Coll.: George J. Gould. *Acq.:* 1927, (27.116 & 117).

Pair of Three-light Candelabra (T); H. 27 in.; ormolu and marble; late eighteenth century. *Acq.:* 1978 (Adele S. Browning Memorial Collection), (78.20.77).

Pair of Vases (R); H. 17⅝ in.; marble and ormolu; late eighteenth century.
Acq.: 1978 (Adele S. Browning Memorial Collection), (78.20.76).

Vase (C); H. 16¼ in.; Chinese celadon vase of double gourd shape set in French ormolu mounts; mounts of mid-eighteenth-century date.
Coll.: Bernal; Octavius Coope. *Acq.:* 1911, (11.14).

Pair of Vases (C); H. 20¼ in.; Nevers faïence, with ormolu mounts; late eighteenth century.
Coll.: Nathaniel de Rothschild; Arthur de Rothschild; Mme C. Lelong; Larcade; E. M. Hodgkins. *Acq.:* 1927, (27.23 & 24).

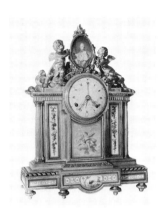

(27.110)

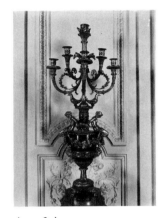

(27.180)

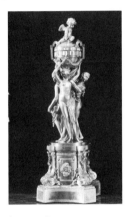

(27.113)

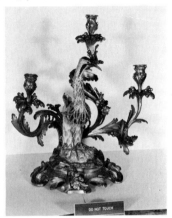

(27.116)

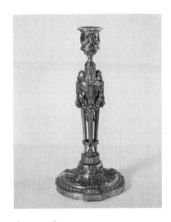

(27.133)

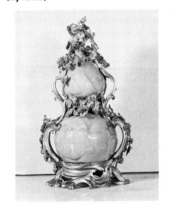

(11.14)

SÈVRES PORCELAIN

The porcelain factory at Sèvres, near Paris, was for the first sixteen years of its existence (1740–56) located at Vincennes. It was moved to Sèvres in 1756 and has been in continuous operation there to this day. In 1759, through the promptings of the marquise de Pompadour, the factory became royal property. The early wares were of soft paste, in contrast to true porcelain, or hard paste, first made there in 1769. Both soft and hard pastes were produced at Sèvres until 1800, when the soft paste was abandoned.

The Sèvres factory was noted for its ground colors, such as the *bleu de roi,* a deep blue with a purple tinge; *bleu céleste,* a turquoise blue; *vert pomme,* apple green; and *rose pompadour* (often wrongly called *rose du Barry*)— all of which are represented here. The output of the factory was of excellent quality and extremely varied. The porcelain figures were among the finest produced in the eighteenth century. Ornamental and domestic wares were usually lavishly decorated in colors and gold. Many of the pieces in this collection are of elaborate rococo design; however, classical remains excavated in southern Italy shortly after the middle of the century had a profound effect on the designs used at Sèvres, and as a result the shapes and ornaments became more restrained. That phase of production is also illustrated. The Sèvres ware shown here is of soft paste and dates from the eighteenth century. All the porcelain described is in the French Porcelain Room (X) unless otherwise noted.

Case I

Set of Three Vases; *bleu de roi* ground; unmarked, probably about 1780; H. 18 in. and 15½ in.
Coll.: Alfred de Rothschild; Lady Carnarvon, (27.138,139,140).

Case II, Top Shelf

Jardinieres, a pair; *rose-pompadour* ground; unmarked, probably late 1750s; H. 6¾ in.
Coll.: George J. Gould, (27.51 & 52).

Porringer and Stand; *rose-pompadour* ground; decorated by Vieillard in 1759; porringer, H. 5 in.; stand, L. 12¼ in.
Coll.: Duke of Leeds, (27.53).

Middle Shelf

Two Plates; *rose-pompadour* ground; probably about 1755; Diam. 10 in., (27.54a & 27.55a).

Tray; *rose-pompadour* ground; decorated by Vieillard in 1757; L. 12¾ in. W. 10¼ in., (27.56).

Covered Cup; *rose-pompadour* ground; 1757; H. 5 in.
Coll.: George J. Gould, (27.57).

Bottom Shelf

Two Plates; *rose-pompadour* ground; left, 1775; right, 1776; Diam. 9⅝ in.
Coll.: George J. Gould, (27.58 & 59).

Porringer and Stand; *rose-pompadour* ground; 1758; porringer, H. 4½ in.; stand, L. 8¾ in., (27.60).

Case III

Vases, a pair; turquoise ground; unmarked, probably about 1765; H. 13½ in.
Coll.: Duc de Gramont, (27.129 & 130).

Vase; turquoise ground; unmarked, probably about 1770; H. 17 in.
Coll.: Duc de Gramont, (27.131).

Case IV

Vases, a set of three; pale-rose ground enriched with jeweling; probably about 1780; H. 16½ in. and 13 in.
Coll.: Alfred de Rothschild; Lady Carnarvon. (27.34,35,36).

Case V, Top Shelf

Fan-shaped Vases, a pair; *bleu de roi* ground; decorated by Thévenet *père* in 1758; H. 7½ in. *Coll.:* Earl Home, (27.42 & 43).

Vase with compartments; *bleu de roi* ground; decorated by Dodin in 1759; H. 5¾ in., (27.44).

Middle Shelf

Fan-shaped Vases, a pair; apple-green ground; decorated by Thévenet *père* in 1759; H. 8¾ in. *Coll.:* Earl Home, (27.45 & 46).

Rectangular Vase; apple-green ground; probably about 1765; H. 5¾ in., (27.47).

Bottom Shelf

Vases, a pair; *bleu de roi* ground; left, decorated by Dodin in 1759; right, decorated by Morin in 1762; H. 4¾ in., (27.48 & 49).

Case VI

Vases, a pair; *bleu de roi* ground; 1774; H. 13 in., (27.38 & 39).

Vase; *bleu de roi* ground; probably about 1775; H. 12 in., (27.40).

Case VII

Vases, a pair; Meissen, mid-eighteenth century; French ormolu mounts of the same period; H. 14¼ in. *Coll.:* Mme C. Lelong; George J. Gould, (27.25 & 26).

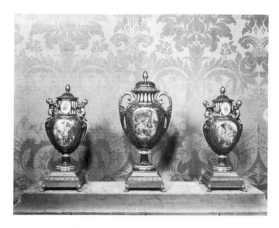

(27.138–140)

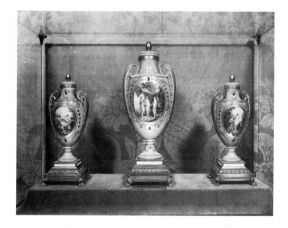

(27.34–36)

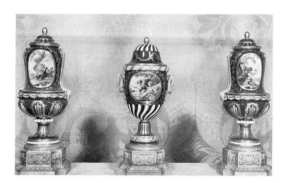

(27.38–40)

Case VIII, Top Shelf

Fan-shaped Vases, a set of three; *bleu de roi* ground; side vases decorated by Vieillard in 1759; center vase unmarked; H. 8¾ and 7½ in.
Coll.: George J. Gould, (27.63,64,65).

Middle Shelf

Vases, a pair; turquoise ground; possibly about 1760; H. 12½ in.
Coll.: George J. Gould, (27.66 & 67).

Vase with cover and ormolu mounts; turquoise ground; decorated by Binet in 1775; H. 10¾ in., (27.70).

Bottom Shelf

Vases, a pair; turquoise ground; probably about 1775; H. 10 in., (27.68 & 69).

Vase; turquoise ground; late eighteenth century; H. 13¼ in., (27.71).

Case IX

Vases, a set of three; turquoise ground; probably about 1762; H. 14 in. and 11 in.
Coll.: Alfred de Rothschild; Lady Carnarvon, (27.27,28,29).

Cases X and XII

Two Vases; *bleu de roi* ground; probably about 1770; H. 18½ in., (27.33A & B).

Case XI, Top Shelf

Two Dishes; *rose-pompadour* ground; decorated by Vieillard in 1761; Diam. 8¼ in., (27.75 & 76).

Porringer and Stand; *rose-pompadour* ground; decorated by Thévenet *père* in 1757; porringer, H. 4¾ in., stand. L. 11¼ in., (27.73).

Middle Shelf

Two Plates; *rose-pompadour* ground; left, decorated by Noel in 1775; right, decorated by Taillandier about the same date; Diam. 9½ in., (27.79 & 80).

Tray; *rose-pompadour* ground; decorated by Vieillard in 1757; L. 11⅝ in. W. 9¼ in., (27.78).

Covered Cup; *rose-pompadour* ground, decorated by Tandart *jeune* in 1757; H. 5 in., (27.77).

Bottom Shelf

Two Plates; *rose-pompadour* ground; probably about 1755; Diam. 10 in., (27.54b & 27.55b).

Ewer and Basin; *rose-pompadour* ground; no painted marks; ewer, H. 6½ in., basin, L. 10½ in., (27.81).

Case XIII (on Table)

Vase; *bleu de roi* ground; probably about 1770; H. 19 in., (27.30).

Set of Three Vases (Y); marbled rose ground; decorated by Morin in 1758; H. 19 in. and 20 in., (27.31, 32, 37).

Pair of Vases; *bleu de roi* ground; decorated by Dodin in 1767; H. 17 in., (23.27 & 28).

Pair of Vases (A); *gros-bleu* ground; ormolu mounts; no marks; H. 17½ in., (13.19 & 20).

Cupid Warning (R); Sevres biscuit; modeled by Bulidon after Falconet; base decorated by Micaud in 1760; H. 12⅜ in. including base.
Coll.: E. M. Hodgkins; Mrs. Henry Walters
Acq.: 1978 (Adele S. Browning Memorial Collection), (78.20.56).

Medallion of Benjamin Franklin (G); Sevres biscuit; Diam. 3½ in.
Coll.: F. M. Philippe *Acq.:* 1961 (61.2).

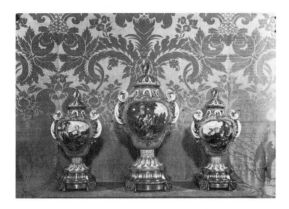

(27.27–29)

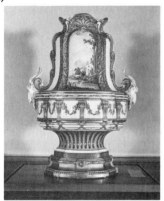

(27.37)

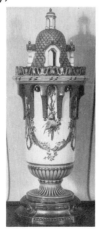

(27.31)

FRENCH SNUFFBOXES

Snuff taking became popular in Europe about the middle of the seventeenth century. Throughout the eighteenth century it was as common as smoking is today. The snuffbox therefore was an important item of a man's personal equipment. It was first made of bone, horn, or brass but in the course of time became an object of luxury. When fashioned in gold, it was variously ornamented with enamels, jewels, and miniatures. The skill of noted craftsmen was involved in its manufacture. Snuffboxes were often bestowed as formal gifts by the king and the nobility. In the eighteenth century possession of a fine collection of them was considered an indication of rank.

A woman's corresponding accessory was the sweetmeat or "comfit" box, called in France *bonbonnière*. The same artistic skill was lavished on this. It is not always distinguishable from the snuffbox but is usually somewhat larger in size. The sixteen boxes here shown are French, of the eighteenth century.

All the boxes in the collection were acquired in 1927, and are displayed in the Small Drawing Room (D).

1. Box; rectangular; gold and enamel; chased gold borders enclose panels, in enamel, of pastoral subjects after Boucher.
 Coll.: Alfred de Rothschild; Lady Carnarvon, (27.3).

2. Box; elliptical; gold and enamel; decorated with panels of mythological subjects.
 Coll.: George J. Gould, (27.4).

3. Box; elliptical; gold and enamel; strapwork design edged with jewels, in green and white enamel; on top, in grisaille, is a medallion of cupids.
 Coll.: George J. Gould, (27.5).

4. Box; rectangular; gold, with crystal-covered miniature paintings; six sides and chamfered corners are decorated with festival and theatrical scenes, presumably at Versailles, in *gouache;* signed (top, lower right) "v. Blarenberghe" (Louis-Nicolas van Blarenberghe [1716–94]).

Coll.: Alfred de Rothschild; Lady Carnarvon, (27.6).

5. Box; elliptical; gold and enamel; top, lapis enamel ground with medallion of shepherdess; border designs and festoons in two colors of gold combined with platinum.
 Coll.: Rodolphe Kann, (27.7).

6. Box; elliptical; gold and enamel; field of green translucent enamel with border designs in chased gold; miniature portrait of a man in a powdered wig, framed in a laurel wreath; engraved inside the lid: "Philip, 4th Earl of Chesterfield. Presented to Henry, 8th Duke of Beaufort, by George, 6th Earl of Chesterfield."
 Coll.: George J. Gould, (27.8).

7. Box; rectangular; gold and porcelain; porcelain panels, with a ground of turquoise blue, are mounted in a framework of chased gold; rectangular reserves, with chamfered corners, are decorated with hunting scenes and animals, called "The Hunts of Louis XV." Signed on the bezel "George à Paris."
 Coll.: Mrs. Alexander Hamilton Rice, (27.9).

8. Box; elliptical; gold and enamel; within a series of chased border designs, separated by strips of blue and white enamel, is a medallion of children playing with a goat; engraved on the bezel "du petit Duncqkerque."
 Coll.: George J. Gould, (27.10).

9. Box; circular; gold, with miniature paintings in *gouache;* border designs in two colors of gold enclose medallions of cupids playing.
 Coll.: George J. Gould, (27.11).

10. Box; rectangular; tortoise shell edged with gold, and miniature paintings in *gouache;* decorated with panels of pastoral scenes after Boucher.
 Coll.: George J. Gould, (27.12).

11. Box; rectangular; gold and enamel; engraved diaper pattern in gold, with enameled reserves of interior scenes and still-life groups.
 Coll.: Alfred de Rothschild; Lady Carnarvon, (27.13).

12. Box; rectangular; gold, miniature portraits, and enamel; borders, decorated in red and green enamel jewels with white enamel dots simulating pearls, frame miniature portraits in enamel. The subjects of the miniature portraits are famous beauties of the court of Louis XIV. They include La Duchesse de la Vallière (top center),

Mme de Maintenon (top left), and Ninon de Lenclos (right end). They were painted by Jean Petitot (1607–91), considered the greatest of all exponents of the enamel miniature-painting craft, and this group is rated among his finest productions. Although the miniatures date from the seventeenth century, the box and mountings are of the period Louis XVI.
Coll.: Marquis de la Reignière; Alfred de Rothschild; Lady Carnarvon, (27.14).

13. Box; elliptical; gold and enamel; the engraved surface is decorated in enamel with a group of children playing with a toy horse on wheels (top) and with other domestic scenes.
Coll.: George J. Gould, (27.15).

14. Box; elliptical; gold, enamel, and pearls; dark-blue translucent enamel ground, with a row of pearls set around the top; in top center is a girl with doves; this box is said to have been presented by Napoleon to a member of the Von Wybicki family of Poland, (27.16).

15. Box; elliptical; gold, enamel, and miniature paintings in *gouache;* on the top is a miniature painting of a theatrical scene featuring a woman on a tightrope; signed "v Blarenberghe" (Louis-Nicolas van Blarenberghe, 1716–94); inscribed on the bezel "donné le 3 aoust 1781 par Joseph II empereur roy des Romains à M. Laurent de Lionne directeur des canaux de Picardie."
Coll.: George J. Gould, (27.17).

16. Box; rectangular; gold and enamel; gold wrought in scroll-and-shell patterns, with reserves of seascapes in enamel.
Coll.: Alfred de Rothschild; Lady Carnarvon, (27.17A).

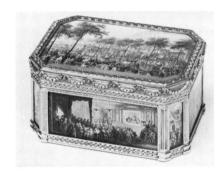

(27.6)

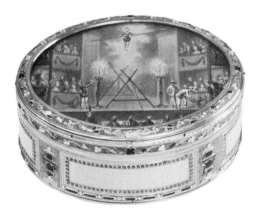

(27.17)

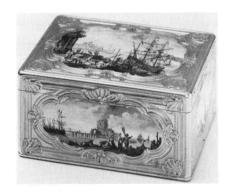

(27.17A)

121

RENAISSANCE PAINTING

THE GROUP OF fifteenth- and sixteenth-century paintings displayed in the Arabella D. Huntington Memorial Art Collection were all acquired from Mrs. Huntington's son, Archer, in 1926. They are part of the extensive art collection that Mrs. Huntington assembled in her New York residence, most of it bought during the first decade of this century when she was the widow of Collis P. Huntington, and before her marriage, in 1913, to the founder of this institution. Her collection, all of which was bequeathed to Archer Huntington, was dispersed in gifts to various museums. Several important seventeenth- and eighteenth-century European paintings were given to the Metropolitan Museum in New York; the French furniture and decorative objects were given to the California Palace of the Legion of Honor in San Francisco and the Yale University Art Gallery.

The Renaissance paintings that came to San Marino are mostly by minor masters of the period. The pictures vary considerably in importance, quality, and condition. Particularly notable are the *Madonna and Child* by Roger van der Weyden, the two portraits of a young man and woman attributed to Sebastiano Mainardi, and the large panel by an anonymous artist known as The Master of the Castello Nativity.

Unless otherwise noted, all the Renaissance paintings are displayed in the Arabella D. Huntington Memorial Art Collection, Renaissance Paintings Room (AA).

Credi, Lorenzo Di (c. 1458–1537)
Ascension of St. Louis;
Canvas: 23 in. diameter.
Coll.: Weber, (26.88).

Francia, Francesco (c. 1450–1517/8)
Madonna and Child with St. Francis and St. Anthony of Padua;
Canvas; 34 x 24 in. *Coll.:* H. Stogden (26.98).

122

Isenbrant, Adrian (1485–1551)
Flight into Egypt;
Panel: 36 x 28 in. (26.94).

Madonna and Child;
Panel: 37 x 27 in. (26.90).

Mainardi, Sebastiano (active 1495–1513), attributed to
Portrait of a Young Man;
Panel: 17 x 13 in.
Coll.: William Drury Lowe; Marchese Gherardi, (26.92).

Portrait of a Young Woman;
Panel: 18 x 13 in.
Coll.: William Drury Lowe; Marchese Gherardi, (26.89).

Master of the Castello Nativity (Florentine, end of the fifteenth century)
Madonna and Child with St. John;
Panel: 43¾ x 30½ in.
Coll.: Lord Brownlow, (26.95).

(26.88)

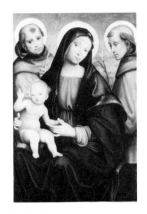

(26.98)

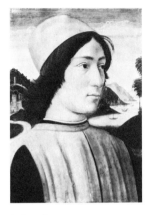

(26.92)

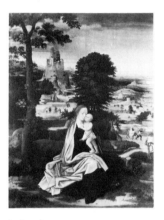

(26.94)

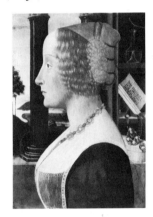

(26.89)

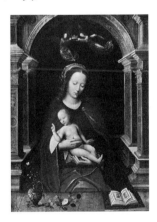

(26.90)

(26.95)

Master of the Presentation (Austrian, first half of the fifteenth century)
Way to Calvary;
Panel: 11⅜ x 11⅛ in. (26.114).

Master of the Scandicci Lamentation (Italian, early sixteenth century)
Madonna and Child with St. John;
Panel: 38½ x 39 in. (26.113)

Master of the Stratonice Panels (Sienese, fifteenth century)
Antiochus and Stratonice, two panels;
Panel: 17 x 43 in, each (26.120 & 121).

Matteo De Giovanni (active 1452–95)
Madonna and Child with St. Jerome, St. Sebastaian, and two angels;
Canvas: 22¾ x 16½ in. (26.104).

Pinturicchio (active 1481–1513)
Madonna and Child;
Panel: 19 x 15 in.
Coll.: Baron Lazzaroni (26.103).

Rosselli, Cosimo (1439–1507)
Madonna and Child with Cherubim;
Panel: 38 x 28 in. (26.100)

Weyden, Roger van der (1399 or 1400–1464)
Madonna and Child
Panel: 19½ x 12½ in.
Coll.: Henry Willett; Rodolphe Kann (26.105).

(26.114)

(26.113)

124

(26.120)

(26.121)

(26.104)

(26.103)

(26.100)

(26.105)

125

ADDITIONAL RENAISSANCE PAINTINGS NOT NORMALLY ON PUBLIC EXHIBITION

Bellini, Giovanni (1428/30–1516)
Madonna and Child
Canvas: 29¾ x 22 in. *Coll.:* Baron Lazzaroni (26.99)
Much abraded and repainted

Conti, Bernardino Dei (1450–1525)
Portrait of a Lady
Canvas: 31 x 22½ in. *Coll.:* Weber (26.97)

Flemish, possibly by Albert Cornelis (active 1500–32)
Madonna and Child
Panel: 36 x 27 in. (26.115)

Florentine School (fifteenth century)
Madonna and Child with Pomegranate
Panel: 30½ x 19 in. (26.87)

French School (?) (sixteenth century ?)
Madonna and Child
Panel: 30 x 14 in. (26.122)

Girolamo di Giovanni da Camerino (possibly by) (mid-fifteenth century)
Madonna and Child with Angels and Cherubim
Canvas: 35½ x 28 in. (26.91)

Hispano-Flemish, School of Palencia
Infant Christ in the Temple
Panel: 42 x 26½ in. (26.96)

Italian School (sixteenth century)
St Peter
Panel: 25½ x 10 in. (26.123)

Lippi, Fra Filippo, imitator of (nineteenth century?)
Madonna and Child with a Bishop
Canvas: 24½ x 19½ in. (26.102)

(26.99)

(26.97)

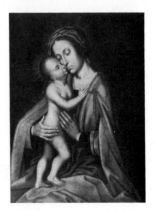

(26.115)

126

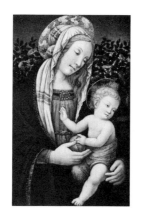

(26.87)

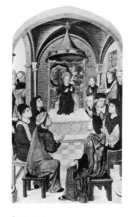

(26.96)

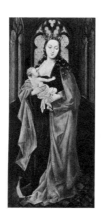

(26.122)

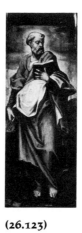

(26.123)

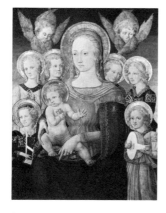

(26.91)

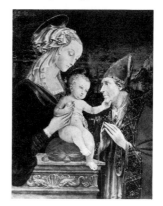

(26.102)

127

Mainardi, Sebastiano (active 1495–1513)
Madonna and Child
Panel: 31½ x 22½ in. *Coll.:* Weber (26.93)

Master of the Whittemore Madonna (Italian, fifteenth century)
Madonna and Child with St. John
Panel: 26 x 16 in. (26.112)

Pseudo Pier Francesco Fiorentino (Italian, late fifteenth century)
Madonna and Child with St. John
Panel: 28¼ x 17½ in. (26.101)

Byzantine (perhaps Dalmatian Coast, seventeenth century)
Triptych with scenes from the life of Christ
Panel: 10 x 21 in. (open) *Acq.:* before 1927 (30.1)

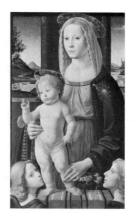

(26.93)

DUTCH AND FLEMISH SEVENTEENTH-CENTURY PAINTINGS

Laar, Pieter Van (1582–1642) attributed to
Italian Street Scene with Peasants
Canvas: 20¾ x 24¾ in. *Acq.:* 1914 (14.64).

Metsu, Gabriel (1629–67)
Pair of Portraits of the Artist and His Wife (S)
Panel: each 8½ x 7 in., rounded at top
Coll.: (?) Johan van der Marck; P. Fouquet; M. Schneider; Erich Luppert. *Acq.:* 1978 (Adele S. Browning Memorial Collection), (78.20.21 A & B).

(26.112)

Ochtervelt, Jacob (1634–82)
Lady and Maid (S)
Panel: 17⅜ x 13¼ in.
Coll.: H. M. Clark *Acq.:* 1978 (Adele S. Browning Memorial Collection), (78.20.23).

Rembrandt, Hermanszoon van Rijn (1606–69)
Lady with a Plume (S)
Panel: 25½ x 20 in. (?) Signed and dated 1636.
Coll.: Duke of Choiseul-Praslin; Koucheleff-Besborodko; Marchese Incontri; Prince of Liechtenstein *Acq.:* 1978 (Adele S. Browning Memorial Collection), (78.20.24).

(26.101)

128

(30.1)

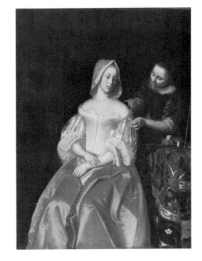

(78.20.23)

(14.64)

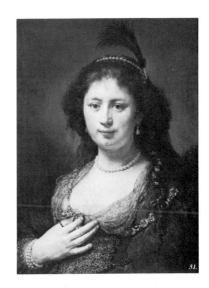

(78.20.24)

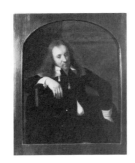

(78.20.21A)

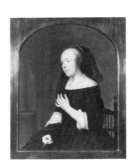

(78.20.21B)

129

Van der Neer, Aert (1603/4–77)
Moonlit Canal with a Windmill (S)
Panel: 13½ x 20¾ in. Signed with monogram.
Coll.: Lord Belper. *Acq.:* 1978 (Adele S. Browning
Memorial Collection), (78.20.22).

Van Dyck, Sir Anthony (1559–1641)
Lady of the Court of Charles I (S)
Canvas: 29 x 23 in.
Coll.: Earl of Peterborough; Mordaunt Fenwick
Bisset. *Acq.:* 1978 (Adele S. Browning Collection),
(78.20.20).

Anne Killigrew, Mrs. Kirke (1607–1641) (M)
Canvas: 87¾ x 51½ in.
Coll.: Sir Peter Lely; Earl of Kent; DeGrey; Cowper;
Lucas; Clive Pearson; Gibson. *Acq.:* 1983 (Adele
S. Browning Memorial Collection), (83.4).

Wouverman, Philip (1619–1668)
Halt of a Hunting Party (S)
Panel: 14 x 16¼ in.
Coll.: H. A. J. Munro Ferguson; Crews; S. de
Jonge. *Acq.:* 1978 (Adele S. Browning Memorial
Collection), (78.20.25).

ITALIAN EIGHTEENTH-CENTURY PAINTINGS

Bellotto, Bernardo (1720–80)
View of an Imaginary Town (T)
Canvas: 18½ x 31 in.
Coll.: Stephen Williams *Acq.:* 1978 (Adele S.
Browning Memorial Collection), (78.20.26).

Canal, Antonio, called Canaletto (1697–1768)
Two Views of Venice (T)
Canvas: each 18⅛ x 24¾ in.
Coll.: Prince of Liechtenstein *Acq.:* 1978 (Adele
S. Browning Memorial Collection), (78.20.27A &
B).

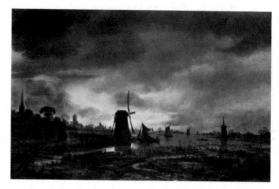

(78.20.22)

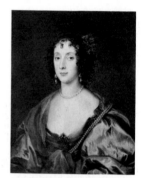

(78.20.20)

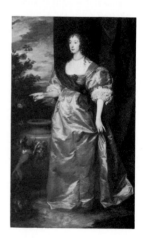

(83.4)

130

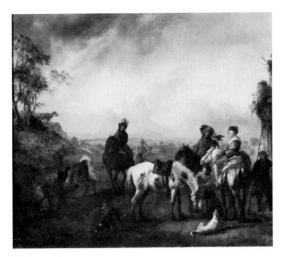

(78.20.25)

(78.20.27A)

(78.20.26)

(78.20.27B)

Studio of Canaletto
View of the Rialto Bridge (O) and *The Salute to the Head of the Canal*
Canvas: 23½ x 38 in.
Coll.: Balderston *Acq.:* 1978 (gift of John Balderston), (78.4A & B)

Carriera, Rosalba (1675–1757)
Girl with a Rabbit (Autumn) (R)
Pastel: 24¾ x 19¾ in.
Coll.: Henry Farrer; George J. Gould *Acq.:* 1978 (Adele S. Browning Memorial Collection), (78.20.28).

Guardi, Francesco (1712–93)
View of Venice (T)
Panel: 8½ x 11½ in.
Coll.: E. Gussoli *Acq.:* 1978 (Adele S. Browning Memorial Collection), (78.20.29).

Tiepolo, Giovanni Battista (1696–1770)
St. Roch (T)
Canvas: 17½ x 13 in. *Acq.:* 1909, (09.07).

(78.4A)

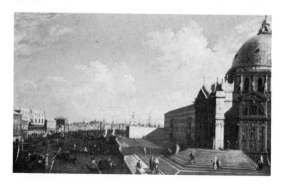

(78.4B)

(78.20.28)

(09.07)

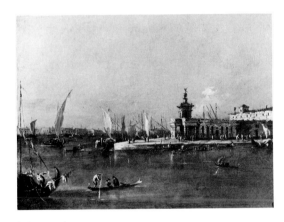

(78.20.29)

THE RENAISSANCE BRONZES form a numerically small but artistically important group within the Huntington collection. They range in date from the end of the fifteenth to the middle of the seventeenth century. Most of them were produced in Italy or by sculptors from other parts of Europe who had close contact with Italian art. The majority were acquired by Mr. Huntington in an en bloc purchase, made through the art dealer Duveen, from the great collection of Renaissance bronzes formed by J. Pierpont Morgan.

Renaissance bronzes have always had a strong appeal for the collector. They are objects for the true connoisseur, intended for intimate private study rather than display in a museum or public building. An important part of their attraction comes from the treatment of surface, and this cannot be fully appreciated unless the objects are held in the hand. Although some of the greatest Renaissance sculptors created bronze statuettes, the majority of these ingratiating little objects were made by artists whose names we no longer know.

Ammanati, Bartolomeo (1511–1592), attributed to.
Hercules (L); H. 14⅝ in.
Coll.: Vincent Astor. *Acq.:* 1927, (27.177).

Bologna, Giovanni (1529–1608).
Nessus and Deïanira (L); H. 16⅜ in. Signed on the centaur's fillet.
Coll.: Duke of Marlborough; J. Pierpont Morgan. *Acq.:* 1917, (17.13).

Crouching Venus (L); H. 9⅞ in.
Coll.: Escudier. *Acq.:* 1927. (27.174).

De Vries, Adriaen (c. 1560–1626), atelier of.
Mercury and Psyche (L); H. 23⅜ in.
Coll.: Chabrières-Arlès. *Acq.:* 1917, (17.28).

Duquesnoy, François (1594–1644), attributed to.
Mercury with Caduceus (AA); H. 25 in.
Coll.: J. Pierpont Morgan. *Acq.:* 1917, (17.22).

Mercury with Bow (AA); H. 25 in.
Coll.: J. Pierpont Morgan. *Acq.:* 1917, (17.23).

Franco-Flemish (first half of the seventeenth century).
Venus with the Apple (L); H. 14⅞ in.
Coll.: J. Pierpont Morgan. *Acq.:* 1917, (17.24).

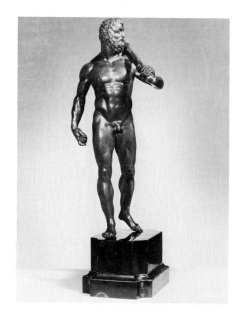

(27.177)

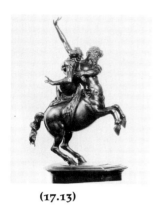

(17.13)

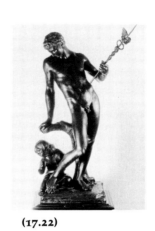

(17.22)

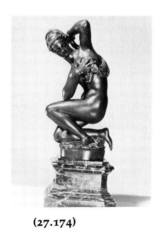

(27.174)

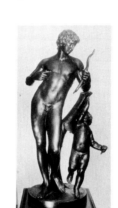

(17.23)

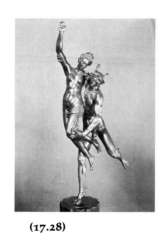

(17.28)

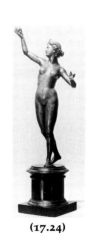

(17.24)

French (eighteenth century).
Mercury (after Coysevox) (H); H. 22¾ in.
Acq.: before 1915, (14.15).

Fame (after Coysevox) (H); H. 23¾ in.
Acq.: before 1915, (14.14).

Italian, c. 1500, circle of Tullio Lombardo.
Apollo (L); H. 15¼ in.
Coll.: Ferencz-Aurel von Pulszky; George von Rath;
J. Pierpont Morgan. *Acq.:* 1917, (17.3).

Italian (sixteenth century).
*Faun with Flute (*after the antique) (AA); H. 17¾
in.
Coll.: Sir Henry Hope Edwards; H. Sternberg; J.
Pierpont Morgan. *Acq.:* 1917, (17.6).

Italian, c. 1600, follower of Giovanni Bologna.
Venus with Cupid (L); H. 9 in.
Coll.: Maunheim; J. Pierpont Morgan. *Acq.:* 1917,
(17.14).

Italian (seventeenth century).
Wrestlers (after Giovanni Bologna) (H); H. 15¼
in. *Acq.:* 1927, (27.175).

**Italian (seventeenth century), probably
Florentine.**
Antinoüs and *Apollo,* a pair (after the antique) (M);
H. 23½ in. and 25 in., (000.112 & .113)

Italian (seventeenth century).
Venus de' Medici and *Hermes,* a pair (after the
antique) (M); H. 20 in. and 20¼ in., (000.114 &
.115)

Italian (seventeenth century [?])
Nude Warrior (AA); H. 20¾ in.
Coll.: Pfungst; J. Pierpont Morgan. *Acq.:* 1917,
(17.9).

136

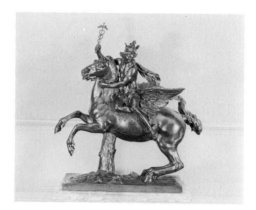

(14.15)

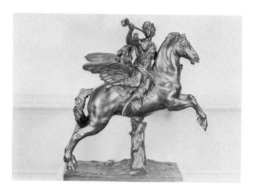

(14.14)

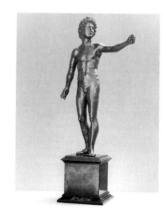

(17.3)

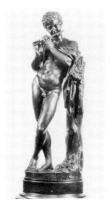

(17.6)

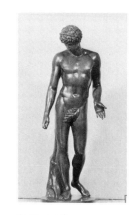

(000.112)

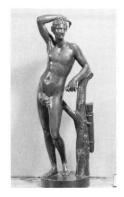

(000.113)

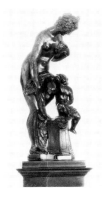

(17.14)

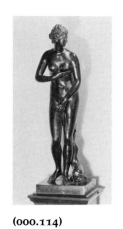

(000.114)

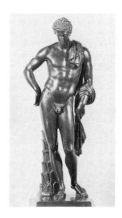

(000.115)

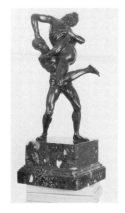

(27.175)

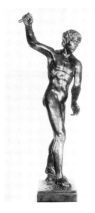

(17.9)

137

Italian, c. 1800.
Nymph and Satyr, a pair (B); H. 23½ in. each.
Coll.: Count Cassini; J. Pierpont Morgan.
Acq.: 1917, (17.11 & 12).

Italo-Flemish, c. 1600.
Woman Combing Her Hair (L); H. 5½ in.
Coll.: Mannheim; J. Pierpont Morgan. *Acq.:* 1917,
(17.18).

Woman Touching Her Foot (L); H. 5 in.
Coll.: Mannheim; J. Pierpont Morgan. *Acq.:* 1917,
(17.17).

Woman Braiding Her Hair (L); H. 7¼ in.
Coll.: Mannheim; J. Pierpont Morgan. *Acq.* 1917,
(17.16).

Woman Bathing Her Feet (L); H. 6¼ in.
Coll.: Mannheim; J. Pierpont Morgan. *Acq.:* 1917,
(17.15).

Man Carrying a Child (L); H. 9³⁄₁₆ in.
Coll.: J. Pierpont Morgan. *Acq.:* 1917, (17.8).

Man with a Sword (L); H. 8⅛ in.
Coll.: Pfungst; J. Pierpont Morgan. *Acq.:* 1917,
(17.7).

Woman Returning from Market (L); H. 8⅛ in.
Coll.: Mannheim; J. Pierpont Morgan. *Acq.:* 1917,
(17.20).

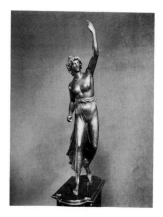

(17.11)

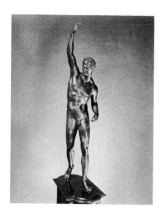

(17.12)

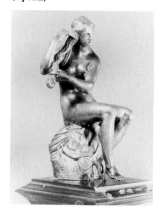

(17.18)

138

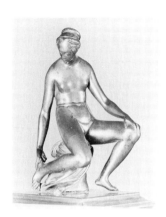

(17.17)

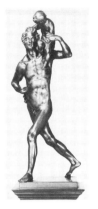

(17.8)

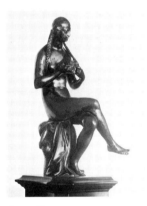

(17.16)

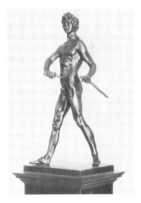

(17.7)

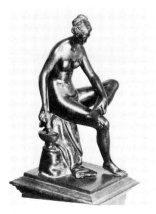

(17.15)

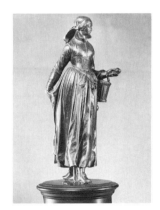

(17.20)

139

Maderna, Stefano (1576–1636), atelier of.
Hercules and Antaeus (A); H. 22 in.
Coll.: Sir Bache Cunard. *Acq.:* 1927, (27.176).

Riccio (Andrea Briosco) (1470–1562), follower of.
Youth Drawing a Thorn from His Foot (L); H. 10½ in.
Coll.: J. Pierpont Morgan. *Acq.:* 1917, (17.4).

Roccatagliata, Niccolo (active 1593–1636), atelier of.
Cupid Blowing a Trumpet (L); H. 12½ in.
Acq.: 1910, (10.150).

Wurzelbauer, Benedikt (1548–1620), atelier of.
Neptune Fountain (Loggia); H. 29 in. (without base or trident).
Coll.: Stephano Bardini; William Newall.
Acq.: 1925, (25.5).

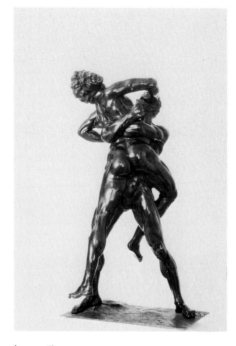

(27.176)

140

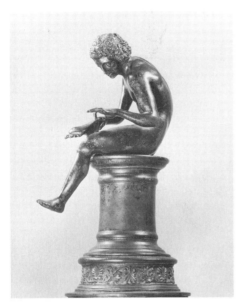

(17.4)

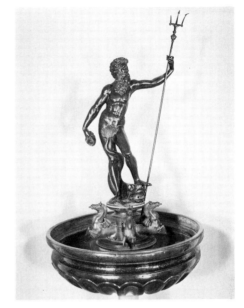

(25.5)

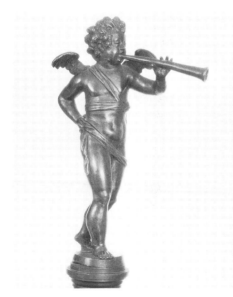

(10.150)

141

THE OPENING OF the Virginia Steele Scott Gallery in mid-1984 established American art as an important part of the public exhibitions offered at the Huntington. The gift of the Virginia Steele Scott Foundation to the Huntington included, in addition to the building, a collection of fifty American paintings carefully chosen to demonstrate the character and range of this phase of American art from about 1740 to 1940. The gift was made under flexible terms which encourage the growth and refinement of the collection in any way that will enhance its attraction and use for the general public and the scholar.

Some American art previously in the Huntington Gallery or Huntington Library is now shown in the Scott Gallery. Included are paintings by J. S. Copley, Benjamin West, and Gilbert Stuart, as well as examples of American sculpture and furniture. Changing exhibitions in the Scott Gallery include selections from the extensive collections of American photographs, prints, and drawings in the Library. Additional American paintings and sculpture, particularly portraits, are shown in the Library building.

Because the Library, ever since Mr. Huntington's day, has vigorously collected materials for the study of American history and literature, substantial resources related to American art are already at hand. The gift of the Virginia Steele Scott Foundation includes an endowment which will enable the Huntington to build these resources further and to establish a scholarly program for studies in American art.

American art down to the middle of the twentieth century has great intrinsic appeal, especially for people in this country. The art also is a fascinating chronicle of the varying responses of artists in a young, emerging nation to the problem of national identity in art. During the eighteenth century and early nineteenth most American painters measured themselves in relation to contemporary British work. West and Copley actually spent the ma-jor portions of their active careers in London. Many others, such as Stuart, Allston, and Sully, returned to this country after a period of study in London. The Huntington Gallery in close physical proximity to the Scott Gallery offers a rare opportunity to explore this interaction in depth.

From the mid-nineteenth century through the early twentieth the focus of attention for those American painters who looked abroad shifted from England to Germany, and especially to France. But at the same time more and more painters became concerned with developing a distinctively American idiom, particularly in the subjects they chose to paint. These developing interests are clearly demonstrated by the paintings in the Scott Gallery.

Paintings exhibited in the Scott Gallery at the time this catalog was printed are identified by the letters "VSS" in parenthesis following the title.

AMERICAN PAINTINGS

Aiken, Mary (b. 1907)
Conrad Aiken
Canvas: 23 x 19 in. Painted at Rye, Sussex, 1938. Acq.: 1975, (75.52).

Allston, Washington (1779–1843)
The Angel Releasing St. Peter from Prison (VSS).
Canvas: 29 x 24½ in. Painted 1812
Coll.: Francis B. Winthrop; Countess Laslo Szechenyi Acq.: 1983, gift of the Virginia Steele Scott Foundation, (83.8.1).

Ames, Ezra (1768–1836) attributed to
Allan Melville
Panel: 30 x 24 in.
Coll.: Thomas B. Clarke Acq.: 1919, (19.6).

Atwood, Jesse (c. 1828–54)
Zachary Taylor
Canvas: 30 x 25 in. Dated 1847. Acq.: 1919, (19.15).

(75.52)

(19.6)

(83.8.1)

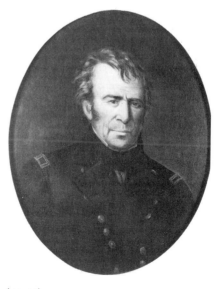

(19.15)

143

Becker, Carl (b. 1862)
Theodore Roosevelt
Panel: 13½ x 9 in. Signed. Acq.: 1922, (22.19).

Bellows, George Wesley (1882–1925)
Portrait of Laura (VSS)
Canvas: 40 x 32 in.
July 1915. Signed.
Coll.: Emma S. Bellows, wife of the artist
Acq.: 1983 (gift of the Virginia Steele Scott
Foundation), (83.8.2).

Benson, Frank Weston (1862–1951)
Reflections (VSS)
Canvas: 43¾ x 36 in. Signed and dated 1921
Coll.: Edwin C. Shaw *Acq.:* 1983 (gift of the
Virginia Steele Scott Foundation), (83.8.3).

Bingham, George Caleb (1811–79)
In a Quandry or Mississippi Raftsmen at Cards (VSS)
Canvas: 17½ x 21 in. Signed and dated 1851
Coll.: Francis P. Garvan Collection (Yale
University); C. W. Lyon; Mrs. Paul Moore; The
Right Reverend Paul Moore *Acq.:* 1983 (gift of
the Virginia Steele Scott Foundation), (83.8.4).

Blythe, David Gilmour (1815–65)
Half-way House (VSS)
Canvas: 22 x 39½ in. Painted about 1860. Signed
Coll.: Mr. and Mrs. Lawrence A. Fleischman
Acq.: 1983 (gift of the Virginia Steele Scott
Foundation), (83.8.5).

Brook, Alexander (b. 1898)
Sentimental Ideas
Canvas: 34 x 26 in.
Coll.: Joyce Treiman; *Acq.:* 1984 (gift of the
Virginia Steele Scott Foundation), (84.37).

Cassatt, Mary (1845–1926)
Breakfast in Bed (VSS)
Canvas: 23 x 29 in. Painted in 1897. Signed
Coll.: Mrs. Chauncey Blair; Mrs. William F.
Borland; John J. McDonough *Acq.:* 1983 (gift of
the Virginia Steele Scott Foundation), (83.8.6).

Chase, William Merritt (1849–1916)
Tenth Street Studio (VSS)
Canvas: 32⅜ x 44¼. Signed *Acq.:* 1983 (gift of
the Virginia Steele Scott Foundation), (83.8.7).

144

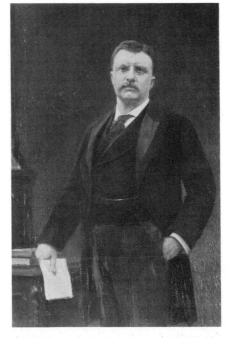

(22.19)

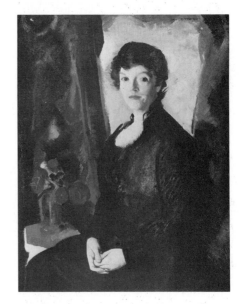

(83.8.2)

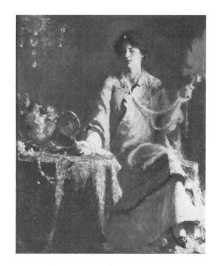

(83.8.3)

(84.37)

(83.8.4)

(83.8.6)

(83.8.5)

(83.8.7)

Clark, Alson Skinner (1876–1949)
Spring in Paris
Panel: 10½ x 13¾ in. Signed and dated,
1903. *Acq.:* 1966 (gift of Kate Van Nuys Page),
(66.73).

Cogswell, William (1819–1903)
Mrs. Benjamin Davis Wilson
Canvas: 29⅞ x 24¹⁵⁄₁₆ in. Painted, 1881.
Coll.: Anne W. Patton *Acq.:* 1974 (gift of Mr. and
Mrs. Peter Wilson Patton), (74.18).

Colcard, H. (dates unknown)
Abraham Lincoln
Canvas: 26 x 21 in. Signed and dated 1888 (?)
Coll.: Libby Prison War Museum *Acq.:* 1919,
(19.18).

Copley, John Singleton (1738–1815)
Charles, Lord Western, and Shirley Western (VSS)
Canvas: 49 x 61 in. Painted about 1783.
Coll.: Sir Thomas Western. *Acq.:* 1914, (14.7).

Sarah Jackson (VSS)
Canvas: 50 x 40 in. Painted about 1765.
Coll.: by family descent to Mrs. Oric Bates (Natica
Y. Inches) *Acq.:* 1983 (gift of the Virginia Steele
Scott Foundation), (83.8.9).

Curry, John Steuart (1897–1946)
State Fair (VSS)
Canvas: 69 x 91½ in. Painted in 1929. *Acq.:* 1983
(gift of the Virginia Steele Scott Foundation),
(83.8.10).

Doughty, Thomas (1793–1856)
River Rapids (VSS)
Canvas: 22 x 32. Signed and dated 1825
Acq.: 1983 (gift of the Virginia Steele Scott
Foundation), (83.8.12).

Durand, Asher Brown (1796–1886)
Strawberrying (VSS)
Canvas: 34 x 51 in. Signed and dated 1854
Coll.: Mrs. Haight *Acq.:* 1983 (gift of the Virginia
Steele Scott Foundation), (83.8.13).

146

Eakins, Thomas (1844–1916)
Sketch for the Portrait of Riter Fitzgerald (VSS)
Canvas: 22 x 18 in. Signed and inscribed
Acq.: 1983 (gift of the Virginia Steele Scott
Foundation), (83.8.14).

(66.73)

(74.18)

(19.18)

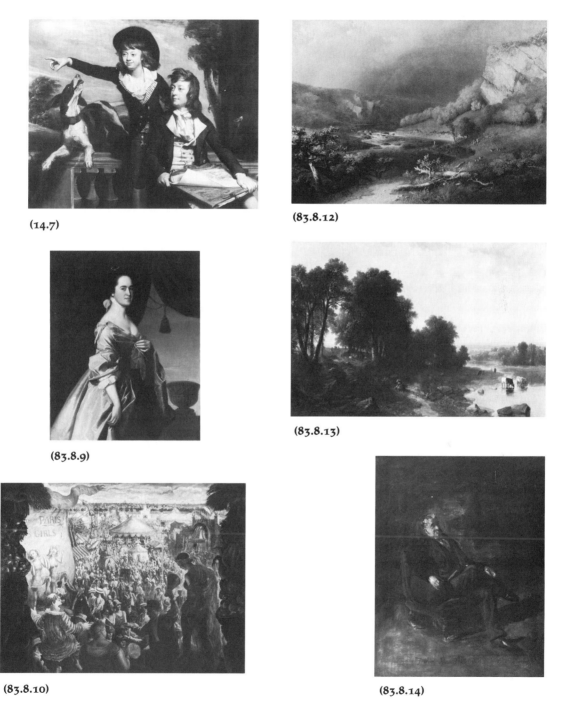

(14.7)

(83.8.12)

(83.8.9)

(83.8.13)

(83.8.10)

(83.8.14)

147

Earl, Ralph (1751–1801)
Portrait of Mrs. Elijah Boardman and Her Son William Whiting Boardman (VSS)
Canvas: 85¼ x 56¼ in. Painted about 1798.
Coll.: Descendants of the subject until 1973
Acq.: 1983 (gift of the Virginia Steele Scott Foundation), (83.8.15).

Eichholtz, Jacob (1776–1842)
Andrew Jackson
Canvas: 30 x 25 in.
Coll.: Thomas B. Clarke *Acq.:* 1919, (19.3).

Fabe, Robert (b. 1917)
Frederick Jackson Turner
Panel: 20 x 16 in. Signed. *Acq.:* 1980 (gift of Ray Allan Billington), (80.2).

Fechin, Nicholai (1881–1955)
Child of Taos
Canvas: 22¾ x 19 in. Signed.
Coll: Virginia Steele Scott *Acq.:* 1984 (gift of the Virginia Steele Scott Foundation), (84.38).

Feke, Robert (c.1705–1751)
Portrait of Mrs. Benjamin Lynde, Jr. (VSS)
Canvas on panel: 30 x 25 in. Signed. Probably painted in Boston about 1748.
Coll.: by family descent to Mrs. Fitch E. Oliver (1910); Mr. F. Moseley *Acq.:* 1983 (gift of the Virginia Steele Scott Foundation), (83.8.16).

Frieseke, Frederick Carl (1874–1939)
Woman Seated in a Garden
Canvas: 26 x 32 in. Signed. Painted in 1914.
Coll.: estate of the artist *Acq.:* 1983 (gift of the Virginia Steele Scott Foundation), (83.8.17).

Lady on a Gold Couch
Canvas: 38 x 51 in. Signed.
Coll.: the artist until the 1920s *Acq.:* 1983 (gift of the Virginia Steele Scott Foundation), (83.8.18).

Glackens, William J. (1870–1938)
Chateau Thierry (VSS)
Canvas: 24 x 32 in. Signed. *Acq.:* 1983 (gift of the Virginia Steele Scott Foundation), (83.8.19).

148

Sketch for Chateau Thierry (VSS)
Panel: 6¼ x 8¾ in. Inscribed on back: W.G. by E.G. *Acq.:* 1983 (gift of the Virginia Steele Scott Foundation), (83.8.20)

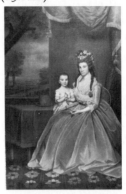

(83.8.15)

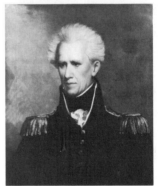

(19.3)

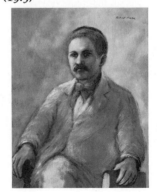

(80.2)

(84.38)

(83.8.18)

(83.8.16)

(83.8.19)

(83.8.17)

(83.8.20)

Hassam, Childe (1859–1935)
Paris Street Scene (VSS)
Oil on carton, 15⅛ x 21⅝ in. Signed.
Coll.: G. Franklin Luddington *Acq.:* 1983 (gift of
the Virginia Steele Scott Foundation), (83.8.21).

Heade, Martin Johnson (1819–1904)
Haystacks (VSS)
Canvas: 28 x 54. Signed. Painted about 1885
Coll.: Henry Morrison Flagler *Acq.:* 1983 (gift of
the Virginia Steele Scott Foundation), (83.8.22).

Henri, Robert (1865–1929)
Orientale (VSS)
Canvas: 41 x 33 in. Signed. Painted in 1915
Acq.: 1983 (gift of the Virginia Steele Scott
Foundation), (83.8.23).

Hicks, Thomas (1823–90)
General John Charles Fremont
Canvas: 24 x 20 in.
Coll.: Jones family of Washington, DC.
Acq.: 1931, (19.31).

Hill, Thomas (1829–1908)
Yosemite
Canvas: 16 x 26 in. (sight). Signed *Acq.:* 1966 (gift
of Kate Van Nuys Page), (66.74).

Hopper, Edward (1882–1967)
The Long Leg (VSS)
Canvas: 20 x 30¼ in. Signed.
Coll.: Philip M. Davis *Acq.:* 1983 (gift of the
Virginia Steele Scott Foundation), (83.8.25).

Inness, George (1825–94)
Washing Day near Perugia (VSS)
Canvas: 72½ by 54 in. Signed and dated
1873 *Acq.:* 1983 (gift of the Virginia Steele Scott
Foundation), (83.8.26).

Sketch for Washing Day near Perugia (vss)
Cardboard: 17¾ x 15 in. Signed. *Acq.:* 1983 (gift
of the Virginia Steele Scott Foundation), (83.8.27).

Johnson, Eastman (1824–1906)
Sugaring Off (VSS)
Canvas: 33½ x 53½ in. Signed with initials. Painted
about 1870 *Acq.:* 1983 (gift of the Virginia Steele
Scott Foundation), (83.8.28).

150

(83.8.21)

(83.8.22)

(83.8.23)

(19.31)

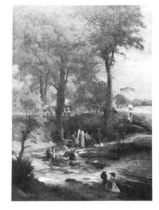

(83.8.26)

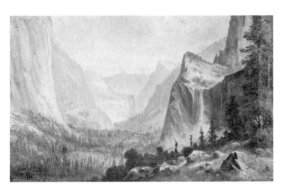

(66.74)

(83.8.27)

(83.8.25)

(83.8.28)

151

Keith, William (1839–1911)
After the Storm
Canvas: 35½ x 59½ in. (sight) Signed and dated, 1899 *Acq.:* 1912, (12.18).

The Golden Hour
Canvas: 14 x 25⅛ in. *Acq.:* 1914, (14.57).

Sunset Landscape with Trees
Canvas: 19¼ x 29½ in. Signed. *Acq.:* 1914, (14.68).

Mountain Landscape with Cattle
Canvas: 30 x 50 in. Signed and dated [18]79
Acq: 1985 (gift of Mr. and Mrs. H. W. Dougherty), (85.49).

Kensett, John Frederick (1816–72)
Rocky Landscape (VSS)
Canvas: 48 x 72½ in. Painted in 1853.
Coll.: Charles Winthrop Gould; Walter P. Chrysler, Jr.; Mr. and Mrs. Perry Adams *Acq.:* 1983 (gift of the Virginia Steele Scott Foundation), (83.8.29).

Kuhn, Walt (1877–1949)
The Top Man (VSS)
Canvas: 72 x 32 in. Signed and dated 1931.
Acq.: 1983 (gift of the Virginia Steele Scott Foundation), (83.8.30).

Lambdin, James Reid (1807–89)
Henry Clay
Canvas: 30 x 25 in.
Coll.: Thomas B. Clarke *Acq.:* 1919, (19.7).

Lane, Fitz Hugh (1804–65)
Sailing Ships off the New England Coast (VSS)
Canvas: 30⅛ by 48¼ in. Painted about 1855.
Coll.: Charles D. Childs *Acq.:* 1983 (gift of the Virginia Steele Scott Foundation), (83.8.31).

Loop, Henry A. (1831–95)
Benjamin Davis Wilson
Canvas: 29½ x 24½ in. (sight), Signed and dated, 1889.
Coll.: Edith Shorb Steele *Acq.:* 1955 (gift of Shorb Steele), (55.4).

152

(12.18)

(14.57)

(14.68)

(85.49)

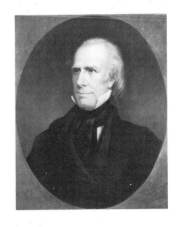

(19.7)

(83.8.29)

(83.8.31)

(83.8.30)

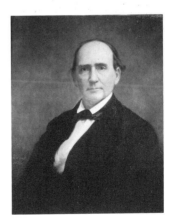

(55.4)

153

Luks, George Benjamin (1867–1913)
The Boxing Match (VSS)
Canvas: 24 x 30 in.
Coll.: Mortimer Brandt *Acq.:* 1983 (gift of the Virginia Steele Scott Foundation), (83.8.32).

Maurer, Alfred H. (1868–1932)
Woman in Interior (VSS)
Canvas: 30 x 28¾ in. Signed. Painted in 1901 *Acq.:* 1983 (gift of the Virginia Steele Scott Foundation), (83.8.33).

Moon, Carl (1879–1948)
Cha-ah-din-'ie. Navaho.
Canvas mounted on panel: 32 x 26 in. Signed. *Acq.:* 1925 (from the artist), (25.33).

Hopi Basket-Maker
Canvas: 32 x 26 in. Signed. *Acq.:* 1925 (from the artist), (25.45).

Hopi Maiden. Village of Walpi.
Canvas mounted on panel: 32 x 26 in. Signed. *Acq.:* 1925 (from the artist), (25.37).

Koy-yai. San Filipi Pueblo.
Canvas mounted on wood panel: 32 x 26 in. Signed. *Acq.:* 1925 (from the artist), (25.32).

Isleta Pottery Maker. Pueblo of Isleta, New Mexico.
Canvas: 26 x 32 in. Signed. *Acq.:* 1925 (from the artist), (25.44).

Navaho Weaver. Canyon de Chelly. Navaho Reserve.
Canvas mounted on wood panel: 32 x 26 in. Signed. *Acq.:* 1925 (from the artist), (25.35).

North Pueblo of Taos
Canvas: 26 x 32 in. Signed. *Acq.:* 1925 (from the artist), (25.38).

Nar-Ah-Kee Gie Etsu. Old Apache Scout.
Canvas mounted on wood panel: 32 x 26 in. Signed. *Acq.:* 1925 (from the artist), (25.26).

Osage Man. Bro-Ga-Hee-Ge.
Canvas: 32 x 26 in. Signed and dated, 1924. *Acq.:* 1925 (from the artist), (25.24).

Peace Pipe.
Canvas: 26 x 32 in. Signed. *Acq.:* 1925 (from the artist), (25.46).

Pedro Cay-eta or Kai-ee-te. Santa Clara Pueblo.
Canvas mounted on wood panel: 32 x 26 in. Signed. *Acq.:* 1925 (from the artist), (25.27).

The Scout. Taos Valley, New Mexico.
Canvas: 26 x 32 in. Signed. *Acq.:* 1925 (from the artist), (25.43).

Taos Hunter.
Canvas: 32 x 26 in. Signed. *Acq.:* 1925 (from the artist), (25.42).

Untitled (Indian with Striped Blanket).
Canvas mounted on wood panel: 32 x 26 in. Signed. *Acq.:* 1925 (from the artist), (25.23).

Untitled (Indian boy with Buffalo Skull)
Canvas: 32 x 26 in. *Acq.:* 1925 (from the artist), (25.29).

Untitled (Indian Child).
Canvas mounted on wood panel: 32 x 26 in. Signed. *Acq.:* 1925 (from the artist), (25.34).

Untitled (Indian Girl with Pottery Jug).
Panel: 26 x 32 in. *Acq.:* 1925 (from the artist), (25.28).

Untitled (Indian Woman with Papoose).
Canvas: 32 x 26 in. Signed. *Acq.:* 1925 (from the artist), (25.40).

Untitled (Indian with Flute)
Canvas: 32 x 26 in. Signed. *Acq.:* 1925 (from the artist), (25.39).

Ya-otza-begay, also called Meguelito. Navaho Medicine Man.
Canvas mounted on wood panel: 32 x 26 in. Signed. *Acq.:* 1925 (from the artist), (25.31).

(83.8.32)

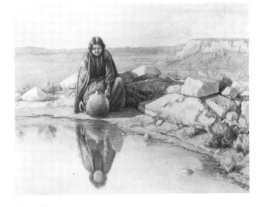

(25.28)

(83.8.33)

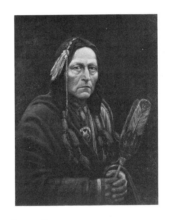

(25.24)

(25.33)

(25.46)

Moran, Thomas (1837–1926)
Rock Towers of the Rio Virgin (VSS)
Canvas: 23 by 30 in. Signed and dated 1908.
Acq.: 1983 (gift of the Virginia Steele Scott
Foundation), (83.8.34).

Mersfelder, Jules (1864–1937)
Evening Landscape
Academy Board: 17¾ x 23¾ in. (sight).
Signed. *Acq.:* 1914, (14.63).

Mount, Shepard Alonzo (1804–68)
Martin Van Buren
Canvas: 30 x 25 in. *Acq.:* 1924, (24.34).

Otis, Bass (1784–1861), attributed to
Thomas Paine
Canvas: 30 x 25 in.
Coll.: Thomas B. Clarke *Acq.:* 1919, (19.12).

Partington, J. H. E. (1843–1899)
Ambroise Bierce
Canvas: 49¼ x 39½ in. (sight), Signed. *Acq.:* 1960
(gift of Henry E. Weiss), (60.10).

**Peale, Charles Willson (1741–1827)
attributed to**
George Washington
Canvas: 78 x 43½ in.
Coll.: Mrs. George Reuling *Acq.:* 1919, (19.13).

Peale, Charles Willson (after)
Thomas Jefferson
Canvas: 22¼ x 26⅛ in.
Coll.: John Conduit, John Porterfield *Acq.:* 1924,
(24.8).

Peale, James (1749–1831)
William Flintham
Canvas: 33 x 28¼ in. Signed and dated, 1805.
Coll.: Flintham family. *Acq.:* 1951 (gift of Mrs.
Susan F. Smith), (51.14).

A Girl holding a Doll (VSS)
Canvas: 34 x 22 in. *Acq.:* 1983 (gift of the Virginia
Steele Scott Foundation), (83.8.35).

(83.8.34)

(14.63)

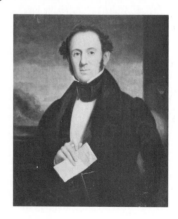

(24.34)

156

(19.12)

(24.8)

(60.10)

(51.14)

(19.13)

(83.8.35)

Peale, Raphaelle (1774–1825)
Still Life: Wine, Cakes, and Nuts (VSS)
Panel: 12¼ by 14¾ in. Signed and dated 1819.
Coll.: Robert Gilmor *Acq.:* 1983 (gift of the
Virginia Steele Scott Foundation), (83.8.36).

Peale, Rembrandt (1778–1860)
George Washington
Canvas: 30 x 25 in.
Coll.: Dr. Joseph Shippen; Dr. Joseph Weatherby
Van Leer; Thomas B. Clarke. *Acq.:* 1919, (19.1).

Perry, Enoch Wood (1831–1915)
Brigham Young
Canvas: 29¾ x 25½ in. *Acq.:* Date of acquisition
unknown. Library Collection.

Peto, John Frederick (1854–1907)
A Full Shelf (VSS)
Canvas: 20 x 24 in. Signed. Newspaper dated May,
1891 *Acq.:* 1983 (gift of the Virginia Steele Scott
Foundation), (83.8.37).

Phillips, Ammi (1788–1865)
Hannah Bull Thompson (VSS)
Canvas: 30 x 24 in. Painted in 1824.
Coll.: by family descent to Jean Thompson
Vogelbach. *Acq.:* 1983 (gift of the Virginia Steele
Scott Foundation), (83.8.38).

Polk, Charles Peale (1767–1822)
George Washington (Copy of portrait by James
Peale) (VSS)
Canvas: 34 x 25 in.
Coll.: Peale Museum; Moses Kimball; Thomas B.
Clark. *Acq.:* 1919, (19.2).

Prendergast, Maurice Brazil (1859–1924)
Park Scene (VSS)
Canvas: 20¼ by 24¼ in. Signed.
Coll.: Estate of the artist until 1976 *Acq.:* 1983
(gift of the Virginia Steele Scott Foundation),
(83.8.40).

Reinhart, Benjamin Franklin (1829–85)
Alfred, Lord Tennyson.
Canvas: 29 x 24 in. Signed. *Acq.:* 1922, (22.57).

Rix, Julian (1850–1903)
Sanderson's Brook, Caldwell, New Jersey.
Canvas: 17 x 11½ in. (sight) Signed. *Acq.:* 1901,
(01.1).

(83.8.36)

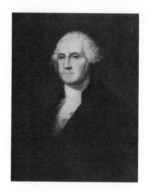

(19.1)

158

(83.8.37)

(83.8.40)

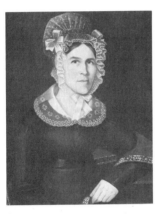

(83.8.38)

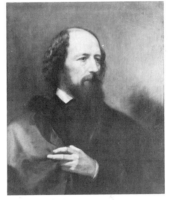

(22.57)

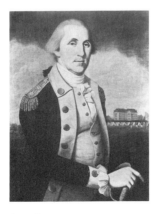

(19.2)

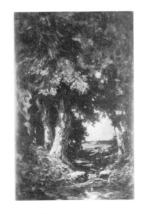

(01.1)

Robinson, Theodore (1852–96)
Nettie Reading
Canvas: 18 x 22 in. Signed.
Coll.: Charles McManamy *Acq.:* 1983 (gift of the
Virginia Steele Scott Foundation), (83.8.41).

Roesen, Severin (active. 1847–71)
Still Life with Flowers and Bird's Nest (VSS)
Panel: 15 x 20 in. Signed
Coll.: C. N. Bliss; W. R. Ellis; Minnie
Vaughan *Acq.:* 1983 (gift of the Virginia Steele
Scott Foundation), (83.8.42).

Sargent, John Singer (1856–1925)
Charles Stuart Forbes (VSS)
Canvas: 28¾ x 21¼ in. Signed and inscribed.
Painted about 1889.
Coll.: Charles Stuart Forbes; John J. McDonough
Acq.: 1983 (gift of the Virginia Steele Scott
Foundation), (83.8.43).

Schussele, Christian (c.1824–1879)
Benjamin Franklin Appearing Before the Privy Council
(VSS)
Canvas: 57½ x 84½ in. Signed and dated, 1867.
Coll.: Joseph Harrison; J. H. Dripps. *Acq.:* 1924,
(24.3).

Sloan, John (1871–1951)
McSorley's Cats (VSS)
Canvas: 35 x 45 in. Signed *Acq.:* 1983 (gift of
the Virginia Steele Scott Foundation), (83.8.44).

Spencer, Robert (1879–1931)
Three Houses
Canvas: 30 x 36 in. Signed.
Coll.: Virginia Steele Scott *Acq.:* 1984 (gift of the
Virginia Steele Scott Foundation), (84.29).

Story, George Henry (1835–1923)
Abraham Lincoln (VSS)
Canvas: 30 x 25 in. Signed. *Acq.:* 1914, (14.8).

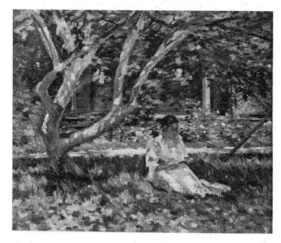

(83.8.41)

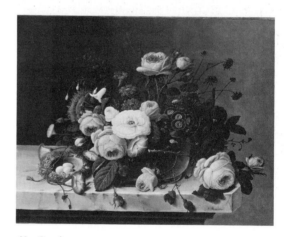

(83.8.42)

(83.8.43)

(83.8.44)

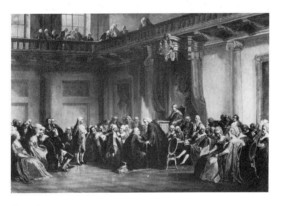

(24.3)

(84.29)

(14.8)

Stuart, Gilbert (1775–1828)
Mrs. Ann Stow (VSS)
Panel, 29⅛ by 23½ in. Signed with initials. Painted 1802–03
Coll.: Family descent until 1922 *Acq.:* 1983 (gift of the Virginia Steele Scott Foundation), (83.8.45).

George Washington (VSS)
Canvas: 28½ x 23⅝ in. Painted in 1797.
Coll.: Charles Baring, Baring family. *Acq.:* 1939 (gift of Mrs. Alexander Baring), (39.1).

George Washington (E)
Panel: 27 x 22 in. Painted in 1819.
Coll.: Isaac McKim; Mrs. Elizabeth Coles; Thomas B. Clarke. *Acq.:* 1919, (19.11).

Lawrence Reid Yates (VSS)
Canvas: 30 x 24¼ in.
Coll.: Mrs. James Taylor; Mrs. Ward Hunt; Thomas B. Clarke. *Acq.:* 1919, (19.3).

Sully, Thomas (1783–1872)
Mlle. Adele Signoigne (VSS)
Canvas: 29½ by 25. Painted in 1829.
Coll.: the sitter; her pupil, Mlle. Ariles: by descent to Mme. L. de Heredia *Acq.:* 1983, (gift of the Virginia Steele Scott Foundation), (83.8.47).

Paul Beck (VSS)
Canvas: 36 x 28 in. Painted in 1813
Coll.: by family descent to John B. Webster
Acq.: 1983 (gift of the Virginia Steele Scott Foundation), (83.8.46).

Tarbell, Edmund C. (1862–1938)
Interior with Mother and Child (VSS)
Canvas: 25 x 30 in. Signed *Acq.:* 1983 (gift of the Virginia Steele Scott Foundation), (83.8.48).

Thompson, Cephas Giovanni (1809–88)
John Howard Payne
Canvas: 30 x 25 in. Signed.
Coll.: Thomas B. Clarke. *Acq.:* 1919, (19.10).

Tilyard, Philip Thomas Coke (1787–1830)
John Pendleton Kennedy
Canvas: 29 x 24 in. Signed and dated, 1825.
Coll.: Kennedy family. *Acq.:* 1939 (gift of John Pendleton Kennedy), (39.3).

162

(83.8.45)

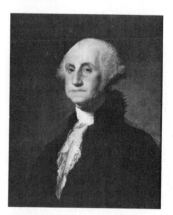

(39.1)

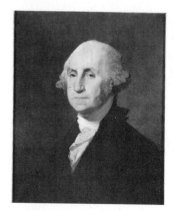

(19.11)

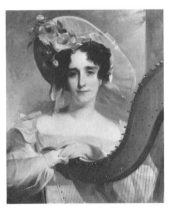

(19.3)

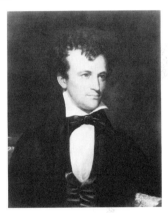

(83.8.48)

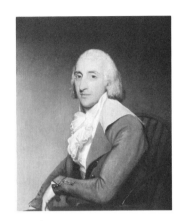

(83.8.47)

(19.10)

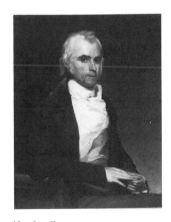

(83.8.46)

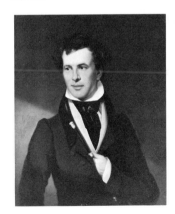

(39.3)

True, Allen Tupper (1881–1955)
Abraham Lincoln
Canvas: 33 x 24 in. (sight), Signed and dated
1911. *Acq.:* 1927, (27.221).

Unattributed
Colonel John Brooks
Canvas: 30 x 25 in. *Acq.:* 1919, (19.16).

Unattributed
Reverend Joshua Huntington
Panel: 26 x 22½ in. (sight). *Acq.:* 1924, (24.7).

Unattributed
Catherine Small Pitcairn
Canvas mounted on panel: 27¼ x 23 in. Dated
1843–4. *Acq.:* 1984 (bequest of Mrs. Catherine
Kendall), (84.31).

Unattributed
John Pitcairn
Canvas mounted on panel: 27½ x 23 in. Dated
1843–4. *Acq.:* 1984 (bequest of Mrs. Catherine
Kendall), (84.30).

Unattributed
John A. Sutter
Canvas: 36 x 29 in. *Acq.:* 1973 (gift of Mrs. Lewis
Torrance), (73.17).

Vanderlyn, Pieter (c.1687–1778)
Cornelis Wynkoop (VSS)
Panel, 43 x 25 in. Painted about 1743.
Coll.: with descendents of the sitter until
1981. *Acq.:* 1983 (gift of the Virginia Steele Scott
Foundation), (83.8.49).

Van Gorder, L. E. (b. 1861)
Apple Orchard
Canvas: 15¾ x 19¾ in. (sight). *Acq.:* 1914,
(14.67).

Vedder, Elihu (1836–1923)
The Dying Sea Gull (VSS)
Canvas: 16¾ by 33½ in. Signed and dated
1879. *Acq.:* 1983 (gift of the Virginia Steele Scott
Foundation), (83.8.50).

(27.221)

(19.16)

(24.7)

164

(84.31)

(83.8.49)

(84.30)

(14.67)

(73.17)

(83.8.50)

Weir, Julian Alden (1852–1919)
The Orchid
Canvas: 24½ x 20 in. Signed. *Acq.:* 1983 (gift of the Virginia Steele Scott Foundation), (83.8.51).

West, Benjamin (1738–1820)
The Meeting of Lear and Cordelia
Canvas: 42½ x 57 in.
Coll.: Gage of Hengrave Hall. *Acq.:* 1912, (12.1).

Saul Before Samuel and the Prophets (VSS)
Canvas: 64 x 101 in. (sight) Signed and dated 1812.
Coll.: Torre Abbey, England; St. Paul's Church, Richmond, Virginia. *Acq.:* 1983 (gift of the Virginia Steele Scott Foundation), (83.8.52).

(12.1)

(83.8.52)

(83.8.51)

166

AMERICAN DRAWINGS

The gift of the Virginia Steele Scott Foundation to the Huntington contained watercolors by Samuel Colman, Charles Demuth, Winslow Homer, Maurice Prendergast, and Grant Wood. Other American works of art on paper in the Huntington collection include drawings and pastels by Washington Allston, Mather Brown, Mary Cassatt, J. S. Copley, William Glackens, Morris Graves, John Sloan, and Benjamin West. In addition there are two large groups of late nineteenth-century illustrator drawings and early twentieth-century cartoon drawings.

Cassatt, Mary (1845–1926)
Francoise Holding a Little Dog
Pastel: 26⅞ x 22¾ in.; signed.
Coll.: Gen. E. C. Young *Acq.:* 1926 (26.124).

Homer, Winslow (1836–1910)
Indians Making Canoes (*Montagnais Indians*)
Watercolor: 14 x 20 in.; signed and dated 1895. *Acq.:* 1983 (gift of the Virginia Steele Scott Foundation), (83.8.24)

Wood, Grant (1892–1942)
Study for Spring Turning
Watercolor and crayon: 17½ x 39¾ in.; signed and dated 1936. *Acq.:* 1983 (gift of the Virginia Steele Scott Foundation), (83.8.53).

(83.8.24)

(83.8.53)

(26.124)

167

AMERICAN SCULPTURE

Epstein, Jacob (1880–1959)
Joseph Conrad (VSS)
Bronze; H. 14½ in.; modeled 1924. *Acq.:* 1984
(gift of the Virginia Steele Scott Foundation),
(84.35.1).

George Bernard Shaw (VSS)
Bronze; H. 24 in.; modeled 1934. *Acq.:* 1984 (gift
of the Virginia Steele Scott Foundation), (84.35.2)

Winston Churchill (VSS)
Bronze; H. 12 in.; modeled 1946. *Acq.:* 1984 (gift
of the Virginia Steele Scott Foundation), (84.35.3).

Albert Einstein (VSS)
Bronze; H. 16½ in.; modeled 1933. *Acq.:* 1984
(gift of the Virginia Steele Scott Foundation),
(84.35.4).

Sleeping Baby
Bronze; H. 5 in. *Acq.:* 1984 (gift of the Virginia
Steele Scott Foundation), (84.35.9).

Gregory, John (b. 1879)
Huntington Mausoleum Reliefs (*Spring, Summer,
Autumn, Winter*)
Marble; 65 x 68 in. (each panel) *Acq.:* 1929 (no
accession number)

Huntington, Anna Hyatt (1876–1973)
A Pair of Great Dane Dogs (VSS)
Stone, H. 46½ in. (male), 45 in. (female), Signed
and dated, 1910. *Acq.:* 1923, (23.1–2).

Huntington, Clara (1878–1965)
Henry E. Huntington (Pavilion)
Marble bas-relief; 44 x 34½ in. *Acq.:* before 1930.
Library Collection.

St. Francis of Assisi (Lily Ponds)
Bronze; H. 6 ft. *Acq.:* 1965 (bequest of Clara
Huntington), (65.17).

Martigny, Philip (1858–1927)
Robert E. Lee (VSS)
Bronze; H. 18 in. *Acq.:* 1924, (24.35).

168

(84.35.1)

(84.35.2)

(84.35.3)

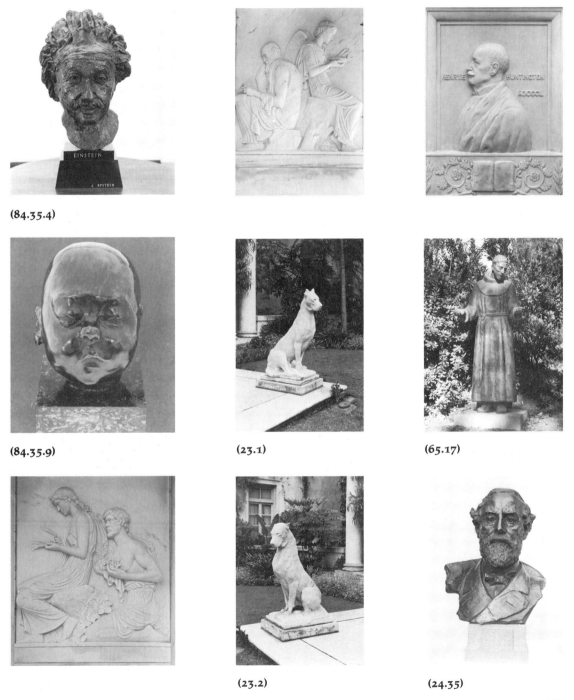

(84.35.4)

(84.35.9)

(23.1)

(65.17)

(23.2)

(24.35)

Macmonnies, Frederick (1863–1937)
Bacchante
Bronze; H. 59½ in. *Acq.:* 1920 (purchased from the artist), (20.10).

Ricketson, Walton (b.1839)
William James Potter
Plaster; H. 29 in. *Acq.:* 1975 (with Conrad Aiken papers), (75.48).

Rogers, John (1829–1904)
The Council of War
Plaster, H. 24 in., 1868 *Acq.:* 1914, (14.86).

Scudder, Janet (1874–1940)
Little Lady from the Sea (VSS)
Bronze, H. 72 in. *Acq.:* 1913 (from the artist), (13.7).

Russell, Charles (1864–1926)
The Scalp Dance
Bronze; H. 13¾ in.; Signed. *Acq.:* Date of acquisition unknown. Library Collection.

Saint-Gaudens, Augustus (1848–1907)
Robert Louis Stevenson
Bronze medallion; 17¾ diam.; 1889 *Acq.:* 1973 (gift of Stephen Royce), (73.2).

Troubetskoy, Paul (1866–1938, active in America, 1914–20)
Danseuse (Mlle. Svirsky)
Bronze; H. 20½ in. Signed and dated 1910. *Acq.:* 1911, (11.20).

Elephant
Bronze; H. 8 in. Signed and dated 1887. *Acq.:* 1911, (11.23).

Hindu Dancer
Bronze; H. 22½ in. Signed and dated 1910. *Acq.:* 1911, (11.21).

Henry Edwards Huntington
Bronze; H. 23½ in. Signed and dated 1917. *Acq.:* 1917, (17.33).

Indian Warrior
Bronze; H. 23 in. Signed and dated 1893. *Acq.:* Date of acquisition unknown. Library Collection.

(20.10)

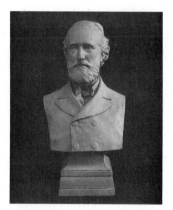

(75.48)

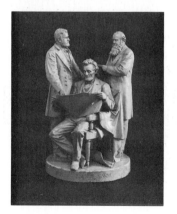

(14.86)

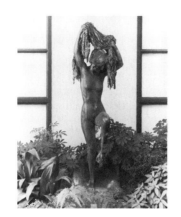

(13.7)

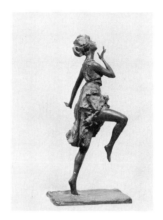

(11.20)

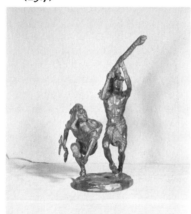

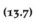

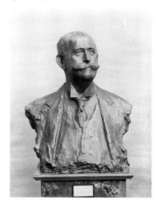

(17.33)

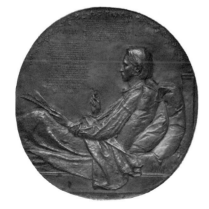

(73.2)

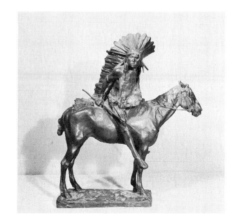

171

Italian Hunting Dog
Bronze; H. 10¼ in., Signed and dated 1893. *Acq.:* 1911, (11.22).

Spanish Dancer
Bronze; H. 21½ in. Signed and dated 1910. *Acq.:* 1911, (11.24).

Tolstoy on Horseback
Bronze; H. 18 in. Signed and dated 1893. *Acq.:* 1911, (11.19).

Two Cowboys
Bronze; H. 18¾ in. Signed and dated 1916. *Acq.:* 1916, (17.32).

Volk, Leonard (1828–95)
Abraham Lincoln (VSS)
Bronze; H. 17 in.; modeled 1860, cast 1880. *Acq.:* 1924, (24.10).

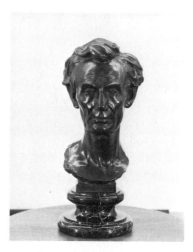

(24.10)

THE HUNTINGTON PRINT collection is divided between the Art Collections and the Library. Most of the fine prints are in the Art Collections; most of the reference prints—topography, portrait, caricatures, reproductive prints—are in the Library collections.

The group of fine prints is numerically small (about five hundred) but of high quality. The greater part of it came to the Huntington as the bequest of Mrs. Edward W. Bodman in 1972. The Bodman collection contains strong representation of early Italian prints, Durer, Rembrandt, and Goya. All of the major European print makers from the late fifteenth century to the late nineteenth are represented by fine, characteristic examples of their work.

The Huntington also has strong coverage of British fine prints, including works by Hogarth, Alexander Cozens, Gainsborough, Blake, J. M. W. Turner, and Lucas (after Constable). American fine prints include examples by Mary Cassatt and Childe Hassam.

The collection of reference prints in the Library is enormous, running to hundreds of thousands of items. Much of this material is in extra-illustrated or grangerized books. The Library owns about one thousand grangerized sets. Several sets run to thirty or more volumes. One particularly ambitious extra-illustrated Bible contains sixty volumes, with thirty thousand prints in that set alone. The Library's print collection is rich in English political caricatures and in "reproductive" prints, that is prints that reproduce a preexisting painting or other work of art.

The Huntington print collection is a major source for temporary exhibitions in the Huntington and Virginia Steele Scott Galleries as well as the Library.

Mantegna, Andrea (1431–1506)
The Risen Christ between Saint Andrew and Saint Loginus
Engraving: 11¾ x 10⅞ in.
Coll.: C. W. de Renesse-Breidach *Acq.:* 1972 (bequest of Mrs. Edward W. Bodman), (72.62.335).

Durer, Albrecht (1471–1528)
Adam and Eve, 1504
Engraving: 9¹³⁄₁₆ x 7⅝ in.
State V Acq.: 1972 (bequest of Mrs. Edward W.
Bodman), (72.62.143).

Rembrandt Harmenszoon van Rijn (1606–1669)
Christ Presented to the People, 1655
Etching and drypoint: 14¹⁄₁₆ x 17¹⁵⁄₁₆
State IV
Coll.: Friedrich August II of Saxony *Acq.:* 1972
(bequest of Mrs. Edward W. Bodman), (72.62.383).

Gainsborough, Thomas (1727–1788)
Country Churchyard, 1780
Soft-ground etching: 11½ x 15⅜ in.
Coll.: Norman Baker *Acq.:* 1963 (82.218.1)

Goya y Lucientes, Francisco (1746–1828)
Tauromaquia No. 1
Etching and aquatint: 9¹⁵⁄₁₆ x 12¼ in.
State III
Coll.: Victor Hugo *Acq.:* 1972 (bequest of Mrs.
Edward W. Bodman), (72.62.236).

Cassatt, Mary (1844–1926)
By the Pond, 1895–98
Etching, drypoint, and aquatint, printed in colors:
13 x 16⅞ in.
State IV, Signed in pencil *Acq.:* 1984 (gift of the
Virginia Steele Scott Foundation), (83.34).

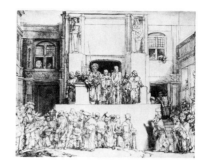

(72.62.383)

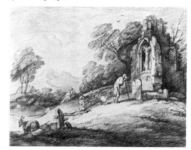

(82.218.1)

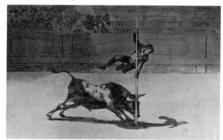

(72.62.236)

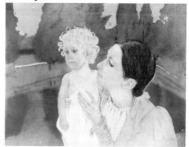

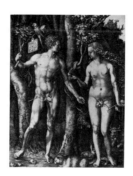

(72.62.335) **(72.62.143)** **(83.34)**

MISCELLANEOUS ART OBJECTS

NEEDLEWORK

Solomon and the Queen of Sheba (L)
Panel, 23 x 58½ in.
English? sixteenth century
Coll.: James A. Garland *Acq.:* 1910 (10.8).

Embroidered table mirror frame (O)
23 x 17 in.
English, late seventeenth century *Acq.:* 1968 (gift
of Abigail von Schlegell), (68.13).

Embroidered casket (O)
H. 7⅝, L. 11⅛, W. 8⅜ in.
English, late seventeenth century *Acq.:* 1968 (gift
of Abigail von Schlegell), (68.14).

TAPESTRY

May (from the so-called *Months of Lucas*) (Trustees
Room)
Flemish, sixteenth century; 10 feet 4 in. x 13 feet
6 in. *Acq.:* 1946 (gift of Averell Harriman) (46.1)

Royal Hunt (Overseers Room)
Flemish, sixteenth century; 10 feet 6 in. x 16 feet
4 in. *Acq.:* 1951 (gift of Mrs. Cynthia Sclater-
Booth) (51.16).

FURNITURE

Cassone (marriage chest) (AA); carved walnut;
Italian, sixteenth century. *Acq.:* 1927, (27.166).

Cassone (marriage chest) (AA); carved and gilded
walnut; Italian, sixteenth century. *Acq.:* 1927,
(27.164).

Cassone (marriage chest) (AA); carved and gilded
walnut; Italian, sixteenth century. *Acq.:* 1927,
(27.165).

Mirror; carved and gilded frame; original glass;
Venetian, eighteenth century. *Acq.:* 1934 (gift of
Kate Fowler Merle-Smith), (34.18).

Hall Clock (J); case of carved oak; works inscribed:
J. F. Benoit à Nancy; French or Flemish, mid-
eighteenth century. *Acq.:* 1911, (11.10).

Card Table (W); mahogany; by Charles Honoré
Lannuier (bears his label); American, early
nineteenth century. *Acq.:* 1914, (14.21).

ITALIAN MAJOLICA

Ewer; trilobate; Urbino majolica; sixteenth
century. *Acq.:* 1927, (27.170).

Three Pilgrim Bottles; Urbino majolica; sixteenth
century. *Acq.:* 1927, (27.168, 169, 171).

ORIENTAL PORCELAIN

Pair of Mandarin Jars (A); H. 50 in.; Kien Lung
period (1736–96).
Coll.: Baron Fould-Springer
Acq.: 1911, (11.42–43).

Pair of Mandarin Jars (G); H. 34 in.; Chinese; early
eighteenth century.
Coll.: James A. Garland; Viscount Wimbourne;
J. P. Morgan *Acq.:* 1927, (27.115).
Vase, Kang Hsi period (1662–1721); H 30 in. *Acq.:*
1909, (09.17).

CHINESE PORCELAIN IN THE QUINN COLLECTION (O)

Jar; lapis-blue, cream, and turquoise glazes; design
of figures, cloud scrolls, waves, and conventional
borders; lid and stand of carved teak; Ming period
(1368–1644), (44.83).

Jar; lapis-blue, cream, and turquoise glazes; design
of figures, landscapes, cloud scrolls, and
conventional borders; lid and stand of carved teak;
Ming period (1368–1644), (44.82).

Figure; a seated goddess with two miniature
attendants; *aubergine* and turquoise glazes; base in
form of lotus flower; Ming period (1368–1644),
(44.95).

Pagoda; enclosing the seated figure of a dignitary
in bisque; before him two bisque columns; outside
two miniature attendants standing within a low
fencelike structure; turquoise and *aubergine* glazes;
Ming period (1368–1644), (44.96).

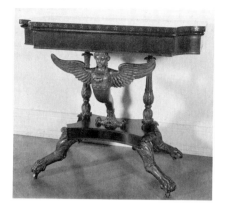

(14.21)

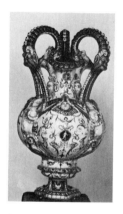

(27.170)

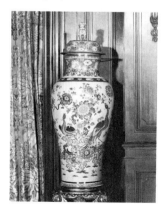

(11.42)

Pagoda; enclosing the seated figure of a dignitary; two miniature attendants at entrance; turquoise and *aubergine* glazes; Ming period (1368–1644), (44.94).

Pagoda; similar to the foregoing.

Wine Pots, a pair; in form of eggplant; brilliant *aubergine* glaze; handle, spout, and leaves in turquoise glaze; carved teak bases in conventionalized lotus form; Ming period (1368–1644), (44.92 and 93).

Libation Cups, a pair; three legs; two handles; *aubergine* glaze; Kien Lung period (1736–96), (44.89 and 90).

Incense Burner; three legs; two handles; turquoise glaze; carved teak cover and base; K'ang-hsi period (1662–1722), (44.91).

Jars, a pair; decoration of peonies in cream white and turquoise on *aubergine* ground glaze; carved teak covers topped with handles of carved turquoise; Ming period (1368–1644), (44.87 and 88).

Jar; design of figures presumed to be the eight immortals, and at bottom a deep wave border; lapis-blue, cream, turquoise, and *aubergine* glazes; lid and stand of carved teak; Ming period (1368–1644), (44.80).

Jar; design of lotus flowers and leaves rising from waves at the base; lapis-blue, cream, and turquoise glazes; lid and stand of carved teak; Ming period (1368–1644), (44.81).

Figure; a statesman seated before a screen, miniature attendants on either side; turquoise and *aubergine* glazes; Ming period (1368–1644), (44.79)

Grottos, two; irregularly shaped shrines with bisque figures inside; pedestals and grottos with *aubergine* and turquoise glazes; Ming period (1368–1644), (44.77 and 78).

GARDEN SCULPTURE, ETC.

NUMEROUS SCULPTURAL WORKS and architectural ornaments in stone, bronze, and lead are to be seen on the grounds. They include fountains, temples, statues, and busts; vases, urns, jardinieres, capitals, and wellheads; benches, sarcophagi, tables, and seats. Many of these are of modern workmanship. The large stone vases in front of the Library building and on the road leading to the north are French, of the period Louis XIV (1643–1715), as are some of those on the terrace of the Huntington Gallery. One pair there dates from the period of Louis XIII (1610–43). The lead urns on the balconies of the gallery are English of the eighteenth century. The catalogue that follows includes only the works of some artistic interest.

NEAR THE LIBRARY BUILDING

Four Bronze Statues (flanking the two front entrances of the Library building); French, seventeenth century; after the marble originals in Rome.
Hermes, Diana, Hercules and Telephos, Apollo Belevedere
Coll.: Nicholas III de Neufville; Alexander, 10th duke of Hamilton; H. Stettiner; George J. Gould. (22.35–8)

Neptune (grass terrace in front of east entrance to the Library building); stone statue from the Hofburg, the imperial palace in Vienna; about 1750. (22.33)

Fountain (terrace in front of the Library building); stone; a copy after one of the sixteenth century at the Grimani palace in Venice. (20.3)

Figure Groups of Children, a pair (west of Library building, path leading into garden); stone; French, eighteenth century. (18.15–16)

Thirty-one Stone Figures (North Vista and along the road to the north); allegorical and mythological subjects; Italian; seventeenth century; most of them were formerly in the garden of a villa near Padua.

Fountain (end of North Vista); Istrian stone; Italian; an effective example of the early baroque style in sculpture. (15.1)

Temple (left of entrance to North Vista); stone and wrought iron; Italian; seventeenth century; inside it is a marble statue, *Cupid Blindfolding Youth;* signed "F. G. Villa, Milan, 1876." (14.55)

ROCK GARDEN NEAR THE ART GALLERY

Fountain; marble; Italian; originally erected in 1570, restored in 1790, (12.8).

These dates pertain only to the base; the *vasque* (or bowl) is modern. Inside the *vasque* is a bronze statuette, *Bacchante* (20.10), by Frederick MacMonnies (American, 1863–1937). There are many other versions of this figure. The original, life-size, is in the Metropolitan Museum, New York.

LOGGIA OF THE ART GALLERY

Six Wellheads; marble; reproduced from the antique.

Fountain Urn; limestone; probably Italian

Four Figure Groups; terra cotta; French, eighteenth century:

Hamadryade; signed "Coyzevox Ft. 1709"; by or after Antoine Coysevox (1640–1720). The stone original is in the garden of the Tuileries, Paris; H. 65 in.
Coll.: Clyde Fitch, (10.154).

Amalthée; by or after Pierre Julien (1731–1804); the stone statue of this figure was made in 1786; it is now in the Louvre; H. 64 in.
Coll.: Clyde Fitch, (10.155).

Flora; signed "Coyzevox Ft. 1709"; by or after Antoine Coysevox (1640–1720); the stone original is in the garden of the Tuileries, Paris; H. 66 in.
Coll.: Clyde Fitch, (10.156).

Diana; signed "Fremin 1717"; by or after René Frémin (1672–1744); the original stone figure is now in the Louvre; H. 63 in.
Coll.: Baron de Ginsbourg, (18.14).

Neptune, bronze, workshop of Benedikt Wurzelbauer (1548–1620); H. 29 in., (25.5).

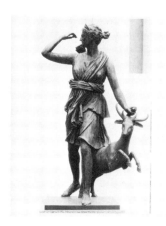

(22.36)

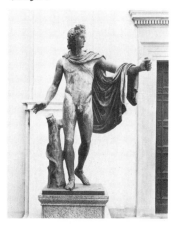

(22.38)

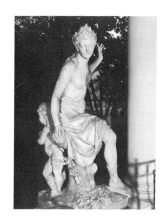

(10.154)

(15.1)

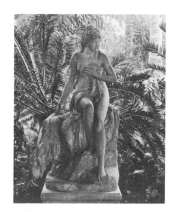

(10.155)

Two allegorical female busts (Comedy and Poetry ?), marble, probably south German, eighteenth century.
Coll.: Mme Wilkinson, (17.1 and 2).

SCULPTURE NORTH OF THE HUNTINGTON GALLERY

Bacchus (circular lawn at the porte-cochere of the gallery); pink marble; Italian, sixteenth century; after the antique. (14.5)

Persephone (north entrance to gallery); stone statue from the Hofburg, the imperial palace in Vienna; about 1750. (22.31)

Juno (opposite the above); stone statue from the Hofburg, the imperial palace in Vienna; about 1750. (22.32)

Sarcophagus (porte-cochere); stone; early Christian; Roman, probably third century, A.D. (22.6)

SCULPTURE SOUTH OF THE HUNTINGTON GALLERY

Animal Groups, a pair (South Terrace); bronze; French, nineteenth century; after Jacques Houzeau (1624–91).

The Boar Hunt; The Stag Hunt.
Coll.: Isaac D. Fletcher. (18.1 & 2)

Sarcophagi, two (South Terrace); marble; Italian, probably of the seventeenth or eighteenth century, after antique models. (10.151 & 12.9)

SCULPTURE IN THE WEST GARDENS

Temple of Love (lawn west of Art Gallery); stone; from Porchefontaine, a dependency of the Versailles palace; possibly designed by Jacques Ange Gabriel (1710–82) for the Versailles gardens; French, about 1765. (27.1)

L'Amour Captif de la Jeunesse ("Love, the Captive of Youth"); stone statue (standing inside the above); by or after Louis-Simon Boizot (1743–1809); French, eighteenth century. (27.2)

178

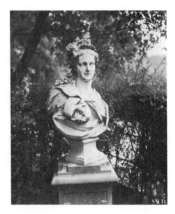

(17.1)

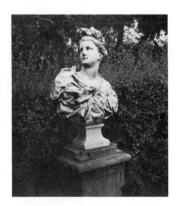

(17.2)

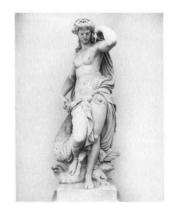

(22.32)

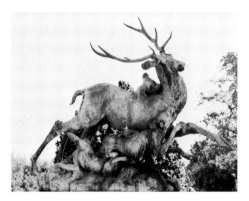

(18.2)

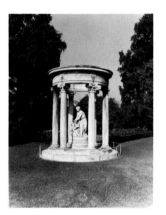

(27.1–2)

Wellhead (garden west of Lunchroom); wrought iron; design of grapevines; probably German, eighteenth century.

Bell (Oriental Garden); bronze; Japanese, eighteenth century.

SCULPTURE NEAR THE LILY PONDS

Allegory of Louis XV guided by Love; marble; by or after Lambert-Sigisbert Adam (1700–59); inscribed "Adam 1743." (14.6)

SCULPTURE NEAR THE ENTRANCE PAVILION

Hébé; marble; copy after the figure by Jacques-François-Joseph Saly (1717–1776). (17.27)

ENTRANCE GATES

Gates, a pair (Euston Road Entrance); wrought iron; from Beddington Park, Surrey, England; erected there by Sir Nicholas Carew in 1714. Above them is an escutcheon which bears the arms of the Carew family. (13.10)

(13.10)

179

INDEX

Abel, Karl Friedrich, 8
Acklom, Richard, 28
Adam and Eve, 173
Adam, Lambert-Sigisbert, 179
Adam, Robert, 72, 74
Adams collection, 26
Adams, Mr. and Mrs. Perry, 152
Affleck, Lady, 46
After the Storm, 92, 152
Agnew, Andrew, 22
Agnew, Colin, 88
Aiken, Conrad, 142
Aiken, Mary, 142
Aikman, William, 4
Albenas, Comte d', 100
Alice Hawthorn, 12
Alken, Henry, 4
Allegrain, Christophe-Gabriel, 96
Allston, Washington, 142, 167
Alston collection, 32
Althorp, Viscount, 28
Amalthée, 176
Ambatielos, Nicolas, 90
Ames, Ezra, 142
Ammanati, Bartolomeo, 134
Ancaster, Duchess of, 14
Anderson, Emily, 16
André collection, 26
Angel releasing St. Peter, 142
Antenor, Journeys of, 107
Antinous, 136
Apollo, 136
Apollo Belvedere, 176
Apostle Spoons, 63
Apple Orchard, 164
Aquado collection, 100
Archer, Baron, 24
Ariadne, 54
Ariles, Mlle, 162
Ascension of St. Louis, 122

Astor, Vincent, 134
Atwood, Jesse, 142
Autumn, 78, 132

Bacchanal, 58
Bacchante, 102, 170, 176
Bacchus, 78, 178
Bacchus and Erigone, 52
Bacon, E. R., 32
Bailiff, 12
Baily, Edward Hodges, 54
Baker collection, 20
Baker, George G., 30
Baker, Norman, 173
Balderston, John, 132
Ball, Mrs., 46
Ballock, Mrs. M., 108
Bankes, Sophia, 42
Bardini, Stephano, 140
Baring, Mrs. Alexander, 162
Baring, Charles, 162
Baring, Mrs. Wyndham, 110
Barlow, Francis, 52
Barlow, S. L. M., 86
Barnard, Mrs., 108
Barney, James W., 112
Baronet with Sam Chifney, 34
Barrett, T. J., 22
Barry, Sir Edward, 26
Barye, Antoine-Louis, 104
Basley, J., 86
Bates, Mrs. Oric, 146
Bathing Nymph, 90
Batson, Edward, 10
Batson, Ricketts, 20
Bayley, Richard, 68
Beaker, 64
Beauchamp-Proctor, Lady, 30
Beaufort, Duke of, 120
Beaufoy, Mrs. Henry, 8

Beaumaris Castle, 48
Beauvais factory, 106
Beck, Paul, 162
Becker, Carl, 144
Beckett, Ernest W., 96
Beckford, William, 30
Beckford Children, 30
Beddington Park, 179
Behaque, Comte de, 90
Bell Salt, 63
Bellevue, Ireland, 58
Bellini, Giovanni, 126
Bellotto, Bernardo, 130
Bellows, Emma S., 144
Bellows, George Wesley, 144
Belper, Lord, 130
Bement, Clarence S., 86
Bemrose collection, 38
Benoit, J. F., 174
Benson, Frank Weston, 144
Bernal collection, 114
Bessborough, Earl of, 28
Bierce, Ambrose, 156
Billington, Ray Allan, 148
Binet, 118
Bingham, Sir Charles, 28
Bingham, George Caleb, 144
Bingham, Margaret, 42
Birley, Oswald, 4
Bishop, Mrs., 16
Bisset, Mordaunt Fenwick, 130
Blair, Mrs. Chauncey, 144
Blair, Insley, 86
Blair, William, 22
Blairman, Philip, 74
Blaixel, Marquis Auguste de, 100
Blake, William, 52
Blarenberghe, Louis-Nicolas van, 120, 121
Bliss, C. N., 160
Blue Boy, 8
Blumenthal, George, 112
Blythe, David Gilmour, 144
Boar Hunt, 178
Boardman, Mrs. Elijah, 148
Boardman, William Whiting, 148
Bodman, Mrs. Edward W., 172, 173
Boizot, Louis-Simon, 96, 178

Bologna, Giovanni, 134, 136
Bonington, Richard Parkes, 4
Bonner, Lilli Stehli, 90
Bonnier de La Mosson, Mme., 90
Boringdon, Baron, 26
Borland, Mrs. William F., 144
Borlase, Walter, 34
Boucher, François, 82, 86, 106, 107, 120
Boudin, L., 112
Boultbee, John, 4
Boulton, Matthew, 76
Bourne, B. W., 6
Bourne-May, Geoffrey, 18
Bow porcelain, 78
Bowers, George, 66
Boxing Match, 154
Boy with Grapes, 100
Boy with Peaches, 86
Brabant, 84
Braddyll, Jane, 56
Brandt, Mortimer, 154
Breadalbane, Countess of, 42
Breakfast in Bed, 144
Breton, Jules, 92
Briosco, Andrea, 140
Brocket collection, 10
Brocklebank collection, 36
Broke collection, 28
Bromley-Davenport collection, 32
Brook, Alexander, 144
Brooke, Richard, 63
Brooks, Col. John, 164
Brown, Mather, 167
Browning, Adele S., Memorial Collection, 4,
 10, 14, 16, 22, 26, 30, 32, 36, 38, 44, 52,
 56, 58, 72, 74, 76, 86, 88, 90, 96, 98, 102,
 108, 110, 112, 114, 118, 128, 130
Browning, Elizabeth Barrett, 18
Brownlow, Lord, 122
Buccleuch, Duke of, 108
Bulidon, 118
Burch, Edward, 42
Burdett-Coutts, Baroness, 80
Burrell, Miss Juliana, 46
Burton collection, 30
Burton, Mrs. Francis, 30
Burton, Henry, 8

Butler, Lady Frances, 46
Buttall, Jonathan, 8
Butts, Thomas, 52
Byron, Lord, 56
By the Pond, 173

Caffieri, Jean-Jacques, 96
Calton Hill, 38
Cambridge, Duke of, 54
Camden, Marchioness, 24
Campden, Lord, 90
Canal, Antonio, 130
Candlesticks, 66
Caraman Chimay, Prince de, 88
Carbery, Lady, 42
Cardonnel, Elizabeth de, 14
Carew, Sir Nicholas, 179
Carhampton, Earl of, 8
Carlin, M., 110, 112
Carnarvon, Lady, 8, 10, 32, 108, 116, 118,
 120, 121
Carpenter, W., 6
Carrick, Earl of, 42
Carriera, Rosalba, 132
Carrier-Belleuse, Albert Ernest, 104
Carter collection, 16
Cassatt, Mary, 144, 167, 173
Cassini, Count, 138
Cassone, 174
Caster, 66
Celadon, 114
Cha-ah-din-ie, 154
Chabot, J. J. M., 34
Chabrières-Arlès collection, 134
Chamberlayne, Tankerville, 32
Chantrey, Francis, 54
Charborough Park, 34
Charles I, 44
Charles II, 56, 64
Charlotte, Queen, 8, 14
Charpentier, Alexandre, 104
Charpentier, Paul P., 110
Chase, William Merritt, 144
Chateau Thierry, 148
Chauchard collection, 107
Chauagnac, Comte de, 86
Cheape, Miss, 46

Chelsea porcelain, 78
Cherub, 54
Chesterfield, Earl of, 120
Chifney, Sam, 18, 34
Child with Bird and Apple, 102
Child with Bird Cage, 102
Child of Taos, 148
Childs, Charles D., 152
Chinoiserie Casket, 66
Chippendale, Thomas, 72
Choiseul-Praslin, Duke of, 128
Chorinsky, Count, 90
Christ Presented to the People, 173
Chrysler, Walter P., 152
Churchill, Winston, 168
Cibber, Caius Gabriel, 54
Clarendon, Countess of, 42
Clark, Alson Skinner, 144
Clark, H. M., 128
Clarke, Thomas B., 22, 142, 148, 152, 156,
 158, 162
Clavering Children, 30
Clay, Henry, 74, 152
Cleopatra, 54
Clifden, Lady, 28, 30
Clifton, Lord, 70
Clinton, Clifford E., 6
Clodion, 96, 114
Clonbrock, Earl of, 74
Cobb, John Winstanley, 36
Cockfight Scenes, 4
Cocks, Margaret, 6
Cockshutt, John, 80, 82, 83
Coconut Cup, 63
Coffee Pot, 68
Cognac, Gabriel, 86
Cogswell, William, 146
Colbert, Marquis de, 110
Colcard, H., 146
Colegate, Sir Arthur, 50
Coles, Mrs. Elizabeth, 162
Colman, Samuel, 167
Colman, William, 26
Communion Cup, 63
Conduit, John, 156
Coningsby collection, 16
Conrad, Joseph, 168

Constable, Anne, 4
Constable, Hugh Golding, 4
Constable, Isabel, 4
Constable, John, 4, 48
Constable, Col. J. H., 4
Constable, Mary, 4
Conti, Bernardino Dei, 126
Conversion of Saul, 52
Conyngham, Lady, 44
Coope, Octavius, 114
Cooper, Samuel, 42
Copley, John Singleton, 146, 167
Coppin collection, 8
Corday, Charlotte, 94
Cornelis, Albert, 126
Corot, Jean-Baptiste-Camille, 92
Cosson, J. L., 108
Cosway, Maria, 44
Cosway, Richard, 6, 42, 46
Cotes, Francis, 6, 50
Cotherstone, 12
Cotman, John Sell, 50
Cottage Door, 8
Council of War, 170
Country Churchyard, 173
Country Dance, 90
Courtauld, Augustine, 68
Couture, Thomas, 92
Cowboys, 172
Cowper collection, 130
Coysevox, Antoine, 136, 176
Cozens, Alexander, 50
Cozens, John Robert, 50
Cramer, M. G., 110
Crathorne, Isabel, 6
Crathorne, Thomas, 6
Credi, Lorenzo Di, 122
Creighton, Lady Elizabeth Penelope, 40
Cressent, Charles, 108
Crewe collection, 16
Crewe, Mrs., 16
Crews collection, 130
Crome, John, 6
Cromwell, Oliver, 58
Cronier, E., 110, 112
Crosbie, Viscountess, 24
Crosse, Peter, 44

Crouching Venus, 134
Cumberland, Duchess of, 8
Cumberland, Richard, 6
Cunard, Sir Bache, 140
Cunliffe Cup, 64
Cunliffe-Offley, Mrs., 16
Cupid, 78
Cupid and Psyche, 82
Cupid between Roses, 86
Cupid Blindfolding Youth, 176
Cupid Blowing a Trumpet, 140
Cupid Warning, 118
Curry, John Steuart, 146
Curtis, Sarah, 14

Dalrymple, Lady, 44
Dance, Nathaniel, 6
Danson Park, 38
d'Armengaud, Chevalier, 88
Dartmouth, Earl of, 48
Daubigny, Charles-François, 92
David, Jacques-Louis, 86
David d'Angers, Pierre Jean, 104
Davies, Randall, 50
Davis, Gilbert, 48, 49, 50, 52
Davis, Philip M., 150
DeCalonne collection, 26
Dedham Mill, 48
DeFarve collection, 108
DeGrey collection, 130
Delaunay, J., 112
DeLoose, D., 110
Delvaux, Laurent, 54
Demidoff collection, 112
Demuth, Charles, 167
Derby, Countess of, 46
Derby, Earl of, 44
DeSaumarez collection, 28
Desportes, Alexandre-Francois, 107
DeTabley collection, 8
Devis, Arthur, 6
Devonshire, Duchess of, 24, 44
DeVries, Adriaen, 134
DeWint, Peter, 6
D'Hancarville, 84
Diana, 90, 176
Diana and Actaeon, 50

Diana Huntress, 100
Diaz De La Pena, Narcisse, 92
Dighton, Isaac, 66
Dillon, Frances, 44
Dillon, Luke, 74
D. M., monogram, 44
Dodin, 117, 118
Doheny collection, 54
Don Quixote, 36
Donaldson, Sir George, 82
Donino, Baron, 88
Doorknocker, 60
d'Orville, Les Demoiselles, 42
Double Cup, 64
Dougherty, Mr. and Mrs. H. W., 150
Doughty, Thomas, 146
D'Oyley collection, 14
Dreux-Breze, La Marquise de, 88
Dripps, J. H., 160
Drouais, François-Hubert, 86
Drummond, Jean, 46
Duckworth, Mrs., 24
Dudley, Earl of, 80
Dufour, Joseph, 107
Dundas, Sir Lawrence, 74
Duplessis, Joseph-Siffrede, 86
Dupont, Gainsborough, 8
Duquesnoy, Francois, 134
Durand, Asher Brown, 146
Durer, Albrecht, 173
Dutasta, Paul, 102, 112
Dutch Cityscape, 94
Dying Sea Gull, 164

Eakins, Thomas, 146
Earl, Ralph, 148
Easton, collector, 8
Edinburgh, 38
Edward the Confessor, 20
Edwards, Sir Henry Hope, 136
Edwards, S., 16
Eglington, Countess of, 42
Egremont collection, 8
Eichholtz, Jacob, 148
Einstein, Albert, 168
Elephant, 170
Elephant, Camel, and two Monkeys, 52

Eliot, John, 40
Elizabeth I, 44
Elliot, Mrs. Hugh, 16
Ellis, W. R., 160
Engleheart, George, 44
Epstein, Jacob, 168
Erskine, Lady Mary, 46
Escudier collection, 134
Esdaile collection, 50
Essex, Countess of, 46
Etty, William, 8
Evans collection, 12

Fabe, Robert, 148
Faithorne, William, 40
Falconet, Etienne-Maurice, 98, 118
Fame, 136
Fane, Mrs. Henry, 10
Farmyard, 20
Farrand, Mrs. Max, 4, 16
Farren, Thomas, 68
Farrer, Henry, 132
Fauconnier collection, 90
Faun with Flute, 136
Fechin, Nicolai, 148
Feke, Robert, 148
Feline, Edward, 68
Ferguson, H. A. J. Munro, 130
Ferry, 36
Ferté, Coche de la, 88
Field, Marshall, 18
Finch collection, 18
Finch, Essex, 18
Fischof collection, 90
Fisher, Lord, 80
Fitch, Clyde, 176
Fitzgerald, Mrs., 42
Fitzgerald, Riter, 146
Fitzherbert, Mrs., 44
Fitzroy, Lady Georgiana, 46
Flageolet Players, 20
Flagler, Henry Morrison, 150
Flatford Mill, 4
Flatman, Thomas, 44
Flavell, C. E., 36
Flaxman, John, 54, 84
Fleischman, Mr. and Mrs. Lawrence, 144

Fleming, Gibson, 20
Fleming, Sir John, 24, 26
Fletcher, Isaac D., 178
Flight into Egypt, 122
Flintham, William, 156
Flora, 176
Flore-Baigneuse, 102
Forbes, Charles Stuart, 160
Forbes-Robertson, Norman, 40
Fould-Springer, Baron, 174
Fouquet, P., 128
Fox, Charles James, 16, 24
Fragonard, Jean-Honoré, 86
France and Bradburn, 74
Francia, Francesco, 122
Francoise Holding a Little Dog, 167
Frankland, Frederick, 14
Franklin Before the Privy Council, 160
Franklin, Benjamin, 86, 118
Fremin, René, 176
Fremont, John Charles, 150
French Frigate Towing an English Man O'War
 into Port, 52
Friedrich August II of Saxony, 173
Frieseke, Frederick Carl, 148
Frightened Baby, 104
Fruit Dish, 64
Full Shelf, 158
Fuller collection, 36

Gabriel, Jacques Ange, 178
Gabriel, T., 8
Gage of Hengrave Hall, 166
Gahagan, Lawrence, 56
Gainsborough, Thomas, 8, 50, 173
Gamichon, 112
Ganymede, 78
Gardiner, Rose, 32
Garland, James A., 174
Garnett, Anne, 52
Garnier, P., 108
Garrick, David, 22
Garth-Turnour, Edward Turnour, 24
Garvan, Francis P., 144
Gascoigne Family, 12
Gay, John, 28
Gellée, Claude, 88

George III, 8, 26, 60
George IV, 34
George à Paris, 120
Gérard, Marguerite, 88
Gherardi, Marchese, 122
Gibbons, Grinling, 56
Gibson collection, 130
Gibson, John, 56
Gillow, G. & R., 74
Gilmor, Robert, 158
Ginger Jars, 66
Ginsbourg, Baron, 176
Giovanni, Matteo De, 124
Girl holding a Doll, 156
Girl in Pink, 40
Girl with Doves, 100
Girl with Rabbit, 132
Girolamo di Giovanni da Camerino, 126
Girtin, Thomas, 49
Glackens, William T., 148, 167
Glen-Coats, Sir Thomas, 38
Glenlee, Lord, 22
Gloucester, Princess Sophia Matilda of, 42
Gobelins factory, 107
Godsal Children, 14
Golden Hour, 152
Goldschmidt-Rothschild, Baron Max von, 108
Goodison, Benjamin, 72
Gordon, Sir Willoughby, 38
Goring Castle, 74
Gott, Joseph, 56
Gould, Charles Winthrop, 152
Gould, George J., 8, 96, 100, 102, 112, 114,
 116, 117, 118, 120, 121, 132, 176
Gouthière, Pierre, 114
Goya y Lucientes, Francisco, 173
Grammatico, 49
Gramont, Duc de, 116
Gramont, Duchesse de, 108
Grand Canal, Venice: Shylock, 36
Grant, Col., 38
Grant, Mrs., 52
Graves, Morris, 167
Gray, E. H., 22
Green, Judge and Mrs. Lucius P., 86
Greenway, Henry, 64
Greffulhe, Comte Henride, 108

Greffulhe, Comtesse de, 88
Gregory, John, 168
Grenfell, Pascoe Norman, 34
Grenfell, Mrs. William, 34
Greuze, Jean-Baptiste, 88
Grey, Lady Jane, 40
Grimani Palace, 176
Grove, Mrs. Thomas, 32
Guardi, Francesco, 132
Guinle collection, 100
Gussoli, E., 132
Guydamour, E. P., 114

Haddington, Earl of, 4
Haight, Mrs., 146
Half-way House, 144
Halhead, Nicholas, 30
Hamadryade, 176
Hamilton, Duke of, 30, 176
Hamilton, Lady, 32, 44
Hamilton, Sir William, 32
Hampden, John, 58
Hanbury collection, 18
Handel, George Frederick, 58
Harache, Pierre, 66
Harewood, Lady, 24, 26
Harmsworth, Sir Geoffrey, 6
Harpignies, Henry Joseph, 92
Harpsichord, 76
Harriman, W. Averell, 22, 174
Harrington, Countess of, 24, 26
Harrison, Joseph, 160
Harvey of Catton, 8
Hassam, Childe, 150
Hastings, Francis, 26
Hauling in the Net, 92
Hayman, Francis, 12
Haystacks, 150
Hayter, George, 12
Heade, Martin Johnson, 150
Hearst, William Randolph, 16
Heathcote collection, 8
Hebe, 179
Helgoe, Calvin L., 70
Heming, Thomas, 68
Henley, Lady Mary, 10
Henri, Robert, 150

Herbert of Cherbury, Lord, 46
Hercules, 134
Hercules and Antaeus, 140
Hercules and Telephos, 176
Hercules in the Garden of the Hesperides, 84
Heredia, Mme. L. de, 162
Hermes, 136, 176
Herring, John Frederick, Sr., 12
Hertford, Marchioness of, 14
Hertford, Marquis of, 100
Herzig, Robert, 90
Hicks, Thomas, 150
Highmore, Joseph, 12
Hilaire, Jean-Baptiste, 88
Hill, Thomas, 150
Hill, Viscount, 46
Hilliard, Nicholas, 44
Hill-Trevor, Lady, 42
Hindu Dancer, 170
Hoadly, Benjamin, 14
Hoadly, Mrs., 14
Hoare, Sir R. C., 10
Hodges, William, 12
Hodgkins, E. M., 114, 118
Hodgson, Robert Kirkman, 110
Hofburg, Vienna, 176
Hogarth, William, 14, 52
Holden, R., 16
Holford, Sir Robert, 90
Holy Family, 26
Home, Earl, 117
Home, George, 22
Homer, Winslow, 167
Homeward Bound, 94
Hopi Basket Maker, 154
Hopi Maiden, Village of Walpi, 154
Hopper, Edward, 150
Hoppner, John, 8, 14
Horse and Jaunting Cart, 40
Horses and Groom, 34
Horton, Christopher, 8
Hoskins, John, 44
Houdon, Jean-Antoine, 100
Houdon, Sabine, 100
Houghton collection, 16
Houze, Baroness de la, 100
Houzeau, Jacques, 178

Howard, Henry, 10
Howley, William, 54
Hudson, Thomas, 14
Huet-Villiers, J. F. M., 44
Hugo, Victor, 173
Hunt, Carew, 8
Huntingdon, Earl of, 26
Huntington, Anna Hyatt, 168
Huntington, Arabella Duval, 4
Huntington, Clara, 168
Huntington, Collis P., 122
Huntington, Henry E., 4, 168, 170
Huntington, Rev. Joshua, 164
Huntington Mausoleum, 168
Hutchinson collection, 34
Huth, Louis, 20

Ibbetson, Julius Caesar, 16
Inches, Natica Y., 146
Incontri, Marchese, 128
Indian Warrior, 170
Infant Christ in the Temple, 126
Ingram, Sir Bruce, 48, 50
Ingworth Hall, 76
Inkstand, 68
Inness, George, 150
Irvine, Viscount, 14
Irwin, Mrs. John, 26
Isenbrandt, Adrian, 122
Isleta Pottery Maker, 154
Israels, Jozef, 92
Isted, 82
Italian Hunting Dog, 172
Italian Street Scene, 128
Italian Village Scenes, 106
Itasse, Adolphe, 104
Iveagh, Earl of, 88
Ives, Brayton, 86

Jackson, Andrew, 148
Jackson, Sarah, 146
Jacque, Charles-Emile, 94
Jacob's Well, 18
Jefferson, Thomas, 156
Jenks, Brian, 8
Jenks, William, 8
Jennens collection, 18

Johnson, Eastman, 150
Johnston, Alexander, 68
Jonas collection, 58
Jonge, S. de, 130
Joseph II, 121
Joseph, cabinet maker, 108
Julien, Pierre, 176
Juno, 178
Juno, Minerva, and Venus, 34

Kadison, Mr. and Mrs. Stuart, 78, 84
Kaendler, J. J., 114
Kahn collection, 18
Kahn, Otto, 112
Kandler, Charles, 68
Kann, Edouard, 100
Kann, Rodolphe, 107, 120, 124
Keith, William, 152
Kemble, Roger, 26
Kemsley, Viscount, 6
Kendall, Mrs. Catherine, 164
Kennedy, John Pendleton, 162
Kensett, John Frederick, 152
Kent, Earl of, 130
Ker, Miss Isabel, 46
Kerr, Lord W. Talbot, 110
Kessler, George A., 110
Kettle, Tilly, 16
Killigrew, Anne, 130
Kimball, Moses, 158
King, Mrs. Anne, 20
Kingshull, William Howley, 54
Kinnersley, Philip, 68
Kirke, Mrs., 130
Kirkman, Abraham, 76
Kirkup, James, 68
Koucheleff-Besborodko, 128
Koy-yai, San Filipi Pueblo, 154
Kneller, Godfrey, 16
Kuhn, Walt, 152

Laar, Pieter Van, 128
Lady on a Gold Couch, 148
Lady with a Spaniel, 10
Lainé, Gilles, 114
Lamb, William, 42
Lambdin, James Reid, 152

Lambert, Charles, 20
Lambton, Ralph, 82
Lamerie, Paul de, 68
Lancret, Nicolas, 88
Landscape with Mountain Brook, 16
Lane, Fitz Hugh, 152
Langlois, Pierre, 74
Lannuier, Charles Honoré, 174
Larcade collection, 114
Largillière, Nicolas De, 88
La Rue, Louis-Felix De, 100
Lascelles, Mrs. Edwin, 24, 26
Last Gleanings, 92
La Touche, David, 58
Lauderdale, Earl of, 16
Laura, 144
Lawley collection, 8
Lawrence, Thomas, 16, 18, 40, 54
Lazzaroni, Baron, 124, 126
Leach, Mrs. Felix, 18
Lear and Cordelia, 166
Lear, Edward, 49
Leda and the Swan, 82
Lee, Robert E., 168
Lee Acton, Penelope, 28
Lee Acton, Susannah, 28, 30
Leeds, Duke of, 112, 116
Leeds, W. B., 90
Leleu, J. F., 110
Lelong collection, 88
Lelong, Mme. C., 114, 117
Lely, Peter, 18, 130
Lemoyne, Jean-Baptiste, 102
Lenclos, Ninon de, 121
Lens, Bernard III, 44
Leon collection, 14
Le Paute, 112, 114
Le Sage, Augustus, 68
Levis Mirepoix, Marquis de, 100
Levy, George, 76
Lewis, Mansel, 30
Libby Prison War Museum, 146
Lichfield, Earl of, 112
Liechtenstein, Prince of, 128, 130
Ligonier, Viscount, 10
Ligonier, Viscountess, 10
Lincoln, Abraham, 146, 160, 164, 172

Linnell, John (painter), 18
Linnell, John (furniture maker), 72, 74
Lionne, M. Laurent de, 121
Lippi, Fra Filippo, 126
Little Lady from the Sea, 170
Little Red Riding Hood, 16
Lock, Matthias, 72
Lockhart-Ross, Sir Charles, 58
Loggan, David, 50
Lombardo, Tullio, 136
Lonely Tower, 50
Long, Lady Jane, 16
Long Leg, 150
Loop, Henry A., 152
Lorta, 114
Loudon collection, 26
Louis XIV, 120
Louis XV, 120, 179
Louis XVI, 96, 121
Louis, Charles, 112
Loutherbourg, Philip James de, 18
Louvre, Grande Galerie of, 107
Love, Captive of Youth, 178
Lovell, Mrs., 46
Lowe, William Drury, 122
Lucan collection, 24
Lucan, Countess of, 42
Lucan, Earl of, 28
Lucas collection, 130
Lucky Sportsman, 20
Luddington, G. Franklin, 150
Ludlow, Lady, 80
Lukin, Miss, 46
Luks, George Benjamin, 154
Lumley, Lady Anne, 14
Luppert, Erich, 128
Lusurier, Catherine, 88
Luttrell, Simon, 8
Lynde, Mrs. Benjamin, 148
Lyon, C. W., 144
Lyon, Henry, 32
Lyttelton, Lord, 6
Lyttelton, Rachel, 6
Lyttelton, Sir Richard, 6

Macklin, Thomas, 10
MacMonnies, Frederick, 170, 176

Maderna, Stefano, 140
Mainardi, Sebastiano, 122, 128
Maintenon, Mme. de, 121
Maitland, G. G., 30
Maitland, James, 16
Majolica, 174
Man Carrying a Child, 138
Man in a White Silk Waistcoat, 12
Man with a Sword, 138
Mandarin Jars, 174
Maniere, 112
Mannheim collection, 136, 138
Mantegna, Andrea, 172
Marck, Johan van der, 128
Margas, Jacob, 68
Marigny, Girardot de, 100
Maris, Jacob Henricus, 94
Marlborough, Duke of, 28, 30, 58, 134
Marriage of the Adriatic, 36
Marshall, Benjamin, 18
Martigny, Philip, 168
Martincourt, 114
Master of the Castello Nativity, 122
Master of the Presentation, 124
Master of the Scandicci Lamentation, 124
Master of the Stratonice Panels, 124
Master of the Whittemore Madonna, 128
Match at Newmarket, 34
Maurer, Alfred H., 154
Mayo, Geoffrey, 68
Mazer, 63
McCalmont, Dermot, 18
McCormack, John, 30
McDonough, Dr. John J., 144, 160
McKim, Isaac, 162
McLean, John, 74
McManamy, Charles, 160
McSorley's Cats, 160
Meares, Mrs. John, 10
Medal, 64
Mee, Mrs. Joseph, 44
Meheux, J., 8
Meissen porcelain, 114, 117
Melville, Allan, 142
Men O'War in the Thames, 50
Mercury, 136
Mercury and Psyche, 134

Mercury with Bow, 134
Mercury with Caduceus, 134
Merle, Hugues, 94
Merle-Smith, Kate Fowler, 174
Mersfelder, Jules, 156
Metsu, Gabriel, 128
Meyer, H., 90
Meyer, Jeremiah, 44
Micaud, 118
Michel, Claude, 96
Michel collection, 10
Michelham collection, 18
Michel-Levy, H., 90
Migeon, 112
Milking Time, 94
Miller, Horrocks, 6
Miller, John, 36
Miller, Sir Thomas, 30
Miller, Sir William, 22
Milles, Jeremiah, 32
Milligan, J., 56
Milton, John, 40, 58, 84, 104
Molesworth, William, 24
Molitor, B., 110, 112
Monckton, Mary, 44
Moncrieff, Mrs. Scott, 22
Monmarque, M. de, 90
Monnot, Martin-Claude, 102
Montagnais Indians, 167
Monte Cavo, 48
Montefiore, Sir Moses, 78
Monteith, 66
Montfaloot, 20
Months of Lucas, 174
Montjoy, Louis, 114
Moon, Carl, 154
Moonlit Canal, 130
Moran, Thomas, 156
Moreau, Louis-Gabriel, 90
Morel and Hughes, 72
Morgan, J. Pierpont, 14, 96, 107, 114, 134,
 136, 138, 140, 174
Morin, 117, 118
Morland, George, 20
Morley collection, 26
Mornington, Earl of, 18

Mortimer, John Hamilton, 20
Mortimer, Stanley, 108
Moseley, Audrienne, 4, 12, 18, 38
Moseley, Mr. and Mrs. C. C., 62, 68, 84
Moseley, Mr. F., 148
Moulton, Charles Barrett, 18
Moulton, Sarah Barrett, 18
Mount, Shepard Alonzo, 156
Mounted Arab Killing a Lion, 104
Mount Temple, Lord, 88
Muller, William James, 20
Munro, Mr. and Mrs. W. B., 62, 63, 64, 66
Murray, Fairfax, 10
Musical Trio, 90

Napoleon, 121
Nar-Ah-Kee Gie Etsu, 154
Nattier, Jean-Marc, 90
Navaho Weaver, 154
Navier, Gabriel, 94
Neapolitan Fisher Girls, 36
Needlework, 174
Nelson, Lord, 56
Neptune, 176
Neptune Fountain, 140
Nesbitt collection, 8
Nessus and Deianira, 134
Nettie Reading, 160
Neumann, L., 108
Newall, William, 140
Nicholas III de Neufville, 176
Noble Pastoral, 107
Noel, 118
Nollekens, Joseph, 56
Norgate, Edward, 44
Norgate, Judith, 44
North Pueblo of Taos, 154
Northcote, James, 20
Northumberland, Duchess of, 46
Northumberland, Duke of, 72
Northwick, Lord, daughters of, 46
Nost, John Van, 58
Nottingham, Countess of, 18
Nourse, Jane Christian, 22
Nursing Mother, 104
Nymph and Satyr, 98, 138

Oath in the Tennis Court, 86
O'Brien, Mrs. R., 12
Ochtervelt, Jacob, 128
Oeben, Jean-François, 108
Oliver, Mrs. Fitch E., 148
Oliver, Isaac, 46
Oppenheim collection, 112
Orchid, 166
Orde, Col., 30
Oriental Porcelain, 174
Orientale, 150
Osage Man, 154
Otis, Bass, 156
Oudry, Jean-Baptiste, 107
Owen, William, 20

Page collection, 66, 68
Page Fund, 56
Page, Mr. and Mrs. James R., 62
Page, Kate Van Nuys, 40, 112, 146, 150
Paget, Captain William, 46
Paillou, Peter, 46
Paine, Thomas, 156
Palencia, School of, 126
Palmer, James, 46
Palmer, Robert, 30
Palmer, Samuel, 50
Palmerston, Lord, 88
Panton, Thomas, 14
Parc Monceau, 88
Paris Street Scene, 150
Park Scene, 158
Park Scene with Women and Children, 88
Parker, Theresa, 26
Parkhurst, Mary, 46
Partington, J. H. E., 156
Pater, Jean-Baptiste, 90
Patriotic Fund Vase, 68
Patton, Anne W., 146
Patton, Mr. and Mrs. Peter Wilson, 146
Paul, Delphine Elizabeth, 74
Paul, Sir Edward J. Dean, 78, 82
Paxos, 49
Payne, John Howard, 162
Peace Pipe, 154
Peale, Charles Willson, 156
Peale, James, 156, 158
Peale, Raphaelle, 158

Peale, Rembrandt, 158
Pearce, Mary Margaretta, 36
Pearson, Clive, 130
Pedro Cay-eta, 154
Peilhon collection, 88
Pelée collection, 90
Peridiez, L., 110
Perrin, Raoul, 100
Perry, Enoch Wood, 158
Persephone, 178
Peterborough, Earl of, 130
Peters, Matthew William, 20
Peterson, Rosa, 114
Petit, N., 112
Petitot, Jean, 121
Peto, John Frederick, 158
Petre, Lady, 10
Pets, 92
Pfungst collection, 136, 138
Phelips of Montacute, 12
Philibert, 112
Philip-Smith, G. J., 6
Philippe, F. M., 118
Phillips, Ammi, 158
Pierrepont Place, 36
Pigalle, Jean-Baptiste, 102
Pilfold, Admiral, 32
Pine, Robert Edge, 22
Pinkie, 18
Pinturicchio, 124
Piot, Adolphe, 94
Pitcairn, Catherine Small, 164
Pitcairn, John, 164
Pitcairn, Mrs. John, 22
Pitt, George, 10
Pitt, Penelope, 10
Pitt, William, 56
Pitts, Thomas, 68
Plenipotentiary, 12
Plessis-Bellière, Marquise de, 90
Plimer, Andrew, 46
Plummer, John, 66
Polk, Charles Peale, 158
Ponsonby collection, 114
Porchefontaine, 178
Porterfield, John, 156
Potocka, Count Vincent, 90

Potocka, Princesse Pélagie, 90
Potter, William James, 170
Poullain collection, 90
Poulter, John, 12
Prendergast, Maurice Brazil, 158, 167
Prudence, 58
Prud'hon, Pierre-Paul, 90
Pseudo Pier Francesco Fiorentino, 128
Pulszky, Ferencz-Aurel von, 136
Pycroft, Joseph, 8

Quinn, Florence M., 6, 14, 16, 18, 20, 22, 26, 28, 70, 76, 88, 107

Rabaut Saint-Etienne, 86
Race horse, 4
Raeburn, Henry, 22, 40
Rainbow on the Exe, 49
Ramsay, Allan, 24
Ramsden collection, 14
Raphael, E. L., 10, 30
Rath, George von, 136
Ravensworth, Lady, 46
Read, Henry, 10
Reflections, 144
Reignière, Marquis de la, 121
Reinhart, Benjamin Franklin, 158
Rembrandt, Hermanszoon van Rijn, 128, 173
Renée de Béarn, Comtesse, 86
Renesse-Breidach, C. W. de, 172
Reuling, Mrs. George, 156
Reveley, Henry, 52
Reynolds, Graham, 42
Reynolds, Joshua, 24, 26, 40
Riboisière, Comte de la, 108
Riccio, 140
Rice, Mrs. Alexander Hamilton, 120
Richardson, Jonathan, Sr., 28
Richmond, Duchess of, 40
Ricketson, Walton, 170
Ricketts, Mordaunt, 20
Riesener, J. H., 110, 112
Ripon collection, 32
Risen Christ between Saint Andrew and Saint Longinus, 172
Riveley, J. H., 50

River Rapids, 146
River Scene: Bathers and Cattle, 38
Rivers, Baron, 10
Rivers collection, 10
Rivière, Jean-Baptiste, 90
Rix, Julian, 158
Robert, Hubert, 90
Robertson, Jean, 22
Robinson, Theodore, 160
Robinson, Sir William, 16
Robson, Edward, 78, 80, 82, 83
Roccatagliata, Niccolo, 140
Rochette, Claudine, 100
Rock Towers of the Rio Virgin, 156
Roden, Countess of, 44
Roesen, Severin, 160
Roettier, John, 64
Rogers, John, 170
Roman Landscape, 12
Romney, George, 28
Rosenheim, A., 90
Roosevelt, Theodore, 144
Roque, 114
Rosewater Ewer and Basin, 64
Rosselli, Cosimo, 124
Rothschild, Baron Adolphe de, 96
Rothschild, Baron Albert von, 10
Rothschild, Alfred de, 8, 10, 32, 108, 110, 114, 116, 118, 120, 121
Rothschild, Edmond de, 88
Rothschild, Baron Gustave de, 78
Rothschild, Baron Louis, 10
Rothschild, Maurice de, 100
Rothschild, Baron Nathaniel de, 98, 114
Roubiliac, Louis François, 58
Roussel, Pierre, 110
Routh, C. R. N., 50
Rowlandson, Thomas, 52
Royal Hunt, 174
Royce, Stephen, 170
Rubestuck, F., 110
Rundell, Bridge & Rundell, 54
Rushout, Elizabeth, 46
Ruskin collection, 36
Russell, Charles, 170
Russell, John, 52
Russell, Lady William, 42

Rutland, Duke of, 34
Rycroft, Sir Richard, 28
Rysbrack, John Michael, 58

Sackville, Viscount, 24
Sailing Ships, 152
Sailor with Mr. Thomas Thornhill, 18
Saint Cloud, 90
St. Francis of Assisi, 168
St. Peter, 126
St. Roch, 132
Saint-Gaudens, Augustus, 170
Saint-Seine, Vicomte de, 114
Salisbury Cathedral, 4
Salting, George, 4
Salute to the Head of the Canal, 132
Salver, 66
Saly, J. F. J., 179
Sam with Sam Chifney, Jr., 18
Sanderson's Brook, Caldwell, New Jersey, 158
Sarcophagus, Roman, 178
Sargent, John Singer, 160
Sartorius, John N., 34
Sassoon, Sir Philip, 100
Satire on False Perspective, 52
Satterlee, Mrs. H. L., 14
Saul before Samuel, 166
Saunier, C. C., 108
Savonnerie factory, 107
Saxony, Kings of, 110
Scalp Dance, 170
Scheemakers, Peter, 58
Schlegell, Abigail von, 54, 62, 68, 174
Schmid, Alvin, 90
Schmitz, J., 108
Schneider, M., 128
Schomberg, Dr. Isaac, 16
Schumann, L., 88
Schussele, Christian, 160
Schweppe, Mrs. Richard, 62, 68
Sclater-Booth, Mrs. Cynthia, 174
Scott, Digby, 68
Scott, Sir John Murray, 100, 110
Scott, Sir Samuel, 50, 82
Scott, Virginia Steele, 160
Scott, Virginia Steele, Foundation (see Virginia Steele Scott Foundation)

Scout, Taos Valley, 154
Scudder, Janet, 170
Seafield, Countess of, 44
Seapiece, Mouth of the Thames, 50
Seaport at Sunrise, 88
Sedelmeyer, Charles, 32
Seidlitz, Baroness von, 86
Sentimental Ideas, 144
Setting Sun, 14
Sèvres porcelain, 112, 116
Seymour, Anne Horatia, 46
Shaw, Edwin C., 144
Shaw, George Bernard, 168
Shee, Martin Archer, 34
Sheep, 94
Shelley, P. B., 40
Shelley, Samuel, 46
Sheridan, R. B., 40
Shield of Achilles, 54
Shippen, Dr. Joseph, 158
Shivering Figure, 100
Siddons, Sarah, 26
Sigoigne, Mlle. Adele, 162
Sleeping Baby, 92, 168
Sloan, John, 160, 167
Smallwood, Robert, 68
Smart, John, 46
Smith, Benjamin, 68
Smith, Mrs. Joseph, 6
Smith, Martin T., 80
Smith, Private, 10
Smith, Mrs. Susan F., 156
Solomon and the Queen of Sheba, 174
Somers, Earl, 107
Sotiau, N., 114
Spaniel and Kitten, 56
Spanish Dancer, 172
Spencer, Countess, 24, 28
Spencer, Earl, 24
Spencer, Lady Elizabeth, 28, 30
Spencer, Lord Henry, 28
Spencer, Robert, 160
Spice Box, 64
Spitzer collection, 88
Spring, 78
Spring in Paris, 144
Spring Turning, 167

Stag Hunt, 178
Stanton, William, 54
State Fair, 146
Steele, Edith Shorb, 152
Steeple Cup, 64
Stehli, Henry E., 90
Stein, S. G., 40
Sternberg, H., 136
Sterne, Lawrence, 40, 56
Stettiner, H., 176
Stevens, Alfred George, 60
Stevenson, Robert Louis, 170
Still Life, 8
Still Life: Wine, Cakes, and Nuts, 158
Stow, Mrs. Ann, 162
Storr, Paul, 68
Story, George Henry, 160
Strawberrying, 146
Strub, Charles H., 34, 40
Strutt, Samuel, 32
Stuart, Gilbert, 162
Stubble, Henry, 46
Stubbs, George, 34
Study of Foliage, 6
Sugaring Off, 150
Sully, Thomas, 162
Summer, 78
Summer and Autumn, 20, 82
Surplice, 38
Sussex, Duke of, 42
Sutherland, Duke of, 107
Sutter, John A., 164
Svirsky, Mlle., 170
Swaythling Salt, 64
Swinburne, Algernon Charles, 6
Swinburne, Sir John, 6
Swing, 90
Szechenyi, Countess Laslo, 142

Taillander, 118
Tandart, 118
Tankard, 66
Taos Hunter, 154
Tarbell, Edmund C., 162
Tate Gallery, 38
Tatlock, Miss, 6
Tauromaquia, 173

Taylor, collector, 6
Taylor, Jeremy, 40
Taylor, Watson, 26
Taylor, Zachary, 142
Tazza, 64
Teapot, 68
Tearle, Thomas, 68
Temple of Love, 178
Teniers, 83
Tennant collection, 24, 28
Tennyson, Lord, 158
Tenth Street Studio, 144
Terray, Comtesse de, 108
Thane collection, 50
Thanet, Countess of, 44
Thévenet, 117, 118
Thomas, Brian, 60
Thomas collection, 14
Thomas, G. A., 22
Thompson, Cephas Giovanni, 162
Thompson, Hannah Bull, 158
Thomson, James, 4
Thornhill, James, 34, 52
Thornhill, Thomas, 18
Three Graces, 46
Three Houses, 160
Thynne, Lord Henry, 80
Tiepolo, Giovanni Battista, 132
Tiger Ware Jug, 63
Tilyard, Philip Thomas Coke, 162
Toilet Service, 66
Tollemache, Lionel, 46
Tolstoy, 172
Top Man, 152
Torrance, Mrs. Lewis, 164
Torre Abbey, 166
Tower, Mrs. Jane E., 74
Treiman, Joyce, 144
Trimmed Cock, 18
Tritton, Robert, 6
Troubetskoy, Paul, 170
Troyon, Constant, 94
True, Allen Tupper, 164
Truman, Sir Benjamin, 10
Truth and Falsehood, 60
Tuffier, 86
Tumbler, 64

Turner, Frederick Jackson, 148
Turner, J. M. W., 36, 38, 48
Turner, P. M., 6, 38
Turner, Walter, 49
Turnerelli, Peter, 60
Two Boys by Candle Light, 38
Two-handled Cup, 64
Tyrrell, Misses, 46

Under the Trees, 92
Unlucky Sportsman, 20

Vallière, Duchesse de la, 120
Valour and Cowardice, 60
Van Buren, Martin, 156
Vanderbank, John, 36
Van der Gucht Children, 28
Vanderlyn, Pieter, 164
Van der Neer, Aert, 130
Van Dyck, Anthony, 40, 130
Van Gorder, L. E., 164
Van Lear, Dr. Joseph Weatherby, 158
Van Loo, C.-A.-P., 90
Van Marcke, Emil, 94
Vasse, Louis-Claude, 102
Vaughan, Minnie, 160
Vedder, Elihu, 164
Venice, 4
Venus and Cupid, 82, 86, 98, 136
Venus de' Medici, 136
Venus with the Apple, 134
Vernon, Robert, 36
Versailles, 178
Vieillard, 116, 118
Vietri, 50
View in a Wood, 50
View near Fort Gwalior, India, 12
View of Rialto Bridge, 132
View on the Stour near Dedham, 4
Vigée-Lebrun, Elisabeth-Louise, 90
Vile, William, 72
Villa, F. G., 176
Villebois collection, 10
Villiers, George, 26
Virginia Steele Scott Foundation, 142–168
Volk, Leonard, 172

Vogelbach, Jean Thompson, 158
Von Wybicki, 121
Vulliamy, 76

Wagon outside an Inn, 18
Waldegrave, Lady, 46
Wales, Prince of, 42
Walferdin, Hippolyte, 86
Walker, T. Stafford, 80
Waller, T. W., 80
Wallis, Henry, 38
Walpole, Horace, 44
Walpole, Lord, 56
Walters, Mrs. Henry, 22, 118
Warburton, Col., 44
Warburton, Mrs., 44
Ward, James, 52
Warren, Sir Peter, 58
Washing Day near Perugia, 150
Washington, George, 100, 104, 156, 158, 162
Wateringbury Place, 72
Waterloo, Battle of, 18
Watt, James, 22
Watteau, Antoine, 90
Watts, Frederick W., 36
Way to Calvary, 124
Weber collection, 122, 126, 128
Webster, John B., 162
Wedgwood, Josiah, 84
Wedgwood pottery, 78
Weir, Julian Alden, 166
Weisbach, Werner, 98
Weiss, Henry E., 156
Weisweiler, Adam, 110
Wellesley, Arthur, 18
Wellington, Duke of, 18, 40
Wellington Monument, 60
Wendland, Hans, 86
Wenlock collection, 8
Wertheimer, Alfred, 110
Wertheimer, Charles J., 50, 107, 110
Wertheimer collection, 58
Wertheimer, Samson, 10
West, Benjamin, 166, 167
West, Mrs. Frederick, 44
Western, Lord, 146

Western, Shirley, 146
Westminster, Duke of, 8, 26
Westmoreland, Earl of, 10
Weyden, Roger van der, 122, 124
Wharton, Earl of, 44
Wheatley, Francis, 36
Whipham, Thomas, 68
Widener, Joseph E., 102
Wiener, Philippe, 88
Wild Boar, 52
Wilkie, David, 38, 52
Wilkinson, Mme., 96, 178
Willaume, David, 68
Willcox collection, 28
Willett, Henry, 124
Willett, Mrs. Ralph, 32
William and Mary, 66
Williams, John, 78
Williams, Stephen, 130
Williams, William, 68
Wilmington, Earl of, 44
Wilmot, Sir Robert, 46
Wilson, Benjamin Davis, 152
Wilson, Mrs. Benjamin Davis, 146
Wilson, Mrs. John, 40
Wilson, Richard, 12, 38, 48
Wimbourne, Viscount, 174
Wine Cup, 64
Wine Taster, 66
Winter, 78
Winter and Spring, 82
Winterton, Countess, 24
Winthrop, Francis B., 142
Wolstenholme, Dean, 38
Woman and Child, 18
Woman and Child at a Fountain, 88
Woman at a Confessional, 38
Woman Bathing Her Feet, 138
Woman Braiding Her Hair, 138
Woman Combing Her Hair, 138
Woman Returning from Market, 138
Woman Seated in a Garden, 148
Woman Touching Her Foot, 138
Woman Washing, 90
Wood, A. R. Wilson, 22
Wood, Catherine, 6

Wood, Grant, 167
Wood, John, 38
Wood, R. M., 78
Wood, Mrs. Ralph Winstanley, 36
Wood, William, 46
Woodford, Miss Sue, 44
Woodis, Samuel, 34
Woolf, Robert, 46
Woolner, Phyllis, 36
Worswick, A. E., 74
Wouverman, Philip, 130
Wright, Charles, 68
Wright, Joseph, 38
Wrythen Knop Spoon, 63
Wurzelbauer, Benedikt, 140, 176
Wynkoop, Cornelis, 164

Ya-otza-begay, 154
Yarmouth, Earl of, 14
Yates, Lawrence Reid, 162
Yerkes collection, 100
York, Duchess of, 42
York, Duke of, 54
Yosemite, 150
Young, Brigham, 158
Young, Gen. E. C., 167
Young Fortune Teller, 28
Young Hobbinol and Ganderetta, 10
Young Knitter Asleep, 88
Young Scholar, 88
Youth Drawing a Thorn, 140
Youth with Cap and Gown, 24
Yvon, Mme. d', 107